Understa Photojournaiism

Understanding Photojournalism

Jennifer Good and Paul Lowe

Bloomsbury Academic
An imprint of Bloomsbury Publishing Plc

BLOOMSBURY
LONDON · OXFORD · NEW YORK · NEW DELHI · SYDNEY

Bloomsbury Academic

An imprint of Bloomsbury Publishing Plc

50 Bedford Square	1385 Broadway
London	New York
WC1B 3DP	NY 10018
UK	USA

www.bloomsbury.com

BLOOMSBURY and the Diana logo are trademarks of Bloomsbury Publishing Plc

First published 2017

British Library Cataloguing-in-Publication Data
A catalogue record for this book is available from the British Library.

ISBN: HB: 978-1-4725-9489-1
PB: 978-1-4725-9490-7
ePDF: 978-1-4725-9491-4
ePub: 978-1-4725-9492-1

Library of Congress Cataloging-in-Publication Data
A catalog record for this book is available from the Library of Congress.

Cover design by Liron Gilenberg | www.ironicitalics.com
Cover image © Paul Lowe / World Press Photo

To find out more about our authors and books visit www.bloomsbury.com. Here you will
find extracts, author interviews, details of forthcoming events and the option to sign up
for our newsletters.

Printed and bound in India

Contents

Illustrations

Acknowledgements

This book is the product of years of working with, and learning from, our students.

More than our knowledge of professional photojournalism practice or our research and writing experience, it is classroom conversations with the students of the bachelor's and master's in photojournalism and documentary photography at London College of Communication that have shaped the ideas that are expressed here. In those conversations we have found the clearest articulation of the meeting point between 'theory' and 'practice': a point of urgency, challenge and growth. We are indebted to these students for every awkward question, every risk taken and every insight shared.

We also thank our colleagues in the photography department at LCC, particularly Max Houghton; and Davida Forbes and Nick Bellorini at Bloomsbury for their patience and guidance. It is a privilege to have been approached with the opportunity to create this book, and it has been a hugely rewarding experience.

Special thanks are due to Martha Rosler for her generous and constructive comments on Chapter 7. Finally, Robert Hariman, Leora Kahn and Wendy Kozol provided us with invaluable feedback on the manuscript as a whole – for their attention to detail, commitment to the most important issues at the heart of the book, and their time, we are hugely grateful.

Preface: Using This Book

This book offers a thematic overview of the history and development of photojournalism and its contemporary nature, guiding readers through the major theoretical, conceptual and practical issues confronting photographers in the field today. Each chapter explores the central debates about key topics in photojournalism from historical, technological and economic points of view, and considers how those developments have shaped current practices, particularly in terms of their ethical impact.

As is often the case, the clearest way to introduce the aims for this book is perhaps by setting out what it is not. First, it is not a technical guide or a 'how to' manual for photojournalists. Although it makes use of extensive practical and visual examples to consider how photographers operate, the book's foundation is theoretical: identifying the critical concepts that impact on the working concerns faced by photojournalists every day. For example, it considers how postcolonial theory can make way for the responsible representation of ethnic minority subjects, or how understanding the concept of aesthetics can help a photographer reflect on the positioning of their work in relation to 'art'. Specific thinkers and theorists are mentioned in order to present particular points of view or to give a fully rounded account of a key issue, but the book is also not, first and foremost, an introduction to critical literature but to concepts. A 'further reading' list provides an indicative list of writers and the texts most closely associated with the issues raised in each chapter along with a more general bibliography at the back of the book.

The same principle applies to the discussion and use of photographers' work. The book is not an exhaustive history of photojournalism nor an attempt to cover all of the most important photojournalists and their work. Where particular bodies of work are engaged with, they have been chosen because they best exemplify the critical questions that are at the core of the book. Often, these come from well-known figures from the history of the medium, but it also means that some of the biggest names and most famous photographs are not included, and sometimes we draw attention to lesser-known work for the same reasons.

Stressing the fact that this is not (outside of the general overview provided in the early chapters) a history of the genre, or a 'who's who' of famous names does not exempt us from the responsibility to consider issues of diversity and representation in deciding whose perspectives to feature. If this book were primarily 'a history', it would show that photojournalism has been overwhelmingly dominated by white, Western, economically privileged heterosexual men. In a recent article for *Time*

magazine's Lightbox blog, photojournalist Anastasia Taylor-Lind presents a stark set of statistics that demonstrate just how underrepresented women, people of colour, LGBTQ and non-Western people are in this industry, both as photographers and at all levels of the media infrastructure on which photojournalism relies.[1] In wanting to address this problem, we have sought (in the manner of feminist revisionist art history, for example), to highlight other perspectives. But at the same time, it has also been our job to recognize some of the most influential developments and landmark bodies of work that have shaped the medium in actuality, and this has meant paying an unequal amount of attention to the work of white, middle-class, Western male photographers. These choices have been made with care, but they are not unproblematic. Essentially, given the scale and scope of the enterprise, this book has to be about what photojournalism is and has been, rather than what we might wish it to be.

Photojournalism as a genre of photography does not exist in isolation. Understanding its roots and influences often means looking to other types of imagery. For example, thinking about aesthetic questions in photojournalism involves the discussion of art and other photographic categories, and to fully understand issues of representation and 'otherness', we might draw on the histories of portraiture, anthropology or even advertising. In all cases, our use of examples is pragmatic and contingent: some are discussed in such depth that they can be called 'case studies', while others are used to illustrate important principles in ways that do not involve as much contextual detail. But they have each been chosen carefully to retain their significance over time. In the publication of any book, especially one whose core subject is visual, many factors must be taken into account when deciding which images to reproduce as illustrations and which to leave out. While it would have been possible to fill the pages with photographs and to include reproductions of the work of every photographer mentioned, we recognize not only that this would have made it a different kind of book entirely, but that it is not necessary. The ability to read and study across platforms, combining digital, visual and textual literacy, is increasingly taken for granted at all levels of education, and as we mention photographers and their work, we do it with the expectation that readers will, either literally or figuratively, have this book in one hand and a digital device in the other, looking up names and finding readily available reproductions of images for themselves. By accessing on their own terms what we do not or cannot include directly, our hope is that readers will discover new connections, build on the text and autonomously develop a range of reference points that uniquely reflect their specific concerns. For similar reasons, some of the images we have chosen not to reproduce are ones that will be known to readers already because they are so famous, widely recognized and digitally searchable with ease.

As well as providing a thorough grounding in the subject, which can either be read through in its entirety or dipped into on a reference basis, the book is designed to act a stimulus for further discussion and reading. With this is mind, there are pedagogic features such as chapter summaries, a comprehensive and subject-specific glossary of terms and guides to further reading at the end of each chapter.

The Chapters

Just as it is helpful to delineate the parameters of this book by explaining what it does not set out to do, introducing the nature of photojournalism itself must be approached by means of its relativity to other forms, practices and concepts. For this reason, most of the first chapter is dedicated to setting out aspects of photojournalism's historical and critical context, and also to acknowledging its perceived cultural associations: it is as important to consider how photojournalism is broadly understood today as to arrive at any kind of accurate definition. The relationship between theory and practice is considered, as well as acknowledging the critical importance of visual literacy for both photographer and viewer.

From there, Chapter 2 presents an overview of key historical aspects of photojournalism's development, not as a definitive or comprehensive account but rather with a view to demonstrating how the kinds of characteristics and perceptions discussed in the previous chapter have come to be: most often as a result of technological and economic factors.

Chapter 3 takes one of these historical staples – the photostory format – and uses it as a starting point to explore questions of the relationship between words and photographs: a relationship that is central to photojournalism's functioning in any media context. This chapter ends with a discussion of how photographic storytelling has been transformed in the digital age, and this leads directly into Chapter 4, a more comprehensive look not only at the ongoing evolution of photographic methods and technologies in the twenty-first century but also at the entire business and distribution models on which they depend. Both of these factors continually shape one another, and cannot be considered in isolation.

The following three chapters then move on to focus on three of the most central issues that shape the work of photojournalists across the breadth of the industry: in Chapter 5, its power to represent people, and the social and ethical responsibility that this presents to all photographers; in Chapter 6, the ethics of 'manipulation' and of representing graphic violence; and in Chapter 7, the relationship between content and form, or aesthetics, in photojournalism. The final chapter is offered as a kind of conclusion, in which we argue for a contemporary notion of photojournalistic witnessing that balances creativity with journalistic commitment and embraces connectedness – both digital and fundamentally human – in the modern world.

What Is Photojournalism?

Chapter summary

In this chapter, we begin by considering photojournalism's contexts from a variety of perspectives: the wider network or economy in which is it located; the cultural and social perceptions of truth to which it is still, for better or worse, held accountable; and, ultimately, how it can be defined as all of these parameters shift and change with the transformations of the contemporary media environment. This involves considering some of the inherited stereotypes and perceived values associated with the photojournalist as a figure within this environment. Finally, as a way of further introducing the priorities of the book as a whole, we discuss the relationship between theory and practice in relation to photojournalism, including the imperative for viewers and photographers alike to commit to visual literacy, or a position of critical engagement with what we see.

The multiple levels of photojournalistic witnessing

On a street in Sorocaba, Brazil, a man takes a photograph. His subject is another man taking a photograph, of a painting, of a photograph. Four days earlier, Alan Kurdi, a three-year-old Syrian refugee of Kurdish ethnic background, drowned in the Mediterranean Sea. He and his family were trying to reach Europe (reportedly they hoped eventually to settle in Canada). Turkish photojournalist Nilüfer Demir took a set of photographs of his lifeless body washed up on the shore, which quickly spread around the world (Figure 1.1). Reproduced on newspaper front pages and in social media feeds, the image of this small boy lying face down in the sand stopped people in their tracks. It led to cries of outrage, horror, grief and shame. It was appropriated and transformed into artworks, memes, tributes and protests that took on 'lives' of their own, and most of which communicated a plea for compassionate action in

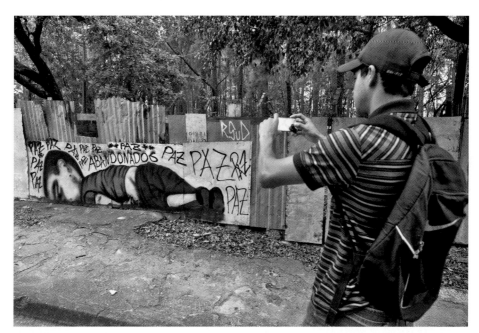

Figure 1.1 Nelson Almeida, 2015. A man takes a picture of graffiti depicting Alan Kurdi (initially reported as Aylan Kurdi, and also known as Aylan Shenu), a Syrian three-year-old boy who drowned off a Turkish beach, in Sorocaba, Brazil, on 6 September 2015 (Getty Images).

response to the growing global refugee crisis in which thousands of people were arriving every day on the shores of Europe, in many cases having fled the terror of war, but all in search of a better life. Alan Kurdi became a symbol of something that transcended the individual tragedy of his death, and that led to change. At the level of government policy in Britain, Turkey, Germany and other European nations, the change is debatable. But in the lives of individual citizens of those countries, there can be no doubt: because of Demir's photographs, ordinary people in ordinary towns have, at the time of writing, Syrian families sleeping in their spare bedrooms and eating at their tables, and there has been a surge in financial donations to migrant and refugee charities. So profound was the empathy stirred up by these photographs that many people could no longer, in good conscience, regard the refugee crisis as a faceless abstraction.

Nelson Almeida's photograph (Figure 1.2) records one of the many vernacular artworks that proliferated around the world in response to the photographs, painted and stuck to a fence in a Brazilian city. In it, the same boy's small body has been made monumental, and is surrounded, in scrawled text that appears frantic, repeated and desperate, by the word 'peace'. Alan Kurdi and the many thousands of other Syrians like him have been 'abandoned' by the governments of the world's most powerful countries, if not (for this short time at least) by their news media. This photograph

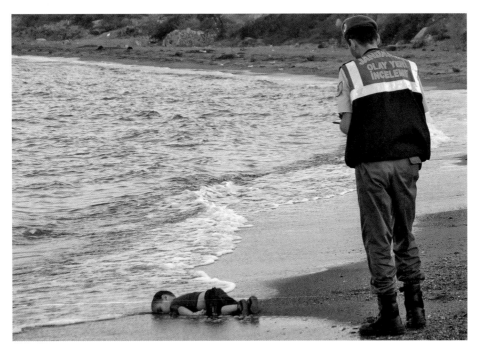

Figure 1.2 Nilüfer Demir, 2015. A Turkish police officer stands next to a migrant child's dead body off the shores in Bodrum, southern Turkey, on 2 September 2015 after a boat carrying refugees sank while reaching the Greek island of Kos (Getty Images).

captures in its numerous layers of witnessing a dimension of contemporary photo-journalism that sets it apart from that of previous generations. In a striking echo of Demir's original photograph, a man stands nearby and bears witness, this time not as a uniformed Turkish policeman but as a citizen photographer in a backpack and baseball cap, likely poised to share his camera-phone image via Instagram or Facebook in a kind of tribute of his own – not weeks or months following the appearance of Alan Kurdi's body on a beach on the other side of the world but within just four days. He is part of a network of witnesses, the same network as Demir, Almeida and the anonymous graffiti artist, through which images travel, effecting the kind of recognition for which photojournalists have worked over generations, but with a speed, ubiquity and proliferation that has not been imagined before.

Together, these two images set the scene for the concerns of this book. One is a photograph that records the essence of a vital and complex historical moment in a way that seems to exceed words; it is a potent symbol that will no doubt before long be called 'iconic', and the impact of which has been deeply felt throughout Europe and beyond (more deeply, we would argue, than any other in recent memory). The other presents in palpable terms – the street, the human observer, hand-drawn imagery and hand-held smartphone – how the contemporary networked digital media economy transcends the boundaries that have governed it in the past while

still preserving, if not enhancing, photography's unique capacity to move hearts and minds in response to the most pressing issues of the moment. Both of these images raise complicated and problematic moral questions about the representation of the other, and of the aftermath of acts of violence, and demand that ethically supportable solutions to them be explored. Central to the concerns of this book are the multiple levels of witnessing and representation that can be seen within these two pictures, including the historical and moral contexts that surround the photographing of death and suffering, and the complex conditions of viewing and dissemination.

The economy of images

The distinct features of the still photograph endow it with a unique quality in that it acts as a technologically enhanced, proxy form of vision, positioning the viewer as a witness of the scene with their own eyes, even if separated spatially and temporally from the actual event. The act of photography therefore links together the event, its participants (including both the photographer and any subjects of the photograph), the photograph itself and then its audience, in an active, ongoing and participatory process of producing meaning. In doing so, photographs provide a kind of raw material for the construction of historical consciousness. They have a remarkable ability to define events and mediate their passage into history. This action does not happen in just one direction: it ebbs and flows as the significance of a particular image changes over time, and is recalled by later events that echo or contrast with it, or recedes into memory.

This movement and flow of imagery can be called a network, as noted above (and explored further in the last chapter of this book). It can also be understood as an economy. Photographs, such as that of Alan Kurdi, go through complex processes of distribution, trade and consumption, and are perceived to have a different kind of value in different contexts. Photographs are also economic in that they are commodities of commerce, bought and sold as part of the commercial activity of selling newspapers, magazines and, increasingly, online publications. But they are also commodities of information, meaning and knowledge production; memory; and ultimately of culture. In the economy of photojournalism information, ideas, opinions, news, propaganda and commerce all interact. Their meanings are altered depending on the context in which they are printed and by the way in which they are presented. They have simultaneously an informational and a monetary value in that they convey meaning but also help sell the product in which they are embedded. As commodities of both informational and commercial exchange, they are vulnerable to the fluctuations of marketplace and audience. This combination of a journalistic or public service function with a commercial one necessarily drives photojournalists to produce work that can perform effectively on both levels. At its best, this generates work that

is socially relevant while also generating audiences, and produces a financial return for the photographer that allows them to continue their practice.

What is a photojournalist?

Another feature of this contemporary economy of images is the increasing difficulty of maintaining clear boundaries between the various practices that make it up. Just as the lines begin to blur between editor and viewer, consumer and producer, professional and amateur, the definition of photojournalism itself is also drawn into question. In particular, the differences between photojournalist and documentary photographer can be so indistinct that many practitioners no longer attempt to choose between these titles. But for our purposes, a distinction is necessary, if only to delineate the scope of this book in a manageable way.

The photojournalist, then, is one who makes work intended for a public audience either through editorial publication – primarily in magazines or online – or for nongovernmental organizations (NGOs). These formats allow for extended photo series or 'essays'. This is, for the most part, what is meant by the use of the term 'photojournalism' in this book.[1] Newspapers, in contrast, tend not to rely on series but on isolated single images to illustrate their stories, and newspaper wire services such as Reuters, the Associated Press (AP) and Agence France Presse (AFP) until relatively recently have typically also concentrated on the single image, largely in order to downplay the individuality of their photographers in a desire to promote a sense of objective reality (however contested this concept may be).[2] These might be more accurately defined as news photographers as opposed to photojournalists, although the technological advances of the digital age have allowed these agencies to begin to distribute longer-form stories that could be considered as photojournalism by our definition. That is not to say that photojournalists do not also cover fast-moving news events nor that their images are never published individually, but that their prime concern is a deeper kind of interaction with the situation, often involving repeated visits over substantial periods of time. Defining documentary photography in relation to photojournalism tends to be a question of both subject matter and form. Longer-term projects intended primarily for exhibition in galleries or publication in books can be features of both, but the documentary photographer usually favours stories that engage with accounts of the state of things and underlying sociopolitical conditions, as opposed to photojournalism's focus on the topical events that constitute news and current affairs.

Clearly there is considerable overlap and blurring of the boundaries between all of these definitions, with individual practitioners at various times – even within a single day – working in ways that could be described using any of them. In this book we discuss some single news images and also work that falls into the category

of documentary and even art (a range of distinctions that is further explored in Chapter 7). But clarifying some of the differences and relationships between them is nonetheless useful, and the book is centred around the term photojournalism in particular because it marks an important and identifiable form while also encapsulating a range of related practices within the increasingly dynamic network that constitutes the wider visual media environment.

Roles and identities

Having put forward a definition of photojournalism itself, we can now turn to some of the other sorts of labels and roles that photojournalists have used more specifically to characterize their particular objectives. Looking at these labels can help in identifying some of the most important critical questions surrounding photojournalism, and the ones with which we are most concerned in this book. Identities that are habitually claimed by photojournalists, such as 'witness' or 'storyteller', sometimes reflect deeply held convictions on the one hand and unquestioned assumptions on the other. In both cases, this makes them worth studying in order to better understand what photojournalism is for, how it is perceived and what makes it a unique mode of address. The following is a brief list of these stereotypical labels or identities, along with an outline of each of their implications, by way of an introduction to the scope of this book's concerns (as opposed to an outline of the book's chapters themselves, which can be found in the section titled 'Using This Book'). These categories are employed here as heuristic devices to help explore potential positions – they are meant to be neither definitive nor exhaustive, and once again there is scope for considerable overlap between them when considering any given photographer's practice.

The objective recorder

'Objectivity' here implies not only a lack of bias but also a complete and reliable account of a situation: the truth, the whole truth and nothing but the truth. Can photography ever achieve this? Of all the critical questions to be tackled here, this is perhaps the one with the richest existing literature devoted to it – and specifically to critiquing, or 'unmasking', the persistent ideology of photography's objectivity. We know, of course, that no photograph can ever truly be objective. Yet it is still, in a sense, an ideology on which the whole project of photojournalism depends; it is a compelling standard to which many photojournalists aspire and to which many viewers hold the photographs they see in the news every day. How can such a paradox be maintained? As well as subtleties of subjectivity or bias in reporting, questions about photo manipulation, staging and outright deception are implicated in the discussion of objectivity. These questions are considered later under the umbrella of 'ethics'.

The observer

Connected to the ideal of objectivity is the perceived function of the photojournal-
ist as one who observes the world from a detached position of emotional distance.
Sometimes this can have ethical implications, leading to discussions about voyeur-
ism, surveillance, power and the dilemma of non-intervention in the face of injust-
ice. But it is also a subject position more often associated with the tradition of street
photography: that related genre which is closely aligned historically and stylistically
to photojournalism but is usually very different in its objectives. Arguably the very
opposite of the photographer with an agenda to 'make a difference', the observer is
one who moves silently through the world, watching events unfold from a distance
with no greater ambition than, in the words of legendary street photographer Garry
Winogrand, 'to see what the world looks like photographed'.[3] Is this a viable propos-
ition for someone who calls themselves a photojournalist?

The storyteller

'Telling stories' through the medium of photography is an explicitly stated aim for a
great many photojournalists. And this is not surprising, given the affinity between
photography and words in the press, where they function side by side, and more
conceptually as it were, embodied in the tradition of the photostory or photoessay,
a staple of the genre for almost a century. What does it mean, though, to expect
photographs to tell stories, when all any photograph can do is isolate a single fro-
zen moment outside the narrative flow of time? What we mean by 'story' is often
not a narrative development with a beginning, a middle and an end, but rather the
treatment of an issue: something that the (photo)journalist judges to be important,
worth pointing the camera towards in order to draw our attention to it. In this way,
they do not tell stories so much as they tell (or, more accurately, show) society what
to look at.

The witness

'I have been a witness, and these pictures are my testimony,' claims James Nachtwey
of his long career documenting war, famine, disease, violence and poverty.[4] The close
alignment of photography with ideals of objective truth is what most often prompts
the use of legal language such as this when describing its social role. The photo-
journalist as witness denotes a very special, privileged position, as one who, often at
great risk or expense to oneself, is deemed worthy of seeing on behalf of the general
public. It is their responsibility to choose, by implication, what the rest of us will see,
and also, paradoxically, to bear witness in order that we do not have to. They pro-
vide the images to which we are all then invited, in a different sense, to bear witness,

contributing to something that is often called collective memory and shaping a historical record to be passed on to future generations. This is a role that is preserved for extremes: the mantle of witness is usually given only in relation to photography of the greatest horrors and glories of history.

The advocate

At the root of many photojournalists' practice is the belief that photography can 'make a difference' in the world. Antithetical to the detached observer and, sometimes even to the witness, is one whose photography is directly and deliberately aligned with a specific cause, engaged and often driven by passionate commitment and personal investment. Also springing from the language of legal systems but associated with a whole range of other terms, including 'humanitarian' and 'concerned photography', this kind of advocacy can range in function from raising public awareness of a particular cause to investigative reporting, the gathering of evidence and fundraising in collaboration with charitable organizations. Though more often associated with the wider category of documentary photography, a great many photojournalists are also driven, explicitly or implicitly, by the principles of advocacy in their work for newspapers and the daily coverage of world events. All photojournalism involves questions of power and 'the politics of representation', but it is within this category that they are often most prominent and heavily weighted.

The interpreter

Rather than holding themselves to any ideals of objectivity, many (not to say most) photojournalists acknowledge that their role involves not only a degree of subjectivity but also the work of active and creative interpretation. Along with this comes the conscious responsibility to make choices, both conceptually and aesthetically, in creating images that conform to their personal view of the subjects they represent. This interpretive process has led some photographers to move completely outside of the parameters of photojournalism towards the sphere of conceptual or fine art practice, as the most appropriate space in which to engage with their concerns. Because of the apparent (but false) dichotomy between photographic recording and creativity, this transition sometimes involves negotiating perceived tensions between the values of art and the values of journalism. These tensions are also encountered by photojournalists who choose aesthetic approaches that seem to clash in some way with their subject matter: the relationship between beauty and suffering, for example, has been the subject of fierce debate, especially in the latter decades of the twentieth century.

The burden of objectivity

Whichever, if any, of these roles a photojournalist chooses to identify with, each of them in one way or another must contend with the question of 'objectivity'. From those who hold it as the central value of their practice (as in the first category, above), to those whose practice as a whole is predicated on critiquing it (as in the last), the issue of objectivity is a kind of touchstone or reference point around which all photojournalists must orient their own unique position. The work of a photojournalist is bound up at every level with questions of their fundamental moral position and the code of ethics that develops from that. Central to this is perhaps the most fundamental of these concerns: the tension between objectivity and subjectivity, or the power to show and the power to create. David Campbell writes,

> the beauty of photography is that it is a creative, interpretive process in which something about the world is visualized. The burden of photography is that its relationship with the world, especially when we think of it as a reflection of the world, is often in tension with its status as a creative interpretation. Finding ways to navigate this tension is one of the challenges for how we understand the purpose of photography, particularly when we are thinking about how photojournalism and documentary photography reports on the world.[5]

Photography is so much a part of daily modern life in the Western world that there is often not a clear difference between talking about photography and talking about seeing. It is deeply embedded in our habitual practices of understanding the world and establishing our identities within it, making it more and more difficult to maintain a critical perspective on the power of the photograph – how it creates meaning; how it selects and frames, highlights, obscures, interprets and represents. Objectivity, truth and indexicality are characteristics that have been associated with photography since its inception, in the truism that 'The camera never lies'. Understanding photography in general and photojournalism in particular involves a recognition that these are ideologies – that is to say, deeply powerful and alluring distortions – that prevail simultaneously with their great power to captivate, move and challenge us.

Like eyewitnesses in court, photographs are potentially unreliable. Their viewpoint is partial, their framing selective and they represent only a brief fraction of time. Yet in their indexicality (the supposedly umbilical link to their referent), their economy of description and their emotional charge, photographs still provide, as Howard Chapnick puts it, 'testimony in the court of public opinion'.[6] They can seem simultaneously to obscure and mislead on the one hand, and on the other to inform, explain, claim and interpret. They operate both spatially and temporally, condensing located experiences into artefacts that are mobile and long lasting. Products of technology mediated by human action, they are tangible, material objects: things

(whether physically as a print or virtually on a computer screen). They can therefore potentially be afforded an agency and life of their own. If, as visual journalism specialist Julianne Newton argues, photographic images are 'indexical forged evidence',[7] they are also, in the words of Susan Sontag, 'bewitching sirens, luring us with promises of knowledge but leaving us with little more than the memory of a compelling face'.[8] This duality of photographs, operating both within the descriptive and the imaginative realms, is central to their nature and central to the practice of photojournalism, in that it frequently seeks to generate an imaginative, empathetic engagement with the real world. As Sontag describes,

> photographs are of course, artefacts. But their appeal is that they also seem, in a world littered with photographic relics, to have the status of found objects – unpremeditated slices of the world. Thus, they trade simultaneously on the prestige of art and the magic of the real. They are clouds of fantasy and pellets of information.[9]

Furthermore, there is a complex process of continuous feedback between the image itself, its formal and descriptive resonance, its distribution through the media and its reception by an audience. Central to this is the act of witnessing. John Durham Peters argues that all forms of media witnessing involve a tripartite relationship between the audience, the witness and the text, and that the interactions between them combine to produce meaning. Witnessing is therefore to be considered as a process, as Wendy Kozol asserts:

> Visual witnessing is not a one-way mirror but a relational process between the photographer or artists, subjects of the image, viewer, and surrounding contexts. That does not make visual politics necessarily progressive, antiracist, antisexist, or anti-imperialist, but it does mean that these cultural practices function as contested sites that as readily destabilize as secure hegemonic ways of seeing and knowing.[10]

Gilles Peress (whose own practice can be located somewhere between photojournalism and documentary photography, as discussed above) sums up this multifaceted relationship from the perspective of the photographer, maintaining that a photograph

> has a multiplicity of authors: the photographer, the camera, each has a different voice – a Leica with 28mm, a Nikon with a 24mm – everything speaks, cameras speak. Then there is 'reality', and reality always speaks with a vengeance; with a very forceful voice. Then there is the reader; the viewer. So the more the images are open, the greater the participation of the audience, the more the photograph can be seen as an open text with a multitude of authors.[11]

Whilst appearing to be a faithful record of what was before the lens, the fixed surface of the photograph never presents an objectively neutral representation. It is highly selective, fragmentary, momentary and subjective. The myriad of variables inherent in the photographic technology combined with the multitude of possibilities of what

is included and excluded from the frame by the hand-eye-brain coordination of the photographer means that any image is only one possible variation on an infinite number of images that could be generated from a given encounter with that same 'real'. As far back as the 1930s Roy Stryker, director of the US Farm Security Administration's comprehensive documentary photography project (which established the careers of some of the most famous American photojournalists of the mid-twentieth century), observed that 'the moment that a photographer selects a subject … he is working upon the basis of a bias that is parallel to the bias expressed by a historian'.[12] This comparison with history – and its shaping – can be taken further, as Alan Trachtenberg explains:

> The historian employs words, narrative and analysis. The photographer's solution is in the viewfinder: where to place the edge of the picture, what to exclude, from what point of view to show the relations among the included details. Both seek a balance between 'reproduction' and 'construction': between passive surrender to the facts and active reshaping of them into a coherent picture or story.[13]

For some critics, emphasis on photography's connection to the 'real' potentially leads to ideological exploitation, with the apparent objectivity of the medium and the media open to exploitation. In particular, critics writing in the last two decades of the twentieth century, most prominently Alan Sekula, John Tagg, and Martha Rosler, have chastised photojournalists for their apparent naivety in supporting structures of ideology rather than challenging them. Rosler argues that photojournalism, instead of 'seeking to promote understanding', too often acts to 'provoke, to horrify, or to mobilize sentiment against a generalized danger or a specific enemy or condition'.[14] But, as we shall argue, and have already noted in the case of Alan Kurdi's image, this same emotive power can equally be used to amplify and enhance more considered or progressive messages. When combined with a thoughtful approach to dissemination and display, it can serve to subvert the problems raised by such critiques. Additionally, we also argue that the imaginative potential of photography is central to its ability to connect with audiences in ways that go beyond the purely informational, and that skilled photojournalists mobilize this consciously and deliberately in their practice.

An alternative perspective on the impossibility of photojournalistic objectivity can be found in social science and anthropology. The role of the 'participant-observer', in which the author is not an automaton or naive innocent unaffected by their worldview, offers an analogy to the photographer. In short, if they are reflective enough to acknowledge their own subjectivity and to mobilize it consciously, this can be a powerful position from which to speak. Newton and Bill Nichols especially have explored how photojournalism and documentary film can become reflexive practices and how such self-awareness can enhance the meaning of their outputs.[15] An awareness of the photographer's own biases and point of view can thus be leveraged

to create a new kind of objectivity. As Peress explains, 'There's a certain honesty in being highly subjective.'[16] Rather than debating simplistic concepts of 'truth', then, it might be productive to adopt the more nuanced ideal of 'mediated communication'.[17] The viewer-photographer relationship which this implies is one in which the photographer is 'believed' to the extent that they are trusted to adhere to a standard of truth as they reasonably perceive it, determined by their skill and integrity as well as by their own personal response, identity and point of view.

Theory and practice

Many of the most highly respected, seasoned and thoughtful photojournalists will testify that this and other ethical negotiations usually happen by an interplay of experience, instinct and trial and error. As with any craft, there is no true substitute for this process, and many photographers have what might be called, to a greater or lesser extent, an 'atheoretical' practice. The subject matter with which many photojournalists engage every day, and the speed with which they must do so, often does not leave much space, moment to moment, for theoretical or critical reflection. (Nilüfer Demir writes of her experience on the Turkish beach, 'as a photographer I have a task that does not allow time for second guessing ... So, I took the pictures.'[18]) However, in our experience of teaching and discussing photojournalism in the context of higher education, we have seen repeatedly that an ability to articulate the methodologies, underpinnings, motivations and assumptions that shape photojournalism practice; to find a critical vocabulary for them and recognize the theoretical context against which they take shape can only make for photography that is deeper, more engaged, more ethically sound and more effective. The aims of this book are to set out this critical vocabulary and theoretical context in a way that emphasizes their vital, dynamic connection to the work of both making and looking at photojournalistic images.

In our experience as educators, we sometimes come across a certain amount of resistance to approaching photojournalism from a theoretical point of view. This is often related to a perceived polarization of 'theory' and 'practice'.[19] For students whose priority is to learn to be photographers, engaging with theory can seem alienating – or worse, irrelevant. We occasionally meet students who react with anger to difficult theoretical texts, objecting to the 'overintellectualizing' or even just 'overcomplicating' of what is essentially a matter of practical skill and experience. At the other end of the spectrum, though, is the example of one undergraduate student in a History and Theory seminar who responded with genuine emotion to the realization that there was a set of theoretical ideas that could articulate the great tension he had felt when assigned to photograph people living with poverty, sickness and exclusion. That this ethical unease had a name (broadly, the 'politics of representation'), for him signalled a kind of liberation, and familiarity with it equipped him to be a

more responsible, confident photographer. Both of these examples show in different ways that theory is powerful. The radical feminist, activist and scholar bell hooks writes, 'when our lived experience of theorizing is fundamentally linked to processes of self-recovery, of collective liberation, no gap exists between theory and practice. Indeed, what such experience makes evident is the bond between the two – that ultimately reciprocal process wherein one enables the other.'[20] This book is a guide to some of the theoretical concepts that, one way or another, have an impact on the practice of photojournalism. It aims, in part, to demystify theory by demonstrating how relevant, urgent and significant it is in relation to practice. The examples we discuss shed different kinds of light on the past, present and future of photojournalism, but in each case theory offers a way of seeing and engaging, not a separate position outside of history or practice. There are other books that can provide this kind of 'arm's-length' overview of theoretical positions (we detail some of them in the guide to further reading); however, our aim here is something different.

Having said that, theory itself has a history: political movements, social changes and economic conditions all have an impact on the ways in which photography is talked about and understood. For example, the 1970s saw a huge transformation in critical ideas surrounding identity and interpretation. This critical movement, known as poststructuralism, emerged in response to the political and social concerns of the time, including the black civil rights and women's liberation movements. Theoretical positions come and go, but some ideas about photography that are firmly rooted in particular historical periods – for example, the notion of photographic realism in the nineteenth century – retain their influence over time despite social changes and the arrival of other, in some cases contradictory, ideas. Some critical debates and positions cannot be fully understood without directly acknowledging their historical specificity (or to put it more simply, their roots). In such cases, we have aimed to do so.

Visual literacy

This book is meant not only for photojournalists, of course, but also for viewers of photojournalism. As well as a resistance to texts that 'overcomplicate' the process of image making, there is also, in our experience, sometimes a kind of affront at the idea of 'overanalysing' images. It is a deep-seated truism that good photography, especially in a news context, 'speaks for itself', and that rather than being critiqued and picked apart, photographs should be left alone to speak their requisite 'thousand words' with self-evident, indexical clarity. This, of course, is a theoretical position in itself. It is sometimes appropriate to respond to images with silence, but in the words of John Berger, 'the relation between what we see and what we know is never settled.'[21] The reactionary separation of theory and practice is just as dangerous when it comes to looking at photographs as to making them, and this book is born out of a

fundamental conviction that critically engaged visual literacy is an essential part of what it means to be a responsible citizen of the world.

From our earliest education, most of us are taught how written language works: how to make and discern meaning from it, and to consider the conventions and agendas by which it is constructed.[22] For the most part there is no equivalent visual education, and this has led some (specifically scholars within the academic field of visual culture studies) to argue that most of us, existing in a 'hypervisual' society, are totally vulnerable to ideological manipulation – specifically, to the ideology that images 'speak for themselves' – if we do not learn to be critical of what we see.[23] In some ways, of course, many of us are more visually literate than ever. We habitually process multiple kinds of visual information, via different platforms and modes of address, all at once and at great speed. Viewers usually take in the denoted and connoted meanings of photographs, for example, integrating them into their own existing system of preconceptions with hardly a thought.[24] But it is this speed and lack of thought that is potentially problematic. Slowing down and trying to 'unpack' the many layers of subjective interpretation, intertextual connection, personal association, emotional identification, symbolic reference and cultural specificity that go into our encounter with a single photograph can be a counterintuitive and difficult thing to do, but it inevitably reveals insights that either pass us by or (more to the point) influence us implicitly when we look without thinking.

For many people, this kind of looking makes sense as an approach to painting or fine art photography that is deliberately multilayered and complex but feels alien when it comes to photojournalistic images that are supposed to offer a clear and direct account of something 'real'. But this apparent transparency is precisely the reason why visual literacy in relation to photojournalism is so important. Images that purport to present any kind of 'truth' about world politics, life-and-death situations, conflicts and social issues – whether this is identified as objectivity or 'mediated communication' – are arguably the ones that warrant the most careful critical attention, not the least.

Further reading

Introductions to critical thought on photography and photojournalism

Barthes, Roland. (1977). 'The Photographic Message' and 'The Rhetoric of the Image', in *Image, Music, Text*. Translated by Stephen Heath. London: Fontana Press.
Bate, David. (2009). *Photography: The Key Concepts*. London: Berg.
Burgin, Victor (ed.) (1982). *Thinking Photography*. London: Macmillan.

Elkins, James. (2011). *What Photography Is*. London: Routledge.

la Grange, Ashley. (2005). *Basic Critical Theory for Photographers*. Abingdon: Focal Press.

Linfield, Susie. (2010). *The Cruel Radiance: Photography and Political Violence*. Chicago: University of Chicago Press.

Newton, Julianne. (2000). *The Burden of Visual Truth: The Role of Photojournalism in Mediating Reality*. London: Routledge.

Sontag, Susan. (1979). *On Photography*. London: Penguin.

Tagg, John. (1988). *The Burden of Representation: Essays on Photographies and Histories*. London: Macmillan.

Trachtenberg, Alan (ed.) (1980). *Classic Essays on Photography*. Stoney Creek, CT: Leete's Island Books.

Wells, Liz (ed.) (2003). *The Photography Reader*. London: Routledge.

Wells, Liz. (2009). *Photography: A Critical Introduction*. Routledge.

Introductory histories of photography and photojournalism

Langton, Loup. (2008). *Photojournalism and Today's News: Creating Visual Reality*. London: Wiley-Blackwell.

Panzer, Mary. (2006). *Things as They Are: Photojournalism in Context since 1955*. London: Chris Boot.

Warner Marien, Mary. (2002). *Photography: A Cultural History*. London: Laurence King.

Practical guides to photojournalism

Evans, Harold. (1997). *Pictures on a Page: Photojournalism, Graphics and Editing*. London: Pimlico.

Hurn, David. (1997). *On Being a Photographer: A Practical Guide*. London: Lenswork.

Kobre, Kenneth. (2008). *Photojournalism: The Professional's Approach*. London: Focal Press.

Light, Ken (ed.) (2000). *Witness in Our Time: Working Lives of Documentary Photographers*. Washington, DC: Smithsonian Institute Press.

2

History and Development of Photojournalism

Chapter summary

The history of photojournalism is closely related to the technological and economic developments of both the photographic apparatus and of the media in general, as specific combinations of advances in the medium coincided with new forms of dissemination of information to allow for new aesthetic and journalistic forms of presentation and mediated the ability of the photographer to engage with audiences. Additionally, the ethics of representation were frequently challenged by the technological restrictions of the medium and by the traumatic nature of the events depicted. It is beyond the scope of this chapter to detail every event and major figure in the history of photojournalism, so instead the focus is on a number of key congruences of this process of technological and economic synthesis and photographers who reflect these moments, including the mid-nineteenth century, the rise of the illustrated picture magazines in the 1920s and 1930s, World War II, the Vietnam War and the impact of digital technologies at the end of the twentieth century. These subjects serve as starting points for further exploration of the development of photojournalism through the subsequent chapters.

Contested narratives of photojournalism

As we outlined earlier, there is a tension between, on the one hand, the political imperative to present a revisionist history of the medium that acknowledges a more diverse range of contributions and subject positions and, on the other, to recognize that the history and outlook of photojournalism as a form, at least until relatively recently, has been the product of a male-dominated Western outlook. What will hopefully become clear is that many of the contested issues that this book engages

with are not new, but recur in various guises throughout the history of the genre. Issues such as the staging of images, the manipulation of negatives, the nature of photographic 'truth' and the relationship of the photographer to their subject, the dangers of exploitation and victimization and the potential limitations of a predominantly white, Western, economically privileged male gaze were just as present and pressing at the birth of the medium as they are today. What is also evident is the central role photojournalists themselves have played in the process, exploiting each technological advance in the medium, testing the limits, taking the opportunities that emerge and in turn wrestling with the ethical issues thrown up in relation to their subjects, audiences and the nature of the photographic process of representing the world. Each generation has had to adapt to an ongoing process of change and has found innovative ways to push the boundaries of the form, exploring the varied ways in which a photograph can be deployed to provide useful and pertinent information about the world.

Conflict and disaster in the nineteenth century

Although the term 'photojournalist' was not applied until the twentieth century, numerous photographers in the nineteenth century operated in ways analogous to those of the classic era of reportage photography, working for editorial publications covering the major social, economic and political issues of the day. Newsworthy events were one of the first subjects for early photographers. Prior to this the public had only had illustrations by painters and sketch artists, and in the mid-nineteenth century photographs still had to be converted into line drawings and then be engraved before they could be published. It was not until 1880 that the American newspaper *The Daily Graphic* published the first halftone photograph of 'A Scene in Shantytown, New York'. The large-format cameras of the period, mounted on tripods, used glass plate negatives that had to be coated with chemicals immediately before exposure and then processed immediately afterwards. The long exposure times necessary with this process meant that it was difficult if not impossible to capture any action, so the resulting images were usually of landscapes, panoramas or portraits. Indeed, at the time when engravings of photographs began to be widely used, the line drawings of war artists such as William Simpson demonstrate a much more contemporary 'photojournalistic' aesthetic, with the use of chiaroscuro lighting, telephoto compression and dramatic action, as in Figure 2.1. The news photographs of the nineteenth century are in many ways precursors to the contemporary genre of 'aftermath' photography, even if these earlier versions were actually often made during the events rather than a significant period of time after them.

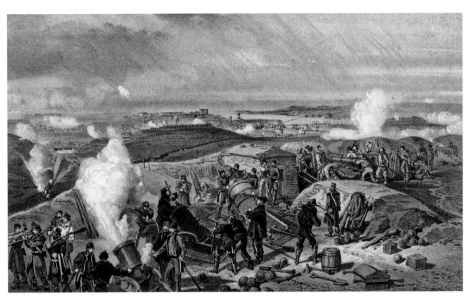

Figure 2.1 William Simpson, 1855. British siege artillery positions with mortars and cannon in action against the Russian fortifications during the Siege of Sevastopol on 13 June 1855 during the Crimean War in Sevastopol, the Crimea, Russia (Hulton Archive/Getty Images).

Conflicts and disasters quickly became a key subject for photography, with the first generally accepted use of photography in depicting a news event occurring in May 1842 when the German portrait photographer Hermann Biow made daguerreotypes of the ruins of Hamburg after the Great Fire that destroyed over a third of the city. Soon after, during the 1848 Revolution in Paris, a photographer known only as Thibault made two daguerreotype images by breaking the curfew and climbing onto a rooftop above the rue Saint-Maur-Popincourt. In the first picture, Figure 2.2, the empty street is blocked by three improvised barricades. The second photograph, Figure 2.3, exposed the next day, is blurrier but shows the dramatic aftermath of the attack by General Lamoricière's troops. The barricades are down, and the street is full of soldiers and cannons. Five days later, the photographs were published as engravings in the weekly newspaper *L'Illustration Journal Universel*. The images show how dramatic events often occur in relatively banal locations: the advertising on the wall visible on the right of the image for a chocolate factory adds a counterpoint to the scene. They also demonstrate the necessary resourcefulness of the photographer, in avoiding the authorities and finding a vantage point from which to survey the scene, and then in returning to exactly the same spot a day later to show the impact of the attack by the government forces. Finally they also show the need for a dissemination platform with a quick turnround to publication – in this case the few days in which to make the engravings so that they could appear quickly after the event. They are also arguably the earliest appearance of the genre now known as

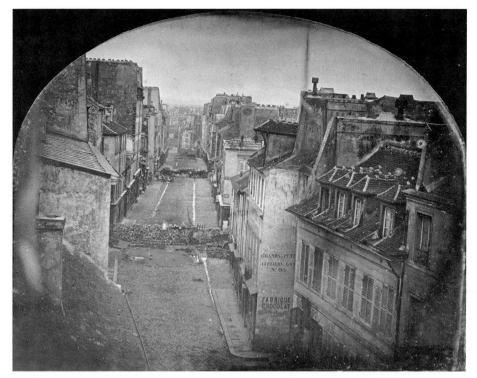

Figure 2.2 Thibault, 25 June 1848. The Barricade in rue Saint-Maur-Popincourt before the attack by General Lamoricière's troops, Paris (Musée D'Orsay).

'aftermath' photography, where the traces left behind by major events are the subject of the photograph rather than the moment of peak action itself, and demonstrate the visual intelligence of the photographer in understanding how the image can have both a temporal as well as a locative and descriptive dimension. Thibault's pairing of images invites the viewer to mentally fill in the gaps in between the moments captured and to imagine the violence and suffering of the assault on the revolutionaries by the military, and is thus a sophisticated example of the complex nature of photography and how this can be used to determine meaning, from one of the very earliest publications of the form.

The work of Roger Fenton raises interesting and complex ethical questions concerning the staging of images and the representation of the dead, questions that still resonate in contemporary discussions of the coverage of warfare. Fenton's work photographing the Crimean War is arguably one of the first photojournalistic 'assignments' in the history of photography. He spent from March to June of 1855 in the Crimea as an official campaign photographer, paid by the British government, with the intention of producing images that would bolster support for the war back at home – in effect he was the first 'embedded' war photographer. Fenton's output from

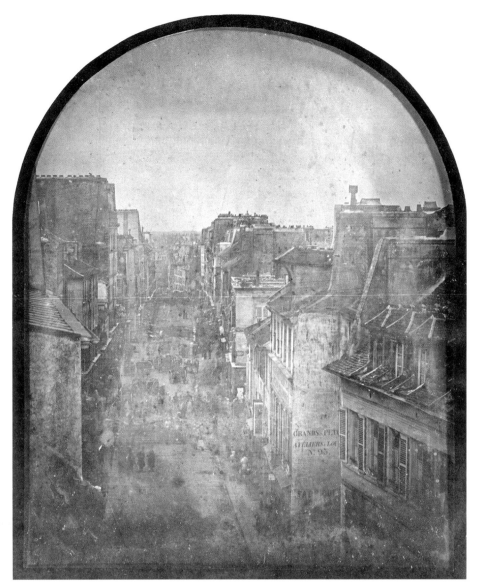

Figure 2.3 Thibault, 26 June 1848. The Barricade in rue Saint-Maur-Popincourt after the attack by General Lamoricière's troops, Paris (Musée D'Orsay).

the Crimea demonstrates a range of attributes often found in the work of photo-journalists today: it was a carefully preplanned, extended and systematic body of work on a newsworthy subject, demonstrating ethical challenges and the need for self-censorship faced with the constraints of political and logistical compromise, and incorporating an eye for the commercial marketability of the resulting images. This range of characteristics is demonstrated in the story of the most famous image from

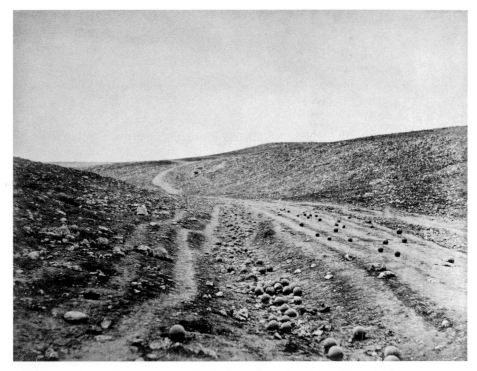

Figure 2.4 Roger Fenton, 1855. The Valley of the Shadow of Death, Crimea (Universal History Archive/Getty Images).

this series, Figure 2.4, and indeed one of the most iconic of all war photographs, *Valley of the Shadow of Death*, taken on 23 April 1855.

Fenton had visited the scene of this photograph previously, as attested in letters to his family and friends. He described the scene on 4 April as follows,

> Further on the balls lay thicker, but in coming to a ravine called the valley of death the sight passed all imagination, round shot & shell lay in a stream at the bottom of the hollow all the way down you could not walk without treading upon them.[1]

Having identified this location without his camera, on 24 April he returned, ready to photograph. This time he wrote that

> I had scarcely started when a dash up of dust behind the battery before us showed something was on the road to us, we could not see it but another flirt of earth nearer showed that it was coming straight & in a moment we saw it bounding up towards us … It was plain that the line of fire was upon the very spot I had chosen, so very reluctantly I put up with another reach of the valley about 100 yards short of the best point. I brought the van down & fixed the camera & while levelling it another ball came in a more slanting direction touching the rear of the battery as the others but instead of coming up the road bounded on to the hill on our left about 50 yards from

us & came down right to us stopping at our feet. I picked it up put it into the van & hope to make you a present of it. After this no more came near though plenty passed up on each side. We were there an hour & a half and got 2 good pictures returning back in triumph with our trophies.[2]

This account is worth quoting at length as it details a number of key points. Despite the resulting image appearing quiet and lacking in action, it seems in fact that Fenton had to expose himself to considerable danger to make it – this was no 'aftermath' as such but was taken during the fighting itself. Fenton was also aware that he had secured a valuable image, describing it as a trophy. Much debate around the two resulting pictures has centred on the differences in the position of the cannonballs: it has been argued that the image showing the road strewn with cannonballs was taken after the one in which they have been cleared away, implying that Fenton himself added or rearranged them for effect, and thus raising questions about the authenticity of his celebrated photographic representation. Given, however, that Fenton had witnessed on an earlier day the road covered in cannonballs, and given the technical constraints of the medium at that time, was his rearrangement of the scene in fact more faithful to what he had originally seen a few days earlier?[3] And, if so, is there still an ethical distinction between this kind of faithfulness to the experience of the situation and the 'truth'?

Social reformers of the early twentieth century

In addition to coverage of dramatic events, photography's ability to seemingly depict 'reality' was quickly adopted by social reformers who wanted to use the evidential force of the new medium to campaign for change. The experience of Jacob Riis demonstrates this realization that the photograph could offer a potentially more powerful form of public address than words alone. Arriving as an immigrant to the United States in 1870, Riis worked as a labourer before becoming a journalist. He joined the *New York Tribune* as a police reporter, based on the infamous Mulberry Street, nicknamed 'Death's Thoroughfare', at the heart of the slum tenements of the metropolis. Determined to raise awareness of the poverty he saw, and frustrated at the lack of impact his words were having, Riis turned to the camera to provide visual evidence of the slum conditions, recalling that 'we used to go in the small hours of the morning to the worst tenements ... and the sights I saw there gripped my heart until I felt that I must tell of them, or burst, or turn anarchist, or something ... I wrote, but it seemed to make no impression.'[4] He made no claims to be a photographer as such, but used the camera as a

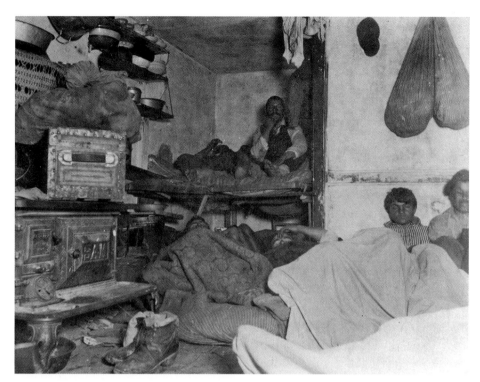

Figure 2.5 Jacob Riis, 1890. Lodgers in a crowded and squalid tenement, which rented for five cents a spot, Bayard Street, New York City. 'Twelve men and women slept in a room not thirteen feet either. It was photographed by flashlight' (Jacob A. Riis/Museum of the City of New York/Getty Images).

recording device to gain proof of the appalling conditions he witnessed. The key technological breakthrough that enabled him to carry out his investigations was the development of flash photography. Much of his reporting work was done at night, when the light levels were too low to be able to photograph. However, with the new discovery of flash he could literally illuminate the darkness, exposing the misery not only of the streets but also of the slum tenements' overcrowded interior spaces (Figure 2.5). Riis used magnesium powder mixed with potassium chlorate, which created a dazzling light and clouds of acrid smoke. He admitted,

> it is not too much to say that our party carried terror wherever it went. The flashlight of those days was contained in cartridges fired from a revolver. The spectacle of half a dozen strange men invading a house in the midnight hour armed with big pistols which they shot off recklessly was hardly reassuring, however sugary our speech, and it was not to be wondered at if the tenants bolted through windows and down fire-escapes wherever we went.[5]

Despite the alarm and distress his invasions of the slum tenements may have caused, his discovery of flash and his deployment of it to record images that could not otherwise have been made is a key example of the way a photographer realizes how a technological advance, often developed for an entirely different purpose, can be aligned with the journalistic and moral purposes of the photojournalist to great advantage. Riis also made the most of another innovation that allowed him to disseminate his work to a wider public. Using magic lantern slide shows, he posed as a tour guide who would lead his audiences through the city's darkest, most impoverished corners. His spectacular performances had a significant impact on audiences, who reportedly fainted and shuddered at his larger-than-life images and dramatic voice-over accompaniment. In his harnessing of this platform, ideally suited for a combination of emotive spectacle and education, Riis anticipated both documentary film and contemporary 'multimedia' production. He also published his photographs and accompanying text in two books, *How the Other Half Lives: Studies among the Tenements of New York* (1890) and its sequel, *Children of the Poor* (1892). The photographs were presented as halftone illustrations, possibly the first significant use of such a method in a book. As an advocate for the poor, his work had a significant impact. As well as providing a unique documentation of a key period in American history, it did lead to limited reform of conditions in the tenements. The future US president Theodore Roosevelt was a keen supporter of Riis, and wrote, 'the countless evils which lurk in the dark corners of our civic institutions, which stalk abroad in the slums, and have their permanent abode in the crowded tenement houses, have met in Mr. Riis the most formidable opponent ever encountered by them in New York City'.[6] Although from a contemporary perspective it is difficult to ignore the ethical compromises that Riis openly acknowledges ('invading' his subjects' homes and 'recklessly' causing 'terror' wherever he went), balancing the treatment of individual subjects against the bigger goals of a humanitarian agenda is a challenge familiar to many photographers today.

Lewis Hine was another leading proponent of the camera as a tool to advocate for social reform. Campaigning in particular for the rights of the thousands of child labourers consumed by America's industrial system, he too believed that photography could light up the darkness and expose ignorance. Hine worked extensively as a photographer for the National Child Labor Committee (NCLC), likening his activity to that of a detective. His work was frequently risky as factory owners did not want the working conditions of their employees exposed, especially if they were illegally using children, and Hine was often threatened by foremen and even by local police. He therefore frequently relied on subterfuge to facilitate access, posing variously as a Bible salesman, a fire inspector and as an industrial photographer making studies of machinery. In another contemporary parallel, we might ask questions about the ethics of such methods: is this kind of blatant dishonesty always outweighed by the ultimate exposure of abuse? When working on an issue or with a social group with

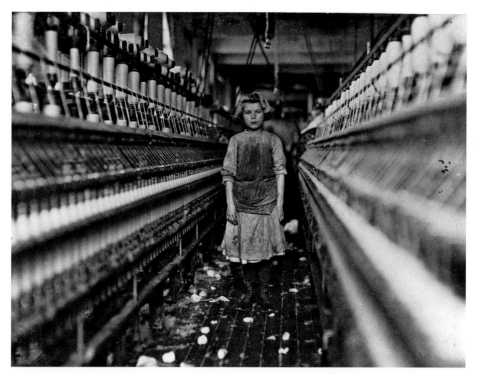

Figure 2.6 Lewis Hine, 1909. A young girl works in the spinning room at the Globe cotton mill, Augusta, Georgia (Lewis Wickes Hine/Library of Congress/Corbis/VCG via Getty Images).

whom the photographer has a difference of political opinion, to what extent is it justified for them to hide their true position in order to gain access and perhaps expose wrongdoing?

Like Riis, initially Hine felt that words were the most important tool in his campaigning activities, but he came to believe that it was actually images that could have the greatest impact: 'in my early days of my child-labor activities I was an investigator with a camera attachment ... but the emphasis became reversed until the camera stole the whole show.'[7] He travelled widely across the United States, frequently up to 30,000 miles in one year, photographing slum housing, factories, fruit farms and tobacco plantations. He proclaimed to his audience, 'perhaps you are weary of child labor pictures. Well, so are the rest of us, but we propose to make you and the whole country so sick and tired of the whole business that when the time for action comes, child-labor pictures will be records of the past.'[8] Hine employed the aesthetics of the large-format cameras he used to good effect, often portraying single figures against the backdrop of their working environment, emphasizing their isolation and presenting them as individuals with whom the viewer can empathize (Figure 2.6). Direct eye contact with the camera augments this emotional appeal, as does Hine's frequent

inclusion of names, and details such as height, weight and age. Designing exhibitions, posters and publications for the NCLC during the decade he worked there, Hine maximized the dissemination of his work through a wide variety of platforms. As a result, conditions for child workers did improve somewhat, but remained difficult throughout the period. Hine and Riis are both early exemplars of the role of photographic advocate, campaigning for social reform and using a wide range of innovative distribution vehicles to reach their audiences in an effective way. They foreshadow the contemporary alliances between photojournalists and nongovernmental organizations (NGOs), and the use of alternatives to mainstream media.

The liberation of '35mm'

For a generation of photographers, the development of smaller, more portable cameras that could be hand held and used roll film was a radical and transformative liberation. The 35mm Contax and Leica cameras, and the medium-format Rolleiflex, allowed a more mobile, spontaneous photographic methodology to emerge, very different from that determined by the cumbersome plate cameras and tripods. This new, faster and more flexible way of working became fundamental to the development of the reportage aesthetic that fuelled the rise of the illustrated magazines of the 1930s. Much of the initial development of this took place in continental Europe, by pioneers including Felix Man, Erich Salomon and Henri Cartier-Bresson, who all recognized this new format's potential.

Salomon took up photography at the relatively advanced age of forty-one, but rapidly mastered the art of 'fly on the wall' news photography, earning the title of the 'Houdini of Photography'. He was one of the first to realize the potential of the smaller cameras, appreciating that they allowed him to work discreetly without flash, as the quintessential unseen observer.[9] He began working at *Berliner Illustrirte Zeitung* in 1928, rapidly achieving a reputation for his ability to gain entry to the highest levels of diplomatic, political and social activity. In 1929 the London *Graphic* coined the phrase 'candid camera' to refer to his work, but he described himself as a *bildjournalist* – still today the German word for photojournalist. Salomon's photographs of the machinations of power were a revelation compared to the stiff, posed images of world leaders to which audiences were accustomed. His appearance belied his skill; he was unassuming, bespectacled, balding and slightly overweight. But he turned this to his advantage. His approach demonstrates the ingenuity, determinedness and persistence, combined with a high degree of self-confidence and chutzpah, that is typical of the photojournalist's attitude in negotiating the numerous barriers and obstacles that often need to be overcome. Dressing in black tie and tails, he merged into the background of these important events and was able to work as if invisible to the participants. His fluency in several languages helped him to find his way past the various guards and doorkeepers, but he also

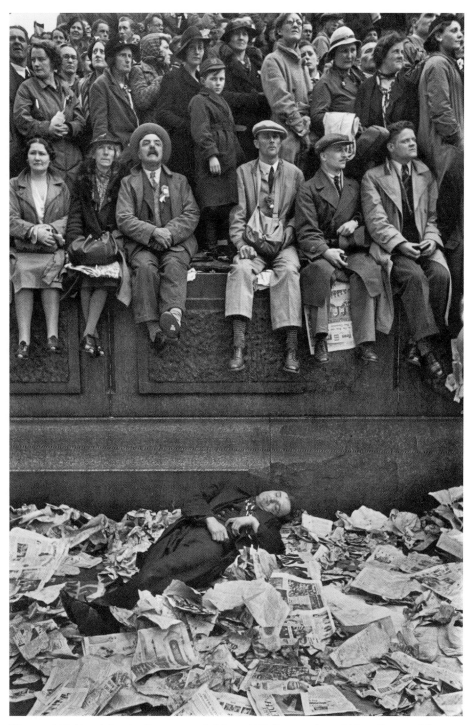

Figure 2.7 Henri Cartier-Bresson, 12 May 1937. Coronation of King George VI, London (Magnum Photos).

used an astonishing repertoire of tricks. On one of his first assignments, a murder trial, he cut a hole in his bowler hat for the lens of his camera. When discovered by a court attendant at the end of the trial, Salomon handed over several blank plates, keeping the exposed images in his pocket. On another occasion, he concealed his camera in an attaché case with a complex set of levers to trigger the shutter. To shoot the famously secretive Casino at Monte Carlo, he hollowed out a mathematics textbook; to gain access to President Herbert Hoover, he hid behind a floral display, and to get into the US Supreme Court he hid his camera in an arm sling. At the signing of the Kellogg-Briand Pact in 1928, Salomon confidently walked into the room and sat in the empty place reserved for the Polish delegate: the perfect vantage point from which to shoot his pictures. Expert at blending into the entourages of the politicians, his presence eventually became accepted as a fundamental part of such events. The Prussian prime minister once remarked, 'surely it is inevitable. Nowadays, you can hold a conference without ministers, but not without Dr. Salomon.'[10] Again, we might ask questions about the professionalism or even the ethics of some of his underhand tactics as well as admire their inventiveness.[11]

Henri Cartier-Bresson was one of the first to use the new Leica rangefinder cameras with 35mm film in the 1930s. Though he preferred to be regarded as an artist rather than a journalist, his aesthetic approach, epitomized in the concept of the 'decisive moment', dominates photojournalistic methodology to this day.[12] Cartier-Bresson, too, was an archetypal observer: unobtrusive, always alert and finding in the everyday an extraordinary beauty that still resonates from his images years after they were made. In an astonishingly creative period in the early 1930s, Cartier-Bresson produced many masterpieces of street photography – images that still stand as poetic celebrations of everyday life. His first real editorial assignment as a photojournalist was to cover the coronation of King George VI and Queen Elizabeth for the French weekly *Regards*. In a body of work that still acts as a benchmark for an alternative, interpretive viewpoint of a major news event, instead of following the other photographers by focusing on the pomp and circumstance of the occasion, he concentrated his attention on the crowds lining the London streets, taking no pictures of the king. Figure 2.7 is a thoughtful commentary on the spectacle of the event, with its contrasting of the excited onlookers and the recumbent man as well as the piles of newspapers offering a wry reminder of the nature of the news – celebrated today, discarded tomorrow. This was typical of his approach, as he sought to illustrate the essence of a situation by engaging with the elements of everyday life, noting that the 'smallest thing can become a big subject; an insignificant human detail can become a leitmotiv. We see and we make seen as a witness to the world around us; the event, in its natural activity, generates an organic rhythm of forms.'[13] His feel for the significance of the events surrounding the main news event, and how they can frequently convey as much if not more of the essence of the situation, remains a central concern of photojournalism to this day.

The golden age of the agency, the photoessay and the illustrated magazine

The 1920s saw a number of technological developments that accelerated the dominance of visual material in mainstream media publications. Wire transmission of photographs became possible in 1921, and new printing processes enabled cheaper, higher-quality reproductions. A confluence of technological and creative innovations allowed editors and designers to develop a whole new form for the medium: the illustrated newsmagazine transformed photojournalism's dissemination, and the extended photoessay transformed its aesthetic and structural features.

Photographers, designers and editors collaborated to develop this new visual language, mixing text and images in innovative layouts that still look fresh today. The period saw an explosion in the growth of mass media in general, especially in Germany, which had more illustrated periodicals, with larger circulation, than any other country in the world. A wide range of magazines catered for niche and specialist interests as well as news and current affairs, and their competition for readers became a key driver for increasingly experimental, dynamic and complex visual design. One of the leading publications was *Berliner Illustrirte Zeitung* (*BIZ*), founded in 1891. *BIZ* had already gained a huge circulation in Germany due to its low cost and eye-catching use of images. In 1914 the magazine had a print run of a million copies, but by 1931 it reached almost two million.[14] A pioneer of the emerging form of the photoessay, its editor, Kurt Korff, explained, 'Life has become more hectic and the individual has become less prepared to peruse a newspaper in leisurely reflection. Accordingly, it has become necessary to find a keener and more succinct form of pictorial representation that has an effect on readers even if they just skim through the pages. The public has become more and more used to taking in world events through pictures rather than words.'[15]

Vu magazine, launched in France in 1928, featured even more innovative layouts, drawing on the influence of Russian constructivism, and included photoessays by Cartier-Bresson, Man Ray, Brassaï and André Kertész. *Vu*'s philosophy was summed up in its motto 'The text explains, the photo proves.' Its art director, Alexander Lieberman, later fled Europe for America, where he became legendary as the art director of *Vogue* in the 1940s and 1950s. Indeed, it could be argued that the wave of émigrés who left Germany, France, and Hungary after the rise of Nazism were fundamental to the development of what is now often regarded as an Anglo-American form, as they had a huge impact on magazines like *Life* and *Picture Post*. One of the most influential of these was Stefan Lorant, who, as editor of the *Münchner Illustrierte Presse*, another of Germany's finest picture magazines, had published the work of Brassai, André Kertész, Martin Munkácsi and Salomon amongst others. Lorant was imprisoned by the Nazis in 1933 because of his opposition to Adolf Hitler, and after

his release six months later he travelled to Britain, where, along with publisher Sir Edward G. Hulton, he was instrumental in the establishment of *Picture Post* in 1938. Lorant summed up his design philosophy as follows: 'I tried to use pictures as a composer uses notes, I tried to compose a story in photographs.'[16] *Picture Post* was a huge success, selling 1,700,000 copies a week only two months after its first publication. Lorant brought in more of the émigré photographers he had worked with in Germany, including Kurt Hutton and Felix Man.

In America, Henry Luce launched *Life* magazine[17] in November 1936, with the following stated aim:

> To see life; to see the world; to eyewitness great events; to watch the faces of the poor and the gestures of the proud; to see strange things – machines, armies, multitudes, shadows in the jungle and on the moon; to see man's work – his paintings, towers and discoveries; to see things thousands of miles away, things hidden behind walls and within rooms, things dangerous to come to; the women that men love and many children; to see and take pleasure in seeing; to see and be amazed; to see and be instructed.[18]

The first issue of *Life* featured photographs by Alfred Eisenstaedt, yet another refugee from Hitler's Europe, and a cover and nine-page story on the industrial north-west of America by Margaret Bourke-White, one of the most successful of all female photojournalists. At its peak, *Life* sold more than 13.5 million copies a week, permeating deeply into American culture and society and establishing the visual essay as one of the prime forms of mass communication.

The visual innovations of the pictorial magazines were centred upon collaboration and a team effort. Instead of using isolated, single pictures, photographers, editors, designers and journalists worked together on sophisticated layouts in which text and image were related to one another in complex and creative ways. The relative size of images was significant in establishing pace, variety and emphasis within a story. Photographers were encouraged to develop their ideas in depth and to 'shoot around' the subject, expanding the narrative of the story. What made this such a formative period in the development of photojournalism was the combination of editorial space to display extended bodies of work on socially relevant themes, with the financial means to support photographers as they worked on stories for substantial periods of time. The technological advances in cameras and in the printing process allowed the new, more fluid, visually energetic style of reportage photography to reach a mass audience, and photographs became, for a period at least, the single most important means by which Western audiences encountered the wider world in their daily lives.

The 1930s also saw the rapid growth of the photographic agency, in some cases as an independent provider of images, and in others, as part of a larger media infrastructure. A distinction needs to be drawn between the wire services like the

Associated Press (AP) that provided mostly single news images, and the independent photographic agencies that represented the work of freelance photojournalists who generally produced photoessays and extended stories like Black Star. The AP began its wirephoto service in 1935, with the first ever 'wire service' photo depicting the crash of a light plane in New York's Adirondack Mountains on New Year's Day. The system allowed images to be transmitted over conventional telephone lines on the same day they were shot, which gave the AP a huge commercial advantage over other media suppliers, the network quickly growing to cover the whole of the United States. Black Star was founded as an agency in 1935, again by émigrés from Germany: Ernst Mayer, Kurt Kornfeld and Kurt Safranski, who had been a designer at *BIZ*. Mayer was also instrumental in the development of *Life*, and Black Star became one of the largest contributors to the magazine, with a stellar roll call of photographers that included Bill Brandt, Andreas Feininger, W. Eugene Smith and Roman Vishniac as well as Robert Capa and Cartier-Bresson before they went on to found perhaps the most famous and influential agency of them all: Magnum Photos. Magnum in particular exemplifies the vital role of the photo agency in the progress of photojournalism, not least in the protection it offered from the commercial realities of business, allowing photographers the aesthetic and journalistic freedom to work on their own terms.

Witnessing the liberation of the camps, 1945

The liberation of the Nazi concentration camps in 1945 presented an utterly unprecedented challenge to photographers and to the media. The scenes witnessed were so traumatic that they challenged the accepted norms of publication and the relationship between ethics and aesthetics. Images of the camps came from a variety of sources, including military photographers, soldiers carrying their own personal cameras and from the small number of professional photojournalists who entered the camps along with the liberating troops, including Lee Miller, Bourke-White, and George Rodger. Miller[19] was with troops from US Forty-Fifth (Thunderbird) and Forty-Second (Rainbow) Divisions as they entered the camp at Dachau. As the camp was liberated, Miller made arguably one of the most haunting and disquieting images of the war, indeed of any war (Figure 2.8). She photographed the partially submerged body of a soldier wearing the camouflage uniform worn only by the Waffen SS. The soldier had been executed by the liberating US soldiers after he was captured, and then his body had been thrown into the canal.[20]

The soldier seems almost asleep, an effect augmented by the symbolic connotation of the water itself, of sleep, dreaming and death. The image speaks of an action

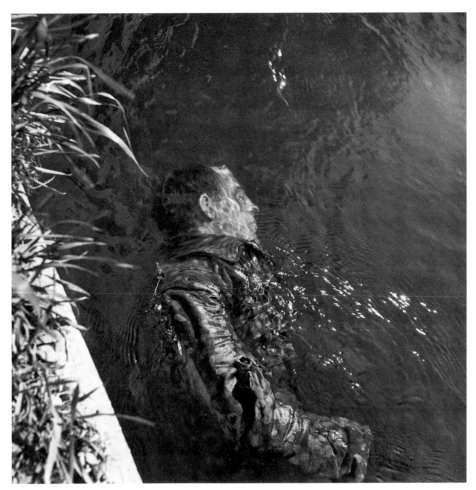

Figure 2.8 Lee Miller, 1945. Dead SS guard floating in canal, Dachau (Lee Miller Archives).

completed: the killing of a soldier, but he is held in a limbo between death and burial. Time is suspended, floating, like the corpse itself. There is a tension in this almost peaceful, evocative treatment of a victim who is also clearly identifiable as a member of the SS.[21] The aesthetic or formal qualities of the image are thus at odds with its content, in a manner that will be further explored in Chapter 6. Miller also famously photographed the 'death train', creating images of the corpses of victims being surveyed by American soldiers, whose astonishment is palpable and inescapable as the gazes of the photographer, the soldiers and the viewer align in a captured moment of unified horror. Her photographs and reports were published in *Vogue* magazine under the headline 'BELIEVE IT' in a special 'Victory' issue published in June 1945. Miller wrote of her experiences:

I don't take pictures of these things usually as I know you won't use them, DON'T THINK FOR THAT REASON THAT EVERY TOWN AND EVERY AREA ISN'T RICH WITH THEM. EVERY COMMUNITY has its big concentration camps, some like this for torture and extermination … well I won't write about it now … just read the daily press and believe every word of it. I would be very proud of Vogue if they would run a picture of some of the ghastliness … I would like Vogue to be on record as believing.[22]

Rodger, later one of the founders of Magnum Photos, entered the camp of Bergen-Belsen shortly after the first British units arrived. Rodger was on assignment for *Life* magazine, and had photographed death and devastation before, during the Blitz on London in 1941. He had made photographs that ran the gamut

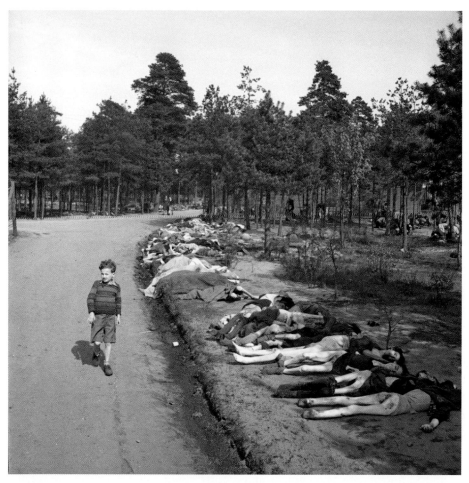

Figure 2.9 George Rodger, 1945. A young boy dressed in shorts walks along a dirt road lined with the corpses of hundreds of prisoners who died at the Bergen-Belsen extermination camp, near the towns of Bergen and Celle, Germany (George Rodger/The LIFE Picture Collection/Getty Images).

of emotions, from poignant sadness to surreal absurdity. However, like most of the soldiers he accompanied, none of Rodger's extensive experience through the major campaigns of World War II had prepared him for what he encountered. He wrote after the event that 'it had to be photographed because people had to know … I just did what I would have done with some landscape or something else, got people into nice compositions and sent the pictures in'.[23] But as he drove himself on to document the suffering in front of him, he felt a growing sense of unease when, as he described,

> I was talking to a very cultured gentleman and he was absolutely emaciated and in the middle of the conversation he fell down dead. I took a picture of him dead. The dead were lying around, 4,000 of them, and I found I was getting bodies into photographic compositions. And I said what has happened to me? It is too much, something had affected me … at the same time I swore I would never, never take another war picture and I didn't. That was the end.[24]

The photographer and historian Janina Struk also maintains that the application of professional standards of technique was inappropriate to the depiction of such stark horrors as the victims of the concentration camps. Critiquing the work of Bourke-White and Miller from the camps of Buchenwald and Dachau, she writes that their photographs have a 'technical merit and an aesthetic quality which appear incongruous. The large format quality with flashlight added a drama that seems superfluous and not only filmic but painterly'.[25] Historian Barbie Zelizer has argued that the images promoted an 'atrocity aesthetic', formed from the 'agonized collectives of survivors and victims, gaunt faces behind barbed wire, vacant stares of the tortured, and accoutrements of torture'.[26] Echoing Rodger's own discomfort, as the photographs from the camps emerged, the Allied media debated how much to show and the level of atrocity to which the public should be exposed. The *Daily Telegraph* rationalized its own self-censorship as follows: 'More than a dozen photographs each giving indisputable testimony of the bestial cruelties … reached the Daily Telegraph yesterday; but they are of such a revolting nature that it has been decided not to reproduce them.'[27] Historian Hannah Caven notes the impact the coverage of the camps had on the general public, observing that when the photographs were shown in newspapers, magazines and public exhibitions, they 'inspired a feeling of intense and profound shock almost universally among the people that they reached' and that the 'emphasis is on how unbelievable the scenes were, how no-one could have imagined what was now being witnessed'.[28] In the news magazines, more graphic images were published. *Life* ran a six-page spread with close-up photographs of burned bodies, and the *Illustrated London News* produced a removable four-page supplement which warned readers that 'our subscribers with young families, whom they would not desire to see the photographs, can remove these pages. These revelations of coldly-calculated massacre

and torture are given as a record for all time of German crimes, and are intended for our adult readers only.'[29]

As the various actors in the liberation of the camps encountered the scenes before them, they struggled to make sense of it. Miller and the other photographers 'took on the responsibility of transmitting these unintelligible occurrences to the public. Something that was not understood had to be represented.'[30] Those who witnessed the camps seemed aware that the magnitude of the events before them demanded that they testify about them to others. Thus the act of witnessing the trauma of the camps went beyond simply seeing, and became instead 'bearing witness', even if the full understanding of what was being witnessed was unclear, and indeed only became better understood a generation later. As Sharon Sliwinski has written, 'at the very place where ordinary speech failed, photography was called upon to transmit the unimaginability of what was witnessed.'[31] Again, the complexity involved in negotiating the aesthetic treatment of such horror is a subject to which we will return in later chapters.

The Vietnam War

The conflict in Vietnam is infamous for the many important questions it has raised regarding the role of the media in covering war. The impact of journalistic reporting

Figure 2.10 Phillip Jones Griffiths, 1970. Hamlet Evaluation System program, Vietnam (Magnum Photos).

on the course of this war, in particular in terms of the support of the domestic audience in the United States, has been hotly contested. A significant number of images emerged from the conflict that have gone on to epitomize that particular war as well as to act as markers of the representation of violence more generally. One body of work from the period does stand out, however, as an example of the combination of coherent, complete journalistic coverage with a personal point of view. Phillip Jones Griffiths's seminal book on the conflict, *Vietnam Inc.*, published in 1971, combined photographs with detailed, dense captions that did not merely describe the scene but revealed a penetrating grasp of the political context of each situation. He was very aware, for example, of the role that technology played in the conflict, far from the jungle battlegrounds. (Few other photographers would have had the perceptiveness, or even the wit, to make an image of one of the military computers that made the American operation possible, as seen in Figure 2.10.) His work in Vietnam was compassionate, intelligent and ironic, and he saw the US involvement there as an imperialist action against which he had to take sides, stating, 'I attempt to channel my anger into the tip of my forefinger as I press the shutter.'[32] He demonstrated the impact that conflict has on both civilians and soldiers alike, arguing that 'all wars depend on de-humanizing the "enemy" – the foreign "other". I've tried to concentrate on showing the human face of conflict.'[33] He had a long relationship with the people of South East Asia, and produced a series of books that dealt with the conflict there and its aftermath, including *Agent Orange: Collateral Damage in Vietnam* (2004). His work led to South Vietnamese president Nguyễn Văn Thiệu declaring him persona non grata in the country, saying, 'Let me tell you there are many people I don't want back in my country, but I can assure you Mr. Griffiths name is at the top of the list.' Along with a series of other books that emerged on the war, including Don McCullin's *The Destruction Business* (1971), and Larry Burrows's *Compassionate Photographer* (1972), *Vietnam Inc.* continues to be seen as a model for how a photographer can present a complex and nuanced argument about a major global issue, with a strong personal point of view backed up by extensive research, challenging the assumptions of 'objective', unengaged journalism. Such bodies of work are frequently the result of one individual photographer's passion, stubbornness and ingenuity to engage with a specific issue or story over the long term.

The digital revolution, 1990–2000

The 1990s marked an important transitional period in the economic and ethical dimensions of photojournalism. The demands of the twenty-four-hour rolling news environment, exemplified by CNN's coverage of the first Gulf War, were extended and amplified by the ongoing conflict in the former Yugoslavia, with its frequent ceasefires, crises and complex developments providing a constant stream of breaking

reports that demanded careful news management. Photographers at the beginning of the conflict in 1990 were still very much in the analogue age, shooting film, developing it in hotel bathrooms and then transmitting it over phone lines on bulky and expensive machines with a resolution of 300kb. It could take more than forty-five minutes to transmit a single image in three stages, a fault in any of which would ruin the whole image, necessitating retransmission. By the end of the fighting in Kosovo in 1999, photographers were using digital cameras with sensors of ten megapixels and transmitting high-resolution images in a matter of seconds over satellite telephones directly from the field. This had a transformative impact on the quality and quantity of photographs distributed by the wire services, and meant that they expanded rapidly from their traditional base in newspapers with low print quality to high-end magazines, typically with 'full-bleed' double pages. It also meant that there was greater scope for creative interpretation in the visual account of a situation.

Both the AP and Reuters agencies actively encouraged their photographers during this period to produce images with greater attention to composition and visual drama. There was often one 'wild card' photographer included in a team to shoot more varied and unusual photographs, adding creative diversity to the more mainstream news coverage. This threefold expansion of the wire services in terms of quantity of images, technical quality of images and aesthetic form of images meant that they made tremendous inroads into the magazine markets, traditionally the territory of freelance photojournalists. Because of the subscription-based model of the wires where publications pay a one-off annual fee for access to the service, the magazine picture desks could essentially use their images for free. Now that photos were often comparable in quality to those produced by photojournalists, clients often chose the free wire image instead of paying for an agency photograph. This shift began to seriously impinge on the already precarious financial stability of many midsize agencies, with the three major French independent agencies of Sipa, Sygma and Gamma particularly hard hit. At the same time, two major new players entered the image market, both with significant funding and ambitions to become the leading players in the commercialization of images globally: Getty Images,[34] funded by the Getty family, and Corbis,[35] underwritten by Bill Gates and Microsoft. They began to operate a predatory strategy of buying out photo agencies and stock suppliers in order to consolidate their market share. Several well-known independent agencies sold out, including SABA, Katz IPG, and Rapho and, in the process, despite claims that their individual identities would be preserved, were effectively closed down and absorbed. Getty then attempted to renegotiate its contracts with contributing photographers, in terms generally seen as to the detriment of the individual. Getty and Corbis then also began to compete with the wires in offering subscription-based news services to clients as well as the more traditional assignment and the rights-managed model of the classic photo agency. They also heavily discounted the rates for stock photography, another mainstay of the independent agencies, undermining their financial

stability again. The huge costs of digitizing stock libraries and making them available online was also a dramatic drain on the resources of the smaller agencies. This was a major shift, as until this point the majority of news and current affairs images were generated by agencies that had production as the core product, whereas for the mega-agencies reportage was a peripheral area, at best a loss leader for the more profitable markets of commercial stock photography.

Under this combined pressure, many independent agencies that had been the lifeblood of the independent photojournalistic profession were either bought out or went out of business, with Network Photographers, the British-based agency, one of the highest-profile examples. Those that survived either had niche markets, like Panos Pictures, which specializes in developmental issues and is part owned by an NGO, or they represented the very top of the profession, like Magnum or the newly formed VII. This transformation of the agency landscape left a sizeable gap between the main players, the mega agencies like Corbis and Getty and the wires like Reuters, AP and AFP, and the 'boutique' agencies exemplified by Magnum. The medium-sized agency that covered a wide range of issues primarily for their journalistic or editorial value, rather than their potential as 'authored' pieces by individual named photographers, has almost evaporated.

The conflicts at the end of the twentieth century also posed serious ethical questions for journalism, particularly over issues of subjectivity. The lack of Western intervention in the Yugoslav crisis challenged the traditional position of impartiality and objectivity of journalists when faced with acts of genocide and war crimes. The events in the Balkans during the last decade of the twentieth century challenged the assumption that if the world and its decision makers were informed about serious acts of wrongdoing, they would take action. This in turn challenged the very tenets of journalism and led to what could be seen as a crisis of confidence in the community over the role it played in reporting conflicts. Martin Bell of the BBC proposed that journalists have a duty to report as objectively and as honestly as possible, but that if the evidence of that reporting determines that one party in a conflict is clearly the aggressor, and the other the victim, that a neutral stance in the face of such violence is unacceptable. This he identified as the 'journalism of attachment' (1998), whereby identifying one side as morally wrong and therefore accountable does not impinge on the professionalism of the journalist. It is important note that this does not mean being partisan or biased, or abandoning the traditions of accurate reporting, as it is 'set around with all kinds of qualifications, like meticulous attention to the details, seeking out supposed bad guys, explaining what's happening, why they're doing what they're doing'.[36] One of the responses to these challenges was the more deliberate and conscious association of some photographers with the humanitarian agenda, to the extent that they positioned themselves more like human rights activists and prosecutors than journalists. Gary Knight had become frustrated with the failure of his own work and that of others to have any real impact on the prevention of the genocide in

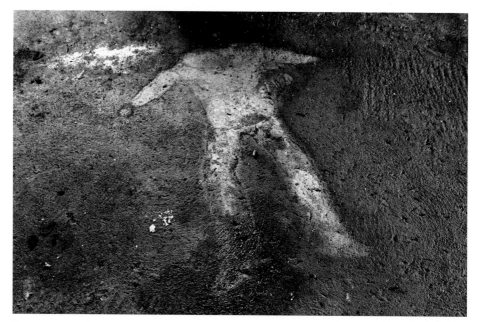

Figure 2.11 Gary Knight, 1999. The outline of the body of Kola Dusmani, Kosovo (Gary Knight VII).

Bosnia, so when faced with the crisis in Kosovo in 1999 he resolved to adopt a more explicit position as an investigator rather than a journalist. As the Kosovo emergency unfolded, Knight made a deliberate choice to cover the events in a different way to how he usually worked as a contact photographer for *Newsweek*, shooting to weekly and sometimes daily deadlines. For Knight, this was a 'very deliberate and thought out process' in which he asked his editor at *Newsweek* for the space to be able to 'take on this issue of war crimes and deliver the images when they are ready, and not be under pressure to deliver them to deadlines'. Knight notes how he 'approached the story as a curator of a crime, rather than as a journalist, photographing mass graves and scenes of crime and interpreting the charges of murder, persecution and deportation. I believe the universal language of photography renders the concept of war crimes less alien to those for whom the idea is normally abstract.'[37] Many of his images have a forensic character, appearing almost like crime scene photographs.

Figure 2.11 shows the outline of where a body had lain in a house that had been destroyed by fire. After the remains were removed the imprint of the corpse remained like a photographic negative burnt into the concrete. For Knight, this experience was very much a turning point in his career, moving him from a journalistic agenda to new territory:

> It has totally changed the way that I work since; I was no longer interested in being a journalist per se. I remain interested in using journalism and the media as part of my tool set but no longer interested in running around chasing lots of stories. I'm much

less interested in creating beautiful photographs and more interested in using photography as a means to an end.[38]

Knight deployed a strategy of using photography to present circumstantial evidence of an atrocity, with a quasi-forensic presentation of the evidence, providing images in sequences and groups that build up a body of evidence around each charge that the events alleged took place. By amassing a large volume of images from a variety of situations and in a variety of visual approaches, they offer a form of 'triangulation' of the visual evidence and allows the viewer to draw inferences. Combined with the textual evidence supplied in the form of captions, court documents, indictments, lists of the missing, personal testimonies, maps and graphs, this forms a quasi-judicial type of inquiry that together offers corroborative evidence. The mass of imagery from the conflict in the Balkans did go on to form a vital part of the prosecution of those accused of war crimes, as Gilles Peress argues that the presence of such a large volume of photographic material from the Balkans was a key driver of the desire of the international community to seek justice in the region. He maintains that it helped to build the circumstantial evidence necessary to prosecute cases, and that it 'builds a track record for the long term not only just for Bosnia and the missing but a path to justice for all in future. If that fails the concept of tribunal and the concept of international justice is likely to fail too.' He concluded that 'I don't think the tribunal would exist, and without the tribunal we would not have the justice. The dark deeds happen in darkness, if it's just a flicker of light it's worth it.'[39] The coverage of the Balkan wars therefore acted as an important precedent for the more advocacy-based approach of many contemporary photojournalists, who overtly align themselves with a humanitarian or human rights agenda.

Further reading

Brothers, Caroline. (1997). *War and Photography: A Cultural History*. London: Routledge.

Franklin, Stuart. (2016). *The Documentary Impulse*. London: Phaidon.

Fulton, Marianne. (1988). *Eyes of Time: Photojournalism in America*. London: Little, Brown and Co.

Hallin, Daniel C. (1992). *The Uncensored War: Media and Vietnam*. Berkeley: University of California Press.

Jeffrey, Ian. (1981). *Photography: A Concise History*. London: Thames and Hudson.

Knightley, Phillip. (2003). *The First Casualty: The War Correspondent as Hero, Propagandist and Myth-maker from the Crimea to the Gulf War II*. London: Andre Deutsch.

Struk, Janina. (2004). *Photographing the Holocaust: Interpretations of the Evidence*. London: I. B. Tauris.

Trachtenberg, Alan. (1989). *Reading American Photographs: Images as History Mathew Brady to Walker Evans*. New York: Hill and Wang.

Warner Marien, Mary. (2002). *Photography: A Cultural History*. London: Laurence King.

Willumson, Glenn. (1992). *W. Eugene Smith and the Photographic Essay*. Cambridge: Cambridge University Press.

Zelizer, Barbie. (1998). *Remembering to Forget*. Chicago: University of Chicago Press

3

The Single Image and the Photostory

Chapter summary

The single, still news photograph functions in a fundamentally different way to the 'photostory', which has been at the heart of photojournalism since the rise of illustrated magazine in the early twentieth century. This chapter explores the differences, including the way in which a photostory functions and what happens when a single image, particularly one that was not initially made to stand alone, becomes 'iconic'. Photographers are often celebrated for creating images that reach the status of cultural 'icon', but what are the implications of this in terms of their journalistic or documentary function? One implication is in the image's symbolic function, or how its elements come to stand for abstract ideas that are usually only represented in words. From photo captions to 'story' layouts and even the idea of 'visual language', words are implicated in the practice of photojournalism in a very different way from other photographic forms. This chapter explores the dichotomy between words and images in this context, and also looks at the new platforms and technologies that allow for different narrative forms, including 'multimedia' or 'photofilms', whose key characteristics may not be as new as they seem.

The paradox of the photostory

At the heart of photojournalism there is a paradox. Since its 'golden age' – the period when picture magazines like *Life* were at their height, and the language of the medium as we know it took shape – the photojournalist's defining format has been the 'picture story'. Sometimes this is interchangeable with the term 'photo-essay' (despite the fact that a story and an essay are two very different things), and often we even celebrate the capacity of an individual photograph to tell a 'story' all

on its own. But what does it mean to speak of photographs telling stories, when photography by its very nature is seemingly antithetical to the narrative form? Stories, we might say, unfold in the temporal dimension: they have a beginning, a middle and an end. They develop. They are, among other things, an account or record of change. Photographs, in contrast, exist in the spatial register. This they have in common with all other still images (paintings, drawings and so on) but to an even greater degree: photographs are made by freezing time, creating a slice of an instantaneous moment and isolating it from the temporal flow of the events that surround it. In this sense, they hold within them no duration, no change, no beginning or end. There is only the present. Yet generations of photojournalists have identified themselves with the mantle of 'storyteller', and – though this has changed with the technological developments of the twenty-first century – the eight- or twelve-picture photostory is the form that has for decades most typically characterized the genre.

The British artist and photographer David Hockney once said, 'Photography is all right, if you don't mind looking at the world from the point of view of a paralysed Cyclops – for a split second.'[1] These three characteristics of the photographic apparatus: its fixed position, monocular vision and capacity to capture only one isolated moment at a time are limitations that Hockney has spent a good deal of time exploring and working against in his own artistic practice. In the early 1980s he made a series of photo collages called 'joiners': composite images that attempted to replicate in a more authentic way the experience of seeing as it unfolds in time through an accumulation of glances, and evoking the movement of binocular, 'embodied' eyes. An effect of these experiments was to incorporate a kind of narrative process into photographic seeing. This brings us to another way of characterizing the apparent paradox of photojournalism: the dichotomy between the spatial and the temporal (as explored by Hockney in his joiner collages) is very closely associated with the dichotomy between words and images. At the most basic level, understanding what is happening in a 'photostory' – theoretically, conceptually, experientially – involves grappling with some of the fundamental differences between these two registers of representation.

Word and image

W. J. T. Mitchell writes that every photograph, whether or not it is accompanied by text (as it might be in a newspaper for example), is always inseparable from language. Indeed, it is 'invaded by language in the very moment it is looked at: in memory, in association, snatches of words and images continually intermingle and exchange one for the other'.[2] In a sense, the photoessay 'works' in part because it extends and

capitalizes on the deep connection that photographs already have with language. Somewhat counter-intuitively, the very word 'photo-graphy' suggests an association with writing, and was first called 'words of light' by William Henry Fox Talbot in 1839.[3] There is a rich theoretical history surrounding this connection, but also a very pragmatic one, experienced by professional photographers and journalists as they negotiate the relationship between the different tools of their trade. As discussed in Chapter 2, in America and Europe, the photoessay was adopted from the context of the book into the illustrated magazine in the 1930s, and as the popularity of publications like *Life* and *Picture Post* grew, advertisers were keen to sponsor photographers documenting world affairs. This period, from the 1930s into the 1970s, is often called a 'golden age' of photojournalism, in part because of the large budgets that editors reserved for the commissioning of long-form photo spreads that allowed photographers enough space, both literally and artistically, to explore subjects freely and in depth (Figures 3.1 and 3.2). This coincided with a shift in editorial priorities towards treating photographs as the central content of magazines, where they had previously (as is still usually the case in newspapers today) served as mere illustrations, secondary to the written word. In this new model, text was often relegated to the role of extended captions, with photo editors and art directors given license to dominate spreads with large photographs, printed in better and better quality, knowing that these were what readers really wanted to see.

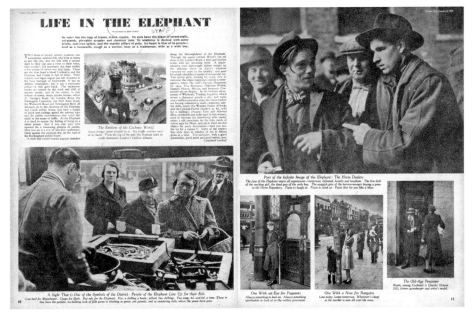

Figure 3.1 Bert Hardy, 1949, 'Life in the Elephant' spread, *Picture Post* (Getty Images).

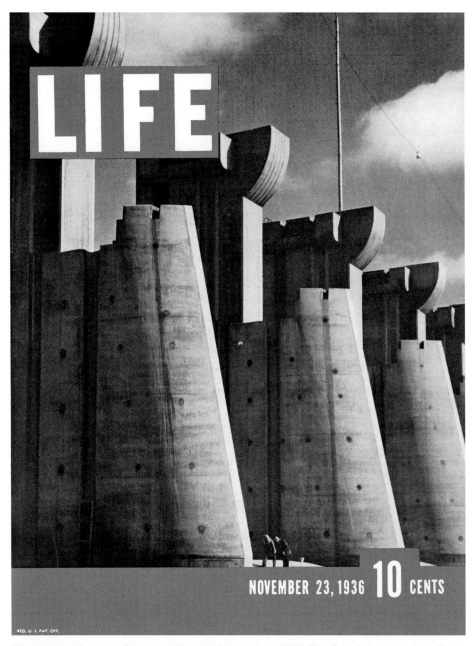

Figure 3.2 Margaret Bourke-White, 23 November 1936, The first *Life* cover: Fort Peck Dam over the Missouri River, Montana (The LIFE Picture Collection/Getty Images).

And yet, the evidence presented on the page was not necessarily, as it were, the whole story. In his memoir, *Words and Pictures*, Wilson Hicks, photo editor at *Life* during this 'golden age', (Figure 3.3) writes,

> The procedure of turning an event or an idea into a picture story begins at *Life* with a writer. The writer or reporter prepares for the assignment editor and photographer

Figure 3.3 William Sumits, 1947, *Life* magazine editor Wilson Hicks (centre, seated) looks through magazines with three of his photographers, from left, Leonard McCombe, Alfred Eisenstaedt (1898–1995) and Jerry Cooke, New York. (Time & Life Pictures/The LIFE Picture Collection/Getty Images).

a script which states as precisely as possible what the story is to be, and attempts to define the 'angle'. The photographer would not be in the office, where plans, layouts and decisions are made, and the magazine would be responsible for shaping out a coherent story. This system was photojournalism's guiding norm. Photographers were illustrators of story concepts, dreamed up by editors and writers serving the vision of the magazine.[4]

Even here, at the heart of an establishment known the world over for celebrating and privileging photographic journalism, there is a tension – we might even call it a power struggle – between word and image. It may just have been decades of tradition which dictated that the writer should lead and the photographer should follow, but many photojournalists will still testify to this tension: having the space for their pictures cut in favour of text, or simply being introduced by a writer on assignment as 'my photographer'. For many professional photojournalists, this is a time-honoured frustration, and no one was more frustrated by it than (to bring out another epithet from the era of 'the golden age') the 'father of the photoessay', W. Eugene Smith.

The single image and the photostory: *Minamata*

Smith was a photographer fiercely driven by his ideals, and was in regular battles with publishers and editors to give his stories the space he felt they warranted. Smith was dependent on magazines to provide exposure for his work, but he was constantly frustrated by their layout and marketing restrictions. His recurring conflict with editors was a testament to his determination, but it was also, more fundamentally, an expression of the basic belief that more pictures meant greater truth. Argued again and again by Smith in magazine editors' offices, and held in equally high regard by photographers today, is the principle that the greater the variety of perspectives on a subject that can be presented, the less danger there is of simplification, abstraction or distancing from its historical specificity. When coverage of a situation is extended from a single image into a series of views, it arguably becomes more difficult for the viewer to remain neutral, just as it becomes more difficult to adhere to stereotypical ways of seeing as we get to know different aspects of a person. This is why the tradition of the photostory is inseparable from the presentation of moral, ethical and political issues, and the bringing together of individual, isolated moments, chosen and sequenced in the right way, continues to offer insights that far surpass photography's frozen, monocular, instantaneous perspective.

One of the photostories that made Smith most famous, and one which raises some important questions about the nature of the photostory itself, is *Minamata* (Figures 3.4 and 3.5). Appearing in 1975 in *Life* and a number of other publications, the project was a powerful account of a small Japanese fishing village whose population had been poisoned by methyl mercury released into the sea from a chemical factory owned by the Chisso Corporation. This environmental poisoning resulted in widespread illness and birth defects known as 'Minamata disease'. Smith and his wife, Aileen, collaborated on the story during what was supposed to be a three-month visit but which ended up taking three years. As well as sacrificing a huge amount of time in their commitment to the story, Smith himself was physically attacked by employees of the Chisso Corporation in 1972, almost losing his sight in one eye. Their story is a moving account of the daily lives of victims of the disease, and also of the community's attempts to resist the corporation and fight for justice. In its various magazine formats as well as its fuller incarnation as a book (*Minamata: Words and Pictures*, by W. Eugene Smith and Aileen M. Smith), the work shows all the characteristics that marked Smith out a master of the photostory form. It balances sensitivity with dramatic impact, demonstrating great skill in its pacing and editing. It is as good an example as any from Smith's career of how to shoot and construct a photostory whose overall impact is a great deal more than the sum of the individual images that make it up.

Figure 3.4 W. Eugene Smith, 1971, Chisso Chemical Plant, Minamata Bay, Japan. Pool for waste water. 1971 (Magnum Photos).

Figure 3.5 W. Eugene Smith, 1971, Chisso Chemical Plant, Minamata Bay, Japan. A victim of the disease (Magnum Photos).

Yet there is one photograph from the project that has gone on to have a particular life of its own, transcending the other images in the series and achieving the status of photographic 'icon'. A sixteen-year-old girl, Tomoko Uemura, born with severe physical and learning disabilities as a result of 'Minamata disease', is cradled lovingly by her mother, Ryoko. Naked in the family's traditional bathing chamber, the visual impact of her deformities is tempered by Smith's dramatic use of light and by the two figures' poses. The resulting picture, intimate, poignant and undeniably beautiful, has been called Smith's greatest photograph. Having taken thousands of pictures of the community in Minamata, he is quoted as saying, 'it grew and grew in my mind that to me the symbol of Minamata was, finally, a picture of this woman, and the child, Tomoko. One day I simply said ... let us try to make that symbolic picture.'[5] Ryoko agreed to deliberately pose with her daughter for the image in the hope that it would draw the world's attention and in some way serve in the fight for justice for her and other victims. So, in contrast to many of the other images in the project, it was carefully lit, posed and staged as the centrepiece of the story, bringing all of Smith's skill and vision to bear in the service of the political cause that motivated his work.

What happens, though, when a single image is set apart from its corresponding series in this way? Tomoko and Ryoko have been turned, by Smith's own deliberate admission, into 'symbols'. His intention was that they become emblematic of the story, to further impress it as a whole on viewers' minds. But in this process they have become symbols of another kind. No longer anchored in the historical specificity of Minamata and its story of very real social injustice, they have also become somewhat ahistorical and transcendent, symbols not of Minamata itself but of other, much more abstract and universalized concepts: motherhood, empathy, compassion, endurance, love.

When it comes to the implications of individual photographed subjects being presented as symbols that transcend their specific circumstances in this way, let us consider two contrasting points of view. First, the argument that it always constitutes a kind of reductive exploitation, and second, that it is in fact productive, progressive and central to photojournalism's purposes.

The problem of iconicity

In the strong public response following its publication, Western viewers began immediately to label Smith's photograph of Tomoko Uemura a pietà – a term from the lexicon of Western Christian religious imagery referring to the long history of depictions in painting and sculpture of the Virgin Mary (or in other cases the disciples) cradling the body of the crucified Christ. It is easy to see why this association might be made here, based on the formal composition and subject matter of Smith's photograph, but we can only speculate as to how conscious the photographer was of this reference at the time. In this sense, it belongs to a category of images from the

history of Western photojournalism which have achieved the status of 'icon' specific-
ally due, in part, to a layer of powerful cultural resonance resulting from this kind of
religious echo. Belonging to this same category of iconic photographs are Dorothea
Lange's 'Migrant Mother' (Figure 6.3), with its perceived similarity to the Madonna
and Child, and Don McCullin's image of a US Marine wounded in the legs during
the 1968 Tet Offensive in South Vietnam, propped up by his comrades, his arms
outstretched as if crucified.[6] When photographs like these make the transition from
historical record into timeless symbol, they are called icons.

The word 'icon', from the Greek *eikōn*, for 'image', already has religious associa-
tions, traditionally meaning a sacred picture venerated in certain denominations of
Orthodox and Catholic Christianity. Icons of this kind are not mere representations;
they are objects of worship and prayer, transcending their material form and taking
on a power that is spiritual. In a related way, one of the things that is signified by
the label of icon when it is applied to a photograph is the capacity to hold whatever
meanings its audience chooses to project onto it: it is so aesthetically 'strong' that it
can bear the weight of any number of interpretations. Not only can it be said to sum
up an entire event or even era, such as the Vietnam War or the Great Depression, but
even further, it can offer insight into universal dimensions of the human condition.
And on another, more basic level, its very aesthetic power can elicit a kind of 'awe'
that can be said to point implicitly towards a higher power.[7]

This kind of transcendent abstraction can happen in relation to any iconic photo-
graph, but arguably, something different occurs in the case of pictures which, like
Smith's, also resemble traditional religious subjects in a formal or literal way. Such
images do not just elicit associations with the divine in general terms by means of
their beauty or aesthetic impact but through direct symbolic interpretation: by refer-
encing the subject of the pietà, Smith's photograph potentially invites a reading that
comes straight from religious doctrine, aligning the death of Christ with the suffering
of Tomoko Uemura. This kind of religious interpretation, especially for a twenty-
first-century audience, is not necessarily the dominant one that comes to mind. But
for the sake of argument, and especially given the speed with which it was in fact
called a pietà (indicating that a significant number of people did indeed read the
image in this way), it is worth exploring what this connotation entails.

First, there is a question of cultural appropriation: here is a Japanese subject pho-
tographed by an American for a primarily American audience, using a symbolic
frame of reference that is rooted in Western rather than Japanese cultural systems
of meaning. A second issue concerns the actual theological doctrine implicit in this
religious symbolism. Because the death of Christ was a sacrificial act by which all of
humankind could be redeemed from sin and given hope of eternal life, and was fol-
lowed by miraculous resurrection, there is an association within Christian theology
between suffering and glory. The validity of these beliefs in themselves is not at issue
here. The problem, rather, comes when this interpretation of suffering is too closely

associated with Tomoko Uemura herself. Her suffering will not result in glory, and she will not defeat death (she died at the age of twenty-one, after which her family requested that this photograph be withdrawn from publication – one of the reasons why we have not reproduced it here, though it is still widely accessible online). In this sense, a religious interpretation can be said to 'get in the way' of what we are actually seeing. Redemptive narratives (a term used to describe readings of any image or situation that points towards a redemptive outcome or 'silver lining') are comforting and convenient, but usually false, and they do no good to the individuals who are used to evoke them. A third and related problem is one of accountability. Tomoko's suffering is not (like Christ's) part of a great metanarrative of the redemption of the human race; rather, it has been caused through the criminal negligence of individual employees of a corporate organization. When a higher, abstracted and timeless metaphysical interpretation is foregrounded in place of this historical reality, its political urgency can be reduced and the focus taken away from any imperative to redress the specific injustice. Recalling the words of the critic Ingrid Sischy in regards to the question of beauty, it can become merely 'a call to admiration, not to action'.[8]

As an outspoken proponent of this kind of critique, Susan Sontag has remarked that the spectacular is intrinsically implicated in the religious narratives through which Western viewers have been conditioned to understand suffering. In other words, photographers do not need to make deliberate reference to Christian iconography in order for their images of catastrophe to be read in this way, because this interpretation is already there in the consciousness of the audience.[9] In increasingly secular Western culture, identification with religious frames of reference is arguably much less common than it was in, for example, the 1970s, when *Minamata* was made, and many today would contest Sontag's view that it comes so automatically to mind, colouring our interpretation of what we see. However, aside from the fact that photographic images in the twenty-first century are still routinely likened within public discourse to pietàs and crucifixion scenes,[10] awareness of religious iconography today may be no less powerful for operating at a less conscious level than it once did.

These kinds of anxieties about iconic imagery present a dilemma for photojournalism. They suggest that the single news image, especially if it is crafted in an aesthetically arresting way, can only ever be misleading, either because its aesthetic qualities divert attention from the specifics of a story or because they simplify that story to the point of misrepresentation. Often, the most celebrated news photographs are celebrated precisely because of this simplifying function. Photo editors and audiences alike are drawn to the visual equivalent of the sound bite: we admire pictures in which a photographer has managed to 'say it all', or 'sum up' an entire event. The dilemma is that in order to do this, complex situations that are nuanced, distant and difficult to understand must necessarily be simplified. But is this misleading or is it just effective communication (as when, to use a verbal example, the weight of an entire historic speech about civil rights is distilled into the single phrase 'I have a dream')?

The history of photojournalism is filled with examples of this tension. One of the most memorable, also made in 1972, is Nick Ut's Pulitzer Prize-winning photograph (in the category for 'Spot News') of a group of Vietnamese children fleeing a napalm attack on their village. Horst Faas, the AP editor who acted as the conduit for this and another of the most famous icons in photojournalism's history, Eddie Adams's picture of the execution of Van Lam, recalls that Adams said after seeing his photograph distributed worldwide, 'I got what I came to Vietnam for.'[11] Nick Ut's 'Napalm Girl' picture has become fixed in the cultural memory of that period as a self-evident symbol of an undeniable and very simple truth: the American involvement in Vietnam was unjust. It represents this 'truth' by apparently showing innocent Vietnamese children being visibly terrorized by the American GIs who have just bombed their village. By extension, it has also gone down in popular history as being directly implicated in the US defeat in Vietnam by turning the American population wholesale against their military's involvement and bringing the war to an end. On both levels, the full story behind this photograph is more complicated. Its iconic force resists that complexity, but at the same time makes possible its transformative intervention into American social and political history.

The aggregated individual

A completely contrasting understanding of the symbolic function of iconic imagery is that it is not reductive or exploitative but plays an important role in public life. Rather than simplifying, iconic photographs are tied to political agency, contributing to civic discourse by communicating important social knowledge in a way that 'exceeds words'.[12] In this view, there is a place for universalizing concepts and signifiers, and the abstraction of specific situations and people is a valid means to this greater end.

Rather than being problematic, the ability of photographs to morph from descriptions of specific spatio-temporal occurrences into vessels that express generalized social values is central to photojournalism's purpose. With its typical focus on the individual, and its strategy of transforming unique human beings into representative agglomerations, photojournalism typically seeks to pull off a visual conjuring trick: to make the viewer interpret the part as the whole, whilst simultaneously retaining the emotional pull of empathetic identification with another sentient human being. Robert Hariman and John Louis Lucaites have termed this the 'individuated aggregate'.[13] The individual's experience is extrapolated to stand in for the group, and in doing so it can mobilize the emotions of the collective. 'Individuated aggregates' are neither 'individuals nor abstractions, neither everywoman and everyman nor specific persons with names and stories, neither unique characters nor a literary type' but rather a 'new construct of human being based on an ideal equipoise of the tension within our political culture between personal sovereignty and public authority'.[14]

This 'new construct' taps into the tendency towards blurring the lines between society and the individual. Roland Barthes observes that the development of photography 'corresponds precisely to the explosion of the private into the public, or rather into the creation of a new social value, which is the publicity of the private: the private is consumed, as such, publicly'.[15] The 'publication' of the private can perform a vital role in humanizing an issue and creating a space in which the audience can identify with the protagonists. When issues are personalized, they can become more relevant to the audience, opening up a space for a more empathetic connection between subject and viewer. Photographs make the 'incorporeal, corporeal',[16] as the viewer responds to flesh and blood more readily than to abstractions or statistics. Rather than obscuring the reality of the Chisso Corporation's crimes through layers of pleasing or universalizing symbolism, Smith's photograph of Tomoko Uemura and her mother facilitates a direct connection between the audience and that very reality, by means of a 'flesh and blood' appeal with which all can identify. The previously stated qualities of empathy, compassion, endurance and love on which the power of the photograph rests make the enormity of the corporation's crime all the more real and urgent.

This sense that photographs render the private public operates in reverse too: the photograph as a discrete object is often viewed in private, compressing the distance between the viewer and the event and bringing the distant into the domestic spaces of the audience. Otherwise overwhelming events are thus made manageable by the operation of the frame, miniaturizing history into a palpable object that can be intimately viewed at close range. This forms a chain of linkages between the recorded subject, the media and the viewer – a chain that forms a relationship of interaction between the different parties. Examples of this process at work in photojournalism are legion, but Smith's most famous photoessays, including *Minamata* (1975), *Country Doctor* (1948) and *Nurse Midwife* (1951) are as good as any: all take single individuals or groups of individuals and invest them with the qualities of archetypes, then disseminate the resulting essays in mass media in the form of picture stories.[17] Each of these stories gained substantial popular appeal in its time, and each raised both awareness of the issues and funds to improve the situations represented.[18] This is a significant point, as although individual images from these stories have attained enough prominence to be labelled iconic, so too have the stories themselves in their entirety. If the single iconic image has a tendency to simplify and abstract, this can be ameliorated in an iconic story, where the nuances of the situation are expanded on in the course of a series of images. This reaches its logical conclusion in photo books that are considered to be seminal or iconic, such as Susan Meiselas's *Nicaragua* or Gilles Peress's *Telex: Iran* (Figure 7.11). The space afforded to explore a subject in depth in such expanded works is vital in dealing with complex political situations.

After their first appearance as rallying points for public awareness of an issue, iconic images become part of the process of establishing the moment as a historical one, with a process of sifting and editing out of some images in preference to others. Over time, iconic images, such as Ut's 'Napalm Girl', come to act as markers of collective memory, so familiar as to 'operate like the stock figures in memorial statuary, ceremonial oratory, and other representational practices that have been used to construct a community's sense of the past'.[19] As Nichols puts it, this sense of public memorialization can endow the subject with a form of eternal life:

> [the] desire for personal immortality is exchanged for a socially defined, mythically commemorated immortality. The individual lives on in the shared memories of others, through the iconic forms in which these memories can be venerated.[20]

Such characteristics as 'myth', 'immortality' and 'veneration' are the same ones that can be written off in a critique of iconic imagery as historically reductive and ideologically suspect. But if the role of photojournalism is not to claim factual objectivity but to contribute as an interpretive lens and a means of reflection on a society's values, then that critique is revealed as misplaced: accusing photography of failing to do something that it is not meant to do. The dilemma presented by the iconic function of photojournalistic images becomes, in fact, a false dilemma.

The identities of images are fluid, as they are appropriated and reconfigured by different interest groups to promote a variety of agendas, often at odds with the original usage of the photograph. Social media newsfeeds provide examples of this every day, such as the avalanche of appropriations and creative interpretations that followed the release of Nilüfer Demir's photograph of Alan Kurdi, a three-year-old Syrian refugee washed up on a Turkish beach after drowning in September 2015 (Figure 1.2). Such appropriations need not be seen as a failure of the original image to maintain its historically anchored position, however, but rather as markers of its success in acting as a focal point for debate. By opening up space for disparate viewpoints, the iconic image's reworking can provide a powerful means of dissent, social cohesion and even political change. The history of appropriation of another iconic photograph, Joe Rosenthal's 'Raising the Flag on Iwo Jima' (Figures 7.2 and 7.3) provides a fascinating account of how the same formal structure can be used to represent diametrically opposed agendas. It served simultaneously as a rallying point for support of the troops in Vietnam and as a countercultural attack on the values of militarism.[21] Hariman and Lucaites explain that the Iwo Jima flag raising

> demonstrates how iconic photographs have strong qualities of artistic performance, a series of transcriptions that carry deep resources for public identification, a rhetorical richness, open emotionality, and attitudinal range that facilitates civic life, and sufficient circulation to ensure continual slippage, reactivation, and reflexivity.[22]

to diversify their skills from still photography into video and sound (called 'convergence') or risk being left behind. Others, particularly those commenting on their use in NGO campaigns, have objected to their 'manipulative' potential. This anxiety seems to be attached mainly to the use of music, which undoubtedly has the power to affect and even overdetermine an audience's response to photographs. The multimedia presentation harnesses the power of spoken words and music, and ties it carefully and selectively to images, often as a means to strengthen a narrative or increase realism. There is great scope for research into the relationship between photography and sound, more generally. At the most basic level, though, it is worth noting the phenomenological implications of seeing photographs accompanied by spoken words, music or other recorded 'atmospheric' sound. Sight, as philosopher Maurice Merleau-Ponty reminds us, is not something that can be disembodied or detached from the viewer in isolation: 'sight is never only sight; it draws in the other senses'.[26] Sound has arguably always accompanied the viewing of photographs in a way that does not apply, for example, to the viewing of paintings. Photographs are usually created specifically with social experiences or platforms in mind, from snapshots of loved ones to be handed around and talked about, to newspapers and magazines read on noisy commuter trains. But multimedia ties photography to sound in a much more deliberate way, giving the photographer control over a further dimension of the viewer's experience, beyond the visual.

More recently emerging is a new sort of multimedia documentary work that destabilizes the notion of narrative altogether. Paving the way for apps such as Van Kesteren's, mentioned previously, Fred Ritchin and Gilles Peress's collaboration *Bosnia, Uncertain Paths to Peace* (1996), made over twenty years ago, still stands as one of the most innovative and original experiments in nonlinear storytelling on the Web. *Uncertain Paths* is a large-scale interactive multimedia piece distributed in collaboration with the *New York Times* that articulates Peress's philosophy of seeing the photographic interaction as an 'open text', involving participation from the subject, photographer and the viewer to co-create the meaning of the work. He believes that this generates a dialogue between reality and the audience, mediated by the process of photography, creating

> a text that is an interestingly structured conversation with other characters interjecting themselves into the text. It's not only me offering you a text and you reading it; it's also reality offering you a text and you reading it; it's the camera and the process doing the same. All this inscribes itself in the tension between memory and history.[27]

Ritchin relates that the 'intent was to take advantage of the new strategies made possible by the web – nonlinear narratives, discussion groups, contextualizing information, panoramic imaging, the photographer's reflective voice'.[28] The viewer is encouraged to navigate through the images, text and supporting evidence on the site in any way they choose, creating an intertextual pathway through the material,

making up their own mind about its meaning. Although there is a linear journey that the viewer can take by clicking through the photographs sequentially, they are also free to navigate through the images via a light-box-like grid. This is meant to represent the choices made by the journalists covering the story: at each point a decision has to be made on where to go next, and this reflects the interventionist nature of reporting as highlighted earlier. As Ritchin describes, 'each click of the cursor would put a reader on another screen with new perspectives and unknown possibilities'.[29] As one commentator put it, this meant that the viewer 'cannot simply sit and let the news wash over them; instead they are challenged to find the path that engages them, look deeper into context, and formulate and articulate a response'.[30] The captions are minimal, and often replaced with personal reflections by Peress. This was a deliberate strategy by the authors, intended to 'encourage a more intuitive, visual reading'. Ritchin notes that 'any confusion that resulted for the reader seemed minimal compared to the actual chaos in Bosnia'.[31]

Again, by making the process of documentation more visible and acknowledging the presence of the photographer as an active agent rather than an invisible observer, this subjective approach generates an enhanced sense of authenticity. Studies in the psychology of narrative interaction by Pierre Gander (2005), designed to detect the differences in user's cognitive function when exposed to a participatory and to a nonparticipatory narrative, revealed that the user perceives their experience in an interactive narrative the same way they perceive their personal experiences in the physical world. The nonlinearity of the story allows them to actively engage and participate in the formation of the narrative, thereby considering themselves as a part of the story. Ritchin describes the experiment of *Uncertain Paths* as a 'hyperlinked nonlinear narrative', and likens it as closer to the oral tradition of storytelling than the textual one, more like a conversation.[32] This more complex narrative, with varying and unique pathways, encourages the viewer to become an active participant in the story and to take more responsibility for their understanding of the issue. He argues that such a presentation 'allows us to better advance the media cycle so it does not end with me, but can be conceived to include a larger conception of we'.[33]

This type of interactive website, which can be navigated any way the viewer chooses, to build up the story in any number of ways, can help give subjects the opportunity of literally telling their own stories in their own voices. These individual fragments of the 'whole story' are embedded in different parts of the work, which can be accessed, like the photographs, in any order. In this way, multimedia opens up the possibility of radically reworking the way stories are structured. It is possible to move away from a narrated sequence of events into a more flexible, nonlinear form where the viewer, the photographer and the subject all have a new level of control. As Ritchin writes in his book *After Photography*, 'non-linearity can be a more subtle approach in the exploration of lives and situations that are themselves multifaceted.' So this is perhaps the next chapter to consider.

Further reading

Theoretical discussion of photography and/as language

Cadava, Eduardo. (1997). *Words of Light: Theses on the Photography of History*. Princeton, NJ: Princeton University Press.

Scott, Clive. (1999). *The Spoken Image: Photography and Language*. London: Reaktion Books.

Wollen, Peter. (2003). 'Fire and Ice', in Liz Wells, *The Photography Reader*. London: Routledge, pp. 76–80.

The photoessay: histories and critiques

Agee, James, and Walker Evans. (2001). *Let Us Now Praise Famous Men: Three Tenant Families*. New York: Mariner Books.

Becker, Karin E. (2003). 'Photojournalism and the Tabloid Press', in Liz Wells, *The Photography Reader*. London: Routledge, pp. 291–305.

Mitchell, W. J. T. (1994). 'The Photographic Essay: Four Case Studies', in *Picture Theory: Essays on Verbal and Visual Representation*. Chicago: University of Chicago Press, pp. 281–322.

Panzer, M. (2006). *Things As They Are: Photojournalism in Context since 1955*. London: Chris Boot.

Iconicity

Hariman, Robert, and John Louis Lucaites. (2007). *No Caption Needed: Iconic Photographs, Public Culture, and Liberal Democracy*. Chicago: University of Chicago Press.

4

Photojournalism Today

Chapter summary

The twenty-first century has seen a seismic shift in the relations between photographers, their paymasters and the consumers of their output, a shift in part determined by the positive and negative forces of technology. This has weakened, and in many cases broken, the links in the traditional chain of dissemination that lead from the photographer to the audience via the mediation of a third party, typically a magazine. Effectively the old formula in which the magazine that commissioned and paid for the work was the one that published it has been replaced by a more complex set of collaborations between the photographer and other interested parties, which can still include editorial clients but also NGOs and humanitarian organizations, grants and donors, self-funding and publishing and the affordances of the Web. The funding for work no longer comes predominantly from the institution that publishes or distributes it but rather from other sources that have an interest in the issues the work addresses. This dramatic and exponential alteration of the landscape has been determined by the transference from an analogue model to a digital one, which has had far-reaching and unexpected consequences for the medium. This chapter maps out the conflicting forces that are shaping current photojournalism and explores how photographers have responded to them with new ways of working.

The demise of the mainstream model of news

In terms of its relations to the means of production and distribution of images, the digital revolution has overthrown many accepted practices, devastating whole sectors of the industry, whilst simultaneously opening up new opportunities for photographers that are only just beginning to be fully explored. This contradiction has meant that more than ever photographers have to be flexible and fluid in adapting

their working practices to ensure their survival in this new terrain. The rapid growth of digital capture, storage, retrieval and dissemination has completely altered the economic models of most working photographers, shifting them from a reliance almost entirely on editorial publication to a mixed model where editorial, online, nonprofits and NGOs, grants, the art market and books all play a part in the successful production and distribution of a project. In addition, digitalization has raised fresh questions about the veracity of the photograph and has revitalized debates around the objectivity and subjectivity of the image. The impact of this can be seen in the following quote from an American newspaper photographer commenting on the atmosphere of her newsroom:

> There is heaviness in the air in newsrooms today. You can feel it pressing down on you as soon as you arrive at your desk. It is as if everyone is in a constant state of grief, and I think it is because we are grieving. We are grieving for our colleagues who have left the business, by force or choice. We are grieving for the way things were just a few short years ago, when we could cover a story despite the expense of mileage or a plane ticket. But most of all, we are grieving because we are losing our profession as we know it.[1]

This paradigm shift in the photojournalistic enterprise has, of course, not happened in isolation, but is rather symptomatic of a much broader shift in the entire terrain of journalism, and it is necessary to explore how the digital environment has impacted on journalism as a whole before returning to examining how it has altered photographic practice. As David Campbell has put it, the media is now entering the 'Age of Post Industrial Journalism'.[2]

The first decade of the twenty-first century saw a radical transformation in the gathering, distribution and consumption of news, as digital media has emerged from a minor part of news operations in the late twentieth century to a position of dominance in the early twenty-first. This transformation has been accompanied by a financial crisis in the industry, as falling circulations and competition from new outlets which resulted in both a loss of advertising income and direct sales, was exacerbated by the global economic downturn of 2008/09. This combination of challenges to the established media has proven to be irresolvable for many publications, as seen in the closure of metropolitan newspapers across the United States like the *Rocky Mountain News*, publications that date back to the mid-nineteenth century. At the time of writing, this process of exponential change is still very much in a state of flux, but although the final form of the medium is open to much debate, one theme emerges strongly, that new media has altered the relationship between subject, audience and intermediary forever. Much of the debate on this transformation has centred on whether this change is revolutionary or evolutionary, but fittingly much of that dialogue has taken place in the public forum of the Web itself, as Web 2.0 spaces of social media in the form of blogs, forums, Twitter feeds and webinars have made

media stars of pundits on a global scale. For Kenneth Lerer, the Internet exhibits all the attributes of what Clayton Christensen characterizes as a 'disruptive technology' that usurped mainstream news media in a way typical of the 'innovator's dilemma',[3] when successful companies fail to take notice of innovations that, while initially irrelevant, later come to challenge and usurp their business model. This pessimistic view of the future of mainstream print media is backed up by the economic analysis of the marketplace for journalism. The Pew Research Center for the People and the Press has charted the decline of the stalwarts of traditional media, and reports that the news magazines, mainstays of photojournalistic publication in the United States and internationally, have suffered especially badly over the last thirty years. *Life* magazine closed for the second time in its existence after a relaunch in the 1990s, and *Time* magazine lost more than one million readers from 1988 to 2008, falling from 4.75 million to 3.5 million, a level at which it has remained at the time of writing, while *Newsweek* lost 0.75 million over the same time frame from 3.5 million to 2.75 million, and closed its print edition in 2012, relaunching in 2014 under new ownership but with a much reduced circulation of only around one hundred thousand. Figures from a survey by the Pew Research Center in 2008 recorded that 23 per cent of adult Americans read a magazine of some kind the day before, down almost a third from 33 per cent in 1994, the first year the survey was conducted. The figure in 2014 was even lower, at 18 per cent, and when questioned about news magazines, 12 per cent reported reading one 'regularly', down two percentage points from 2006 and down six percentage points from a similar survey in 1994. The Pew Research Center sees this as evidence that 'for American news magazines, 2008 may be seen as the year when the traditional mass audience model finally collapsed', leading them to conclude that 'one thing appears clearest. In the 21st century, the truly mass-market news magazine appears on the way out'.[4]

Given that the weekend supplements to newspapers such as the *New York Times Magazine* or the *Sunday Times Magazine* are inextricably linked to the fortunes of their parent publications, the whole range of printed editorial publications that supported and disseminated the classic mode of operation of photojournalism in the form of the picture essay and secondary publications of stock imagery is in deep crisis. For photojournalism, then, the collapse of the traditional heartland of magazine publication seems to be assured, whether in analogue or digital formats. The disruptive innovation of Web 2.0 has swept away the main scaffolding of the whole enterprise of photojournalism. It remains to be seen what can be rebuilt from the wreckage.

Many authors concur that the most significant reason for the failure of the old business model has been the reorientation of the relationship between consumers of news and the news itself. This can be seen as a process of disintermediation, where the supply chain of information passes directly from the source to the audience, bypassing the established gatekeepers of the news and thereby cutting them out of

the economic gains of distribution as well. What does remain expensive, then, is not the cost of dissemination but the cost of production, that is, how to fund the news gatherers, be they professional, amateur, citizen or advocate. How to fund this human cost becomes the paramount objective, not how to rescue the existing media, which in turn entails a complete reconfiguring of the financial basis of the enterprise. The need, therefore, is to develop a range of potential business models that will support a range of practices from fully fledged professional reporters down to citizen media, in a participatory, collaborative enterprise that leverages the strengths of disintermediation whilst minimizing its risks. This does not alter the fundamental mission of journalism, but rather enhances and amplifies it by bringing both more depth to the story but also allowing for the potential of collaboration and feedback from the subject as well as the audience. Media analyst Charlie Beckett argues that in the world of networked, linked and ubiquitous information, a new social contract between the audience and the producer is being forged where the onus is on the journalist, however defined, to prove the case for the significance of what they are delivering,

> Whether 'amateur' or 'professional' the Networked Journalist must understand that if they want an audience they must gain trust and attention. I call this 'relevance'. By this I mean it in a very broad sense to describe how 'pertinent, connected, or applicable something is to a given matter'.[5]

By unpacking the process of journalism through expanding the single story into a network of contexts, the journalist can bring the audience into a more proximate relationship with the information, revealing the route by which it has been obtained and verified. This opening up of the mechanism of certification of the story enhances the 'believability' in the eyes of the consumer. The key then is to generate an environment in which the network can be monetized. If the link between media institution, subject, audience and journalist has been severed by disintermediation, the key question becomes how to break out of the vertical silo of traditional news production into a horizontal model where the news publication is no longer both the paymaster and the disseminator of the output of the news gatherer. Multimedia producer Brian Storm sums up the issues thus:

> How do we get the right people to get to the stories that we care about? That's entrepreneurial thinking. It's not just how do we go make money, it's also, how do we connect with the right people, how do we get involved with the right groups who can advocate for change? That's a big leap. At MediaStorm, we're focused on advocacy, not just information. We don't want to just create awareness with our stories, we want to create action.[6]

In the paradigm model that dominated practice for most of the history of the genre, photojournalists generally operated as individual agents, relatively free of the constraints on movement of staff photographers and able to a certain extent decide on

what stories they covered, when and for how long. This independence of action is today circumscribed by the economic realities of the media, but many practitioners have operated in spite of rather than with the full support of mainstream media, frequently taking an oppositional stance to the established news agenda and highlighting situations that get little or no coverage in the press. Indeed, they often consciously seek to avoid the news agenda to produce work that cuts across the one-sided messages of the mainstream media. As Simon Norfolk says of his work on the 'War on Terror', he steers clear of the establishment viewpoint:

> I wanted to get away from the tired motifs that we're used to, the refugee camp clichés of white gloves on little black babies' bellies, or nose cone footage of a bomb flying through Osama Bin Laden's front door. My work is anti-telly, anti-news photography. TV viewers have no real sense of what Afghanistan was, that it was a landscape in crisis. It was extraordinary how they had no idea what it was really like after watching hours of footage. I don't have a TV at the moment, and it's like unchaining yourself from a mad horse.[7]

Like Norfolk's work in *Afghanistan: Chronotopia*, there is a long list of exemplary bodies of work documenting important but underreported issues that have been undertaken by photojournalists, largely self-funded and the result of a long-term commitment to the story. Books such as Phillip Jones Griffiths' *Vietnam Inc.* (1971), Stanley Greene's *Open Wound* (2003) and Marcus Bleasdale's *Heart of Darkness* (2002) were all produced in this way, combining funds from editorial assignments, grants and large amounts of the authors' own resources, unpaid. Such projects form a long lineage of independent voices documenting current affairs from an oppositional perspective. Indeed, it is important to note how many issues have generated one major body of work documenting them in this way, almost all of which have been produced against the odds and by virtue of the single-minded determination of the photographer and individual commitment to that particular story. Almost all display a distinctive authorial 'voice' in terms of the visual and storytelling approach utilized by the photographer.

Photojournalism as an industry has thus in many ways undergone a more dramatic transformation than at any other time since the introduction of the 35mm Leica in the 1920s, but the core values of the industry largely remain: to reach an audience with a compelling form of visual storytelling whatever the format. Despite the downturn in the editorial market, new opportunities for funding and producing work have emerged at the same time as radically new ways of distributing it to an audience. Especially in recent years, significant sums of money have become available to photographers through the explosion of grants and funding opportunities available, ranging from sources such as the W. Eugene Smith Award, the Aftermath Grant and the Getty Grants, all in the $20,000–$50,000 range, the bestowing of notable honours such as a Macarthur grant of $250,000 to Susan Meiselas and the TED

prize of $100,000 to James Nachtwey. Photographers have become adept at knitting together these varying sources of funding, logistical support and dissemination to create sustainable projects that can reach an audience. They are thus fully aware of the contradictions inherent in their practice, and in both the limitations but also the possibilities that they generate.

The commercial landscape of editorial photography has therefore changed dramatically from that prevailing at the end of the twentieth century, with a new set of actors, with changed roles for others and with many no longer operating. The slump in editorial sales and assignments too has made the economic reality of photojournalism much more problematic. However, these massive changes have in many ways operated as a 'reality check' on the industry, making practitioners evaluate their work to reassess how it might best address an audience and remain at the very least a break-even business.

The demise of the classic photojournalistic essay in magazine format has limited one avenue of dissemination, but has opened up many others. Photojournalists have become far more adept at creating spaces in which to tell their stories, funded by a wider variety of sources and distributed through a wider range of outlets. Photographers such as Ed Kashi and David Alan Harvey have used blogs[8] successfully to communicate news about their work and to unpack the process of being a photographer by explaining the background to stories and assignments. Platforms like Instagram too can be used to build audiences who directly engage with the photographer, again emphasizing the value of personal testimony over institutional media: the photographer is the one who is believed, not the publication. At the time of writing, Kashi had 250,000 followers on Instagram, and was one of five photographers commissioned by *Time* magazine to cover the aftermath of floods in the wake of Hurricane Sandy in 2012.[9]

The key to this new methodology is in matching the output, the funding and the audience in a symbiotic relationship. The move towards closely targeted projects with clearer intended audiences, as demonstrated in the following case study, has meant that the business case for photojournalism is easier to prove to interested parties like NGOs or pressure groups. The disintermediation of legacy media into a variety of publishing platforms both analogue and digital has therefore generated a wealth of new opportunities for photographers to engage with audiences in ways outside of the traditional format of printed magazines and newspapers. The photographer Donald Weber, a member of VII, expands on this theme:

> We don't want to say goodbye to editorial, but we realise that editorial is not 'the' component, but rather 'a' component. What we're really about is a collective of storytellers. That's what we do. The question becomes: how do we tell a story? In one case it could be through editorial clients, but it could also be about setting up an infrastructure so that if [someone] wants to make a film he has the freedom, contacts and support to make that film.[10]

Even if the established models of business and distribution have been disrupted, the new models offer potentially even more effective means of bridging the gap between audience and subject, by making the connections between them more direct and immediate. Compared to a generation ago, photojournalists now operate in a significantly different environment. Gary Knight, one of the founders of VII, explains how 'assignment work for us is a tiny part of our income now' and that in fact they are beginning to rival the very publications on which they previously relied for the bulk of their income in terms of outreach to an audience. As he explains, 'our website is now getting thousands of hits a day, the traffic we get to it is almost as much as the websites of our major clients, and it's coming directly to view our stories'.[11] Multimedia has allowed photographers to diversify into video and longer-form digital storytelling, with platforms such as Mediastorm offering the financial and editorial support to develop ambitious and complex projects. Anthony Suau, a photographer who has adapted his methodology to the potential of the moving image, explains that documentary film greatly expands his ability to address the issues he is concerned about. He notes how he can 'use sound and motion, to bring all of those elements together. I make my photographs in the same way but I can add sound, music, motion, I fly a drone, use a GoPro. I'm collecting these amazing images and then bringing that together with a great story that you can tell.' Suau says that he feels great excitement at the possibilities of film, with its 'huge white canvas to build and build and build the story, using these timelines to create the most important way of communicating in our culture'.[12] Whilst the traditional business model of the magazine assignment has become less relevant and less common, it has been replaced and supplanted by a wide range of other publishing platforms and possibilities, allowing photographers to engage with their audiences in new and potentially powerful ways, by offering nuanced, complex and intelligent bodies of work that demand that the audience engage with them in an imaginative intellectual exercise of sense making and which can act as powerful drivers of connection and interaction that might otherwise go unnoticed.

The humanitarian stance

One area that has seen a significant growth in the last decade is the collaborative production of photographic essays by photographers acting in concert with NGOs. As editorial opportunities have withered, photographers have expanded on the established alliances between journalists and charities. The traditional practice of NGOs offering logistical support to journalists in the field in return for hopefully favourable coverage of their activities has morphed into a much more explicit relationship where both parties operate symbiotically to produce a body of work in depth with a clearly identified plan for dissemination to a carefully targeted audience. This in turn

generates important questions about the relationships between images and NGOs that are akin to those in the more traditional media. Within the NGO sector images are just as important as in other forms of media in their value in setting the agenda for discussion and debate. But there are clear battle lines drawn between conflicting opinions as to the value of an image and the ethical and moral dilemmas that its usage might generate. These dilemmas emerge from both within the internal politics of non-profits and also from within the relationships between image-makers, that is, photographers, and image commissioners and end users, that is, the NGOs. In addition, external elements, such as critics, impact on discussions of what is acceptable to photograph and which forms of representation are morally and ethically sound, and which are not.

Within the NGOs themselves there is an often fierce debate between the financial imperative and the informational one. On the one hand there is the desire to raise funds for the cause, which often relies on high-impact, iconic or even stereotypical images with strong emotional appeal, which tend to reinforce received opinion about a situation, particularly when applied to disaster or emergency appeals. On the other hand there is the desire to educate the audience by challenging stereotypes, contextualizing situations, emphasizing the nuances of a situation and using more complex, subtle and multilayered images that may well be 'quieter' and less immediately dramatic in their emotional charge.

From the point of view of the professional image-maker, who is most commonly a freelance photojournalist, there are conflicting and competing perceptions of their role within such an exchange. They are often hired for their journalistic and reporting skills, yet are briefed as if they are an advertising photographer working to sell a product. Are they documentarians or dramatists, objective witnesses or partisan propagandists, independent agents or committed advocates? This conflict of interest necessitates photographers working tactically to ensure that the projects they engage in can navigate this complex interaction between financial issues, journalistic imperatives, moral and ethical questions, humanitarian concerns and issues of representation and aesthetics.

Marcus Bleasdale's association with Human Rights Watch and other related NGOs is a valuable example of how such an alliance between a photographer and a humanitarian organization can be far more powerful than the work of one agent alone, and can thus enhance the potential impact of bearing witness. Bleasdale has a long-term commitment to documenting the situation in the Congo, from the days of Mobuto to the collapse of civil society and the rise of the warlords who dominate the Democratic Republic of Congo (DRC) today. Visually, his images often take the perspective of a participant in the situation, situating the viewer within the scene, as in Figure 4.1. In his methodology, he deploys the perspective of the prosecutorial witness in that he clearly identifies particular actors as responsible for the situation and seeks to implicate them as causal agents. He is an excellent example of the kind of photographer

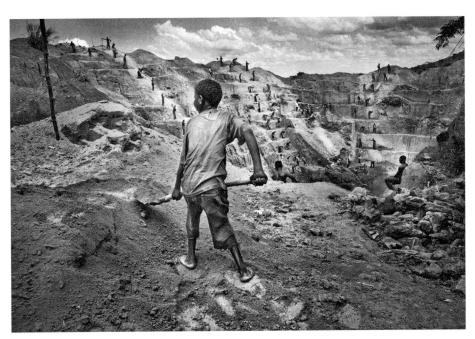

Figure 4.1 Marcus Bleasdale, 2004. A child gold miner, Watsa, Congo (Marcus Bleasdale).

who has emerged from the complex changes in the industry driven by the digitalization of image distribution and the demise of the traditional magazine market. He has a clear personal agenda focused on a particular issue and uses a variety of outlets and funding streams to maximize his ability to get his message across. By forming alliances with editorial clients who will give short assignments, NGOs that work in the field for logistical support and grant-giving entities to fund the work on a long-term basis, he has been able to produce sustained bodies of images that address key issues in the conflict in the DRC. These can then be used by a variety of interested parties from news magazines to non-profits, to keep interest in the story alive. Bleasdale sees himself as a specialist, and compares his skill set to the way in which a company would use a business consultant to improve its profitability,

> If you are JP Morgan and you don't have a specialist you hire a consultant who is, everyone has an MBA, so you go for someone with a speciality in marketing or managing change. In the same way look for a photographer who has spent a lot of time in that area and who brings a lot more that just a good photograph, they understand the politics, they have the connections on the ground, they know the story.[13]

Bleasdale brings his contacts in the industry to the project, and his reputation as a successful freelancer allows him to get his stories placed in high-profile magazines such as *Time* or the *Sunday Times*. Such deals need to be carefully managed so that no conflict of interest occurs. The NGO and the photographer need to carefully assign

the rights to distribute the images so that they are not both simultaneously trying to place the same story in two competing magazines. The photographer can therefore act as the fulcrum between the marketplace and the NGO, leveraging contacts in the industry to gain coverage for the NGO's activities that would otherwise be harder to gain. In addition, the photographer can act as a link between NGOs and other funding parties. Bleasdale's work again provides a good example. He has worked on projects in Congo on rape as a weapon of war, for example, and the resulting images have been used both by Human Rights Watch (HRW) and Médecins Sans Frontières (MSF) in campaigns, and his work there has been partly funded by the Open Society Foundation to sustain the long-term commitment necessary. The photographer can thus put together a package that blends together the needs of the NGO, the demands of the marketplace, funds from grant-giving organizations and their own personal agenda in a project that becomes greater than the sum of its parts. This can be a powerful combination, as he explains:

> The solution for me is to use the mainstream media to finance an issue initially, that might not be sufficient to fund me for a more than a week, I'll need more than a week to do it, so to enhance access and the quality of the work I am doing I'll find one or two NGOs with access to the issue I am dealing with, in payment they might give me one or two days, or logistics on the ground. Then that whole body of work can be used by the magazine to reach a large audience, by MSF on the ground in a report about health issues, and by HRW on ending human rights abuse. There is a synergy there, the photographer shooting the issues, brings together those NGOs that cannot directly work together so that I'm a kind of bridge that allows those two organisations to co-operate together.[14]

Bleasdale's work demonstrates that there is a need for a strong correlation between the work of the NGO and the existing or planned projects of the photographer, a clear agenda and division of commercial syndication rights, and a well-researched and thought-through photographic brief that allows for the individual voice of the photographic author to stand out. It also requires a planned and sustained programme of dissemination that uses all available distribution channels, from mainstream media to direct marketing to specific interest groups through the Web or through exhibitions. This approach is echoed by Campbell, who argues that to 'go beyond commendable acts of charity and contribute to larger and more substantive social change means appreciating how photojournalism gets its power through collaboration. Photojournalism is one actor amongst many on long-term campaigns, and we should not have the unrealistic expectation that it can be the sole cause of change.'[15] A project conceived in this level of detail has the context, photographic vision and impact on the audience necessary to diffuse the criticism that it is merely an exploitative vehicle to raise funds, or that it simply adds to the mass of distressing images about the world's suffering without actually making a difference.

Such alliances can again emphasize the testimonial qualities of a photographer's work, as allying with the aims of humanitarian organizations rather than journalistic ones enhances the moral weight of the witnessing act, aligning it more overtly with an ethical component. This body of work is thus emblematic of the themes of this book. It is a project developed from a journalistic and conceptual engagement with an issue, in which the author developed a formal strategy to represent a complex situation in a visually engaging way. The work was supported by a grant and produced in a dialogue with a humanitarian organization. The format of presentation of the work was chosen carefully to address specific audiences in specific ways. The work has meaningful content, but is presented in an aesthetically interesting and appealing way that fits the particular dissemination vehicle and the intended audience. The testimony of the photographer is thus delivered in ways that enhance the sense of bearing witness and engage the viewer in a more direct and personal interaction with the act of witnessing.

Finding alternative means of dissemination to traditional media is vital too. Projects like Gideon Mendel's work with the Global Fund for Africa in which innovative posters were produced to target directly those living with HIV or like Panos Pictures's large-scale project around the millennium goals where eight photographers partnered with eight NGOs working on each of the goals to produce an exhibition and website in conjunction with the *Guardian* newspaper exemplify this approach of using intelligently targeted presentations to reach specific audiences.

Again, Bleasdale's work provides an instructive example. In conjunction with HRW he produced a photographic exhibition, DVD and multimedia piece entitled The *Curse of Gold* about the illegal gold mining trade in Congo which fuels much of the violence and instability in the region. The HRW report and exhibition have been used to directly target the Western banks and companies that buy the illegal gold and allow it to be recycled into international markets. The work has been shown in the headquarters of UBS bank in Switzerland and at the Chicago Public library to an audience of financiers, bankers and gold traders in a 'name and shame' operation that combines the authority of the documentation produced by HRW with the emotive impact of Bleasdale's stark black and white images to bring home to the audience the reality of the policies they have been following. This combination of facts and illustration has been effective in securing the withdrawal of several significant international players from trading in illegal gold, and has been used to widen the debate about trade in mineral rights in the majority world in general. This project has also been produced in collaboration with Mediastorm as an online slideshow, which, as Storm explains, has reached a relevant audience and interacted with them directly:

A women from Oak Glen, California, Shea Downey, wrote in our reader feedback: 'Thank you so much for your coverage on this devastating issue.' Reading this

I felt we accomplished our first goal of raising awareness and compassion. But then she goes on to say, 'I am a small, fine jewelry retail owner.' This is the most powerful type of connection that we can hope to make. This is a person who can create real change by choosing where to purchase her diamonds. She then writes, 'I intend to forward this to all I know in the industry.' YAHTZEE! She's driving awareness to her personal network, a highly targeted group of diamond buyers. It's true that less people care about Congo than Britney's belly button. For me, it's not about reaching the largest possible audience; pandering to the lowest common denominator. It's about reaching the right audience with a relevant message.[16]

A successful relationship between a non-profit and a photographer should therefore go well beyond a 'this gun for hire' scenario.

Another approach that has developed recently is the enhancement of the voice of the subjects themselves in the process of creating their own stories about their lives rather than being depicted by outsiders. The use of participatory and collaborative photography has expanded significantly since the start of the twenty-first century, with organizations such as Photovoice developing ethically responsible methodologies that put the participants at the centre of the process. Photovoice has carried out dozens of projects internationally and in the United Kingdom in collaboration with a range of NGOs and other stakeholders, covering a wide range of subjects including refugees, HIV-positive women, sex workers, teenagers infected or affected by HIV, street and working children, young people with disabilities and adults with mental health needs. Such projects often use established photojournalists such as Jenny Matthews as the facilitators to help communities develop photography as a way of engaging with and understanding their situations. Photovoice states that the 'guiding ethos of our work is to use photography to build skills and confidence, and to act as a platform for participants to represent themselves and document their views and ideas to others'.[17]

The lure of the white cube

The other major shift in the last decade has been the collapsing of the space between fine art documentary practice and photojournalism. In the previous generation, photojournalists operated primarily for editorial clients, and whilst there were occasional forays into galleries and museums, such as the Magnum 40th anniversary show in 1988, they created considerable debate and criticism over whether such work was suitable for that kind of environment. Similarly, fine art documentary practice was confined almost entirely to the gallery and book world, and had little exposure in mainstream media except in the form of book and exhibition reviews.

Photographers were thus confined to separate camps, with little interaction between them and with criticism of such activity when it occurred. However, recent years have seen a change in this scenario, with an increasing number of photographers situating themselves in between these silos, operating outwards into the editorial and the art world rather than across from one sphere into the other. The paradigm example of this practice is Martin Parr, who has established a reputation at the highest levels of almost every sector of photography, from magazines to books, exhibitions to advertising. Many others have followed his lead, however, with Norfolk, Adam Broomberg and Oliver Chanarin, John Roberts and Luc Delahaye examples of photographers who skilfully stitch together their practice in a variety of outlets. Norfolk uses all the skills he developed working as a photojournalist in the 1980s on undercover investigative reporting into the far right in the United Kingdom and Europe to help him get access to the scenarios he wishes to explore. For example, as a result of his infiltration of the British National Party, he works commercially under an alias; his real name is not Norfolk. In Turkey he is officially banned under this name after the work he did on the Armenian genocide, but his real name on his passport allows him to travel back to the country to make other projects. He also regularly uses the journalistic access provided by working for high-profile magazine clients like the *New York Times, The Sunday Times* and the *Guardian* to obtain access to sensitive issues like military supercomputers and nuclear submarines. The images he makes as a result of this entry point are then exhibited in large-scale format in galleries as part of his 'Battle Space' project on the technologicalization of military activity. Norfolk continues to operate in effect as an investigative journalist, covering the new realities of conflict, researching constantly into obscure and secret military technologies and applications. Many of these activities are effectively unphotographable. They are either so secret that access is impossible or so nebulous that they do not exist in a physical reality. Norfolk has therefore adopted the large format language of landscape photograph as a way to photograph the unphotographable. In his recent series on satellites, for example, he images the moment of launch of top-secret military hardware, the only moment at which it is visible, and the arc of the rockets motors blasting across the night sky before they disappear into unviewable high Earth orbit. The resulting images are awesome in the true sense of the word, producing photographs of transcendent beauty but also shocking content. These prints then sell for significant sums to both private collectors and institutions, thus cross-funding and subsidizing his editorial production. His earlier project on the landscapes of genocide, *For most of it I have no words*, is illustrative of how the climate has changed. The book was not as successful as his later projects because at the time it was seen as too artistic for editorial clients and too journalistic for galleries, unlike his breakthrough work, *Chronotopia*, on the ravaged landscapes of Afghanistan. Norfolk now uses gallery space as an entry point from which he can

confound his audience's expectations and preconceptions of what they will encounter in such an environment,

> The subject matter I deal with is repellent, these days, people shy away from genocide, refugees the kinds of subject matter I want to deal with, so if I'm going to punch you, it's got to be a sucker punch, I see myself as a seducer, in order to begin any kind of dialogue, I need to draw the viewer into my space, the opinions we have about things are already formed, if you hear something is about refugees, you immediately know what to expect, likewise a show about seascapes. My strategy is to confuse these stereotypes, to shatter that preconception of the work, in that split second before the viewer rebuilds the fortress of their preconceptions, you can get inside with all kinds of subversions of symbols, if people don't get what they expect, then they have to re-interrogate their preconceptions about what the pictures are meant to be about, in a gallery, I watch people look at the pictures, especially the fine details, and you can see their minds working, searching, thrown back upon their own critical resources for once, forced to reassess their expectations of what information the picture is going to give them.[18]

Norfolk is thus subverting the established rules of engagement of the art world and combining the editorial sphere with that of fine art practice to leverage the strengths of both to produce work that has a compelling effect. Without one, the other would be weakened. Each gives the other credibility, market presence, financial support and journalistic integrity. Norfolk, like many others, is a master of operating tactically and reflectively, working in the cracks and spaces between different silos of practice and clinging like lichen to the rock face of the media.

The terrain of photojournalism in the twenty-first century is thus dramatically different from that of the end of the twentieth in both positive and negative ways. The demise of the classic photojournalistic essay in magazine format has closed off one avenue of dissemination, but has opened up many others. As Brian Storm exhorted in a speech to graduating students at the University of Missouri School of Journalism,

> It is one of the most exciting times in history to be a young journalist. You have an almost limitless palette of storytelling tools, an audience unbound by physical borders and the most powerful communications technology ever developed at your disposal. Martin Luther King said, 'The arc of the universe is long but it bends toward justice.' Our role as journalists is to help the bending process. This is your time. This is your moment.[19]

Photojournalists have become far more adept at creating spaces in which to tell their stories, funded by a wider variety of sources and distributed through a wider range of outlets. The key to this has been matching the output, the funding and the audience. More closely targeted projects with clearer intended audiences has meant that the

business case for photojournalism is easier to prove to interested parties like NGOs or pressure groups.

Further reading

Campbell, David. (2013). *Visual Storytelling in the Age of Post-Industrialist Journalism*. Amsterdam: World Press Photo.
Ritchin, Fred. (2009). *After Photography*. New York: W.W. Norton & Company.

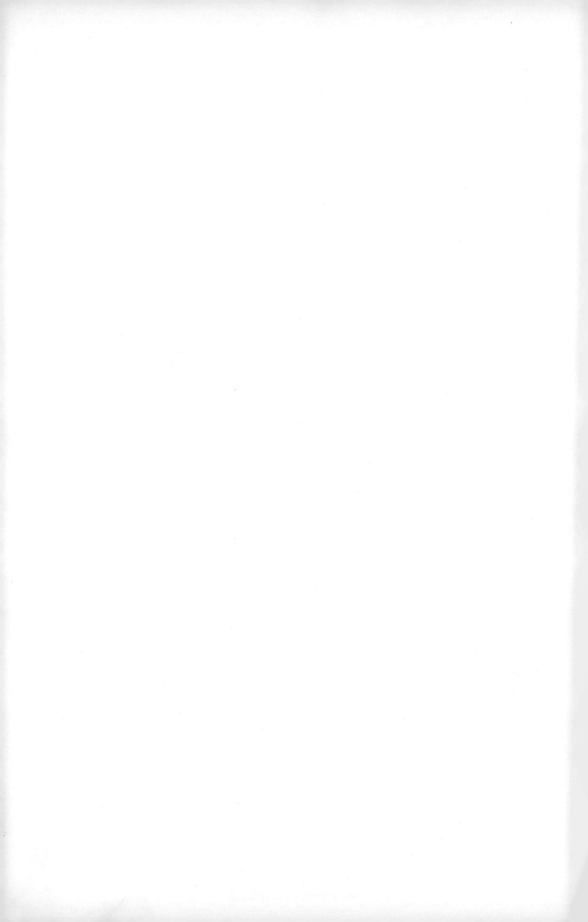

5

Power and Representation

Chapter summary

This chapter is concerned with the camera's power to represent people, and the choices that photojournalists must make in depicting situations where they encounter difference or 'otherness'. There are many kinds of 'otherness': disability, sexual orientation, class, economic deprivation and gender, all of which present ethical questions when it comes to responsible photographic representation. But here, our focus is on race. Often, the ethical challenges of representation are impacted greatly by history, and this chapter uses examples from the history of British 'colonial photography' to illustrate some of the potential pitfalls involved in the representation of race in the present day. Discussing the power of the camera as a social apparatus involves looking at theoretical ideas to do with the nature of power itself and with the significance of 'the gaze'.

The camera is a tool of power

Most people can appreciate, in one way or another, what is meant by 'the power of photography'. Many of us have had encounters with photographic images that convey meaning with such potency that they impact us, stay with us and maybe even change us. Many of these will likely have been photojournalistic images, and this kind of affective power is very often among the greatest ambitions that photojournalists have for their work. But in order to appreciate the true social and cultural influence that photojournalism can have, it is necessary to consider power of a different kind, using a different sort of language. This is not the power of photography simply to move or impress its viewers but to shape the representation of situations, historical moments and especially people. This power is implicated in a complex set of ethical and political questions, and to address these questions we must begin with an understanding that before a single picture is ever taken, a camera is a tool of power.

When any two people encounter one another, a dynamic of power is at play between them through the exchange of gazes. Sometimes this dynamic is very subtle, almost imperceptible, because the degree of power they hold is more or less equal. This might be the case if two strangers exchange glances in the street, or if good friends greet one another. At other times it might be felt a little more distinctly, for example, if one of these people is a figure of authority, or if one is asking the other for help. When a teacher stands in front of a room full of students to deliver a lecture, an exchange of gazes is taking place in which power relations are at play. The students look at the teacher with the expectation that she will offer them something, and, in turn, by the social (and economic) convention of the student-teacher relationship, she expects that they will pay attention. As well as having the responsibility to speak, she has an awareness of the performative nature of her visible presence. Ultimately, she is the figure of authority within the situation and holds most of the power, but as the object of the students' collective gaze she is also exposed to their visual and critical scrutiny. There are complex dynamics at play. To take an even more pronounced example, consider a prison officer in a cell block. He walks up and down the rows of cells, inspecting and surveying each prisoner in turn. As he does so, they each look back at him, but their gazes signify very different degrees of power. He is free to move around at his own discretion, choosing what he looks at and for how long; they are not. He has the power, based on what he sees, to reprimand or punish; they do not. They know that a certain kind of behaviour is expected of them, and it is in their interests to be seen conforming to this. In short, by virtue of who he is, the gaze of the officer is powerful.

Now imagine a camera being introduced into any one of these hypothetical situations, and notice how, as an apparatus of power, it further alters the dynamic. The relationship between the two friends meeting in the street changes when one is suddenly a photographer and the other is their subject. The nature of their relationship in that moment becomes less equal: regardless of whether 'the subject' is confident or shy, willing or unwilling to be photographed, he is still 'subject' to the power of the photographer and how she will choose to represent him. In the lecture room, if one of the students takes out a camera and points it at the lecturer as she is speaking (which is not unheard of in photography lectures), there is an immediate and discernible shift in the dynamic of power that has existed between teacher and student, and even between that particular student and the others in the group. The lecturer must now consider why she is being photographed and how she will appear, and this will have an impact on her sense of her own subjectivity in that moment, if not on her outward behaviour. Now imagine a camera in the hands of either the prison officer or one of his prisoners, and consider the very different potential implications this would have.

When a photojournalist arrives at the scene of an event to carry out their work, their very presence, and especially the presence of their camera, will often have an

impact on that situation. The awareness of being photographed will often affect the behaviour, or at least the consciousness, of their subjects. Sometimes this is because of an awareness that photojournalists operate with an agenda to record and present events for the scrutiny of the public eye. Their cameras give them the power of accountability, of shaping a subject's image favourably or unfavourably – the same properties that all cameras have, but amplified by the added institutional power of their profession and the apparatuses of the press. In short, photojournalists have more power than most other photographers not only because they might make 'better' images but also because more people will look at their work. It is a cliché to say that with greater power comes greater responsibility, but the power of representation is a serious thing to undertake. A fundamental part of being a 'responsible' photojournalist is appreciating, first, the power embodied by the camera itself, and secondly, the stakes involved in how it is used.

As we observed briefly in Chapter 1, there is a great social, psychological and historical obstacle to gaining a clear sense of this responsibility. This is the enduring idea of photography's objectivity. In our work teaching photojournalism students, one of the most important principles we try to communicate, and often one of the hardest for them to appreciate, is that, one way or another, a photographer's political views will always manifest themselves in the aesthetic choices they make. What they choose to include in the frame and what is excluded; whether their chosen viewpoint is high or low; the minute subtleties of facial expression and body language that are captured; even the use of black and white versus colour: each of these choices may feel purely arbitrary, intuitive or aesthetic, but each has important implications for how their subject is represented. Each says something, intentional or not, about how the photographer 'sees' their subject. The power of the camera, and of photojournalism, is so great precisely because that point of view is then passed on as it is captured and seen again and again, sometimes by thousands of other people. These viewers may then, in turn, accept the image as 'objective', not realizing that their perception of a person or event has already been wordlessly shaped by a medium that is supposed to speak for itself. When the power of photographic representation and its presumed transparency intersect in the public space of the media, the stakes are often very high indeed.

The colonial gaze

This is best illustrated by looking to extreme examples, and some of the most troubling historical cases of photography's use as an apparatus of power date from the British colonial period. By its broadest definition, the British empire spanned a period of roughly five hundred years, from the arrival in the Americas in 1497 to the withdrawal from Hong Kong in 1987. But its peak was in the late Victorian

era and the first few decades of the twentieth century. At this time, British rule accounted for over a quarter of the globe in both population and geographical terms, making it the largest empire in history. This peak period coincides with the rise of photography as a widespread means of communication, a time of great openness in regards to what this new technology was capable of, how it should be defined and, in particular, how it might further the cause of British imperialism in a whole range of different ways. The empire has had far-reaching consequences to say the least: every place it touched has experienced both great injustice and, to some extent, advances (in infrastructure, technology, systems of governance, education and trade, and even language and sport). In turn, British society has been impacted immeasurably by the cultures and riches of its former colonies as well as by the ambiguous legacy of such huge power, and its subsequent loss. The influence of colonial expansion on the practices of photography itself has also been huge, and photography is very much implicated in some of the imperial project's darkest and most shameful violations.

In the hands of British colonial officers and administrators, photography was used for a wide range of purposes including the exploration of foreign landscapes, military strategy, education (both of colonial 'natives' and the British population at home), personal or commemorative record and, most notably perhaps, as a tool in the burgeoning science of anthropology. This range is a reflection of the diverse, and sometimes contradictory, motivations behind the imperial project itself. These motivations can be summed up as Christianity, civilization and commerce. For the Victorian ruling classes in particular, 'civilization' encompassed a commitment not only to bringing 'uncivilized' peoples into line with British social ideals by any means necessary but also to use the exploration of new territories to advance scientific knowledge, thus increasing Britain's claim to intellectual as well as economic superiority on the world stage. Photography was uniquely suited to these scientific objectives, which were more often than not, as literary theorist and pioneer of postcolonial theory Edward Said has argued, thinly veiled means of asserting control on local populations.[1] Photography could, with apparent objectivity and detached scientific rationalism, classify 'racial types' (Figure 5.3) and survey the strange and 'uncivilized' cultural practices of native populations. But because of the pronounced imbalance in the power relationships involved (consider again the example of the prison guard's gaze), objectivity and scientific detachment in these situations was, to say the least, a simplistic ideal. Instead, photography was complicit in upholding ill-founded theories of racial and cultural superiority that were both a cause and an effect of colonial domination. This kind of pseudoscientific propaganda was routinely presented in explicit terms, depicting human subjects as no more than specimens (Figure 5.1), but it also appeared in slightly more tacit ways, where the 'natural' inferiority of colonized people was normalized and represented as part of a God-given social order (Figure 5.2).

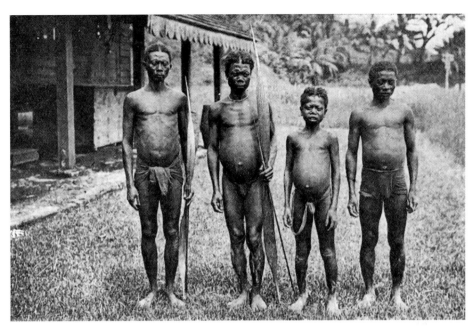

Figure 5.1 Andamanese, India, Anthropological picture, 1900 (Getty Images).

The danger of such imagery, of course, lay in photography's mode of address, as an irrefutably transparent window untouched by any political interest. For the original British viewers of such pictures, this transparency was accepted even more readily than it might be today, and as the only pictorial representations ever seen by many such viewers of a black or South Asian person, their influence was very great indeed. Not only were these pictures demeaning to their individual subjects but also for British viewers they were received as instructive documents that exponentially reinforced the hierarchy of imperial power, entrenching racist attitudes decades into the future.

The nature of 'otherness' is complex. In this chapter, we focus on the question of race: how the colonial legacy has shaped the photographic representation of race in the nineteenth century and today. But a person's race can never be separated from the other characteristics that make up who they are. Gender, age, ability, religion, sexual orientation and socio-economic background, along with other kinds of 'difference' including race, all intersect to make each person's identity unique. ('Intersectionality' is the name given to the study of how these overlaps combine, in particular to create systems of discrimination and disadvantage. It has predominantly been devoted to considering the intersection between race and gender.) For example, in terms of discrimination and disadvantage, a black middle-class man's experience cannot be presumed to be the same as that of a black lesbian woman from a poor background: even though their ethnicity is an important shared characteristic, it can be reductive to

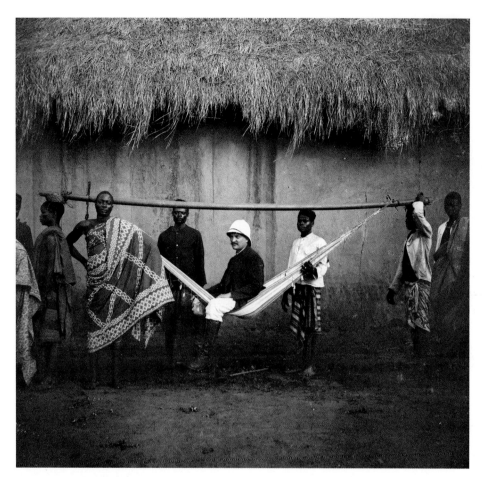

Figure 5.2 European moving in hammock, Allada, Benin, 1895 (Getty Images).

focus on this at the exclusion of gender, sexual orientation and class. We return to this issue in the discussion of later examples.

The apparatus and the gaze

Figure 5.1 is in some senses a very 'straightforward' photograph. The subjects are posed frontally and simply; the camera is positioned squarely and at close range; no elaborate staging or direction has taken place. The individual subjects do not appear to have been humiliated or abused in any way in its making. Aesthetically, it is neutral, as befits a picture that is constructed to operate within a discourse of science: objective, informative and clear. What is it, then, that makes such an image problematic? If we are proposing that the picture does a kind of harm to its subjects, is that harm located within the frame of the picture itself – can we see it visibly? – or does it somehow lie outside?

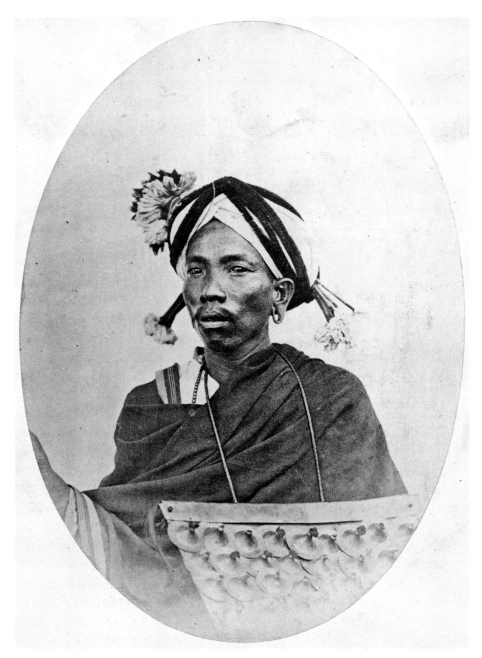

Figure 5.3 From *The People of India* archive: 'Kookie Man' (Getty Images).

We might also ask the same questions about Figure 5.3. *The People of India* is an eight-volume photographic study that was compiled between 1868 and 1875 by two British civil servants, John Forbes Watson and John William Kaye. The volumes contain 468 captioned photographs that aim to provide a comprehensive survey of the native castes and tribes of India. The 'jewel in the crown' of the empire, India was

both a source of magnificent wealth to the British and also a great cultural conundrum: its huge size, its inherent cultural diversity and, in particular, its baffling range of ethnic groups made it difficult to administer effectively. If a nation is to be properly controlled, it must first be understood, and Watson and Kaye's project was commissioned as a means of bringing a kind of order to this perceived chaos. This example (Figure 5.3) shows a man identified only as belonging to the 'Kookie or Kuki robber tribes of Cachar'. He has no name, and his function is to serve as a symbolic marker of an entire community. He is reduced to a 'type', a specimen. In contrast, unlike Figure 5.1, this picture, with its oval frame and upper-body three-quarter profile, conforms to the visual language of Western portraiture. This is a genre of image that, far from demeaning or reducing its subject (or 'sitter'), traditionally signifies respect. Since the European Renaissance period, portraiture of this kind has been a means of highlighting the individual characteristics of a person of note, predicated on the basic belief that this individuality is located and manifested most evidently in the face.

There is a disconnect, then, between the form of this image and its function. We might say, returning to the question posed previously, that the symbolic 'harm' inflicted by this photograph lies not within the image itself but entirely outside of the frame, within the apparatus of its use. The idea of 'apparatuses' of power comes from the French critical theorist Michel Foucault, whose writings, while they did not tackle photography directly, have been of great interest to the critical discourse of photography because of the way in which he conceptualizes power, and in particular the connection between seeing and control.[2] For Foucault, power is not a stable or quantifiable commodity belonging to particular individuals or things, but rather it is something that flows via social and political systems (themselves called 'discourses'). A Foucauldian understanding of photography recognizes that no photograph contains any power in or of itself, but can be invested with power in a way that depends absolutely on who is using it and for what purpose. This photograph of the 'Kookie Man' derives all of its meaning, and all of its capacity for oppressive control, from the political system of British rule within which it has been commissioned and implemented. As Said argues (and the creators of *The People of India* project freely admit), this kind of pseudoscientific knowledge is always a means of asserting some form of dominance over a subject. The 'Kookie Man' is not overtly 'dominated' in the process of sitting for a photographic portrait, but his image is part of a system of domination that reduces his humanity in a symbolic way. There may be no visible trace of this in his eyes, but when the context that surrounds the picture is taken into account, it is undeniable.

Another important theoretical idea presented by Foucault concerns the significance of the gaze in the power relationship between subjects.[3] For Foucault, the gaze refers not so much to a literal function of vision as to a subject position within a particular discourse. For example, he writes about 'the medical gaze' as one that

separates the personhood of a medical patient from their status as a body, contingent on the unequal power relationship between doctor and patient. It is not hard to transfer this idea to a whole range of other contexts, including 'the colonial gaze', and when we combine it with an understanding of the camera as a tool of power and the apparatuses in which photography is implicated, we have a theoretical framework by which we can respond to questions of photography and racial 'otherness', among many other things.

Accounting for the multiplicity of gazes that exist in and around a photograph can be a very productive method of critical analysis,[4] because it takes into account the various discursive frameworks and contexts of viewing as well as what is happening 'inside' the image. For example, Figure 5.1, formally simple as it is, represents a whole range of subject positions that are each invested in the picture in different ways. It is not easy to make out the eyes of the four subjects within the picture, but at least one of them looks directly at the camera, and at least one other looks beyond at something outside the frame. These different gazes signify different relationships to the camera, possibly including confidence, self-consciousness, defiance, confusion, compliance or aggression. As in most photographic images, the gaze of the photographer, who has his own specific agenda and relationship to the subjects, is aligned with that of our own as viewers, looking at the picture in a very different time and place, judging both the photographer and the group of subjects according to completely different terms than viewers might have in 1901. A full account of the image would also consider the various investments implied by the institutional gaze of the photo agency which controls the rights to the image in the present, historical or academic institutions specializing in the study of its ethnographic subject and, finally, its educational usage in this book. You, the reader, have your own gaze, informed by your own subject position, time and place.

The exotic

In examples such as those shown above, it is relatively easy to recognize the problematic treatment of people who have been depicted as inferior, reduced to indicative symbols of racial difference or presented as objects of scientific study. In such cases, it is clear not only that all of the power lies with the photographer but also that the camera has been used to reinforce this power imbalance, in the making of the picture itself and also often by institutionalizing it via apparatuses of state and officially sanctioned systems of knowledge (such as schools or museums). This kind of imagery is, for the most part, firmly in the past. The views and relationships represented in it are no longer acceptable, and we look at these photographs now as historic documents, as relics of a different time.

We marvel at you!' It seems to elevate and pay respect. But all of this comes on the condition that the person be kept at arm's length, looked at but not identified with, valued not on the basis of their humanity but of their novelty. In short, it objectifies. Objectification is a complicated notion too: we very often see this in discussions about the media's representation of women, which for the most part conditions women not only to accept that they will be valued according their appearance but also to embrace this condition of their value, for example, in feeling so affirmed (or 'flattered') by positive judgements of their appearance that it seems like a kind of empowerment. Even though we do not want to be seen as objects, the double-edged ambiguity of this desire can be confusing, especially for the young and the vulnerable. A similar tension exists within the idea of the exotic. Just as a person can be 'objectified', so too can this adjective be turned into a verb with overtones of violence, as whole cultures are 'exoticized', reduced to a level of visual novelty for the consumption of curious Western eyes.

This exoticizing impulse has been especially potent when applied, within the context of colonial photography as well as more generally, to the representation of women of colour. In such images, the exotic, as a conflation of strangeness and desire, has the effect of doubly reducing women, by presenting them as objects of both cultural curiosity and sexual voyeurism. Here is a pertinent example of the kind of 'intersectional' discrimination mentioned previously in this chapter. Many photographs of this kind were made for commercial purposes around the turn of the twentieth century, often to be reproduced as picture postcards.[8] Hundreds of examples exist of these postcards, in which female subjects from a whole range of cultures are directed to pose according to the conventions of Western painting, and are photographed in studio settings furnished with carefully chosen props and painted backgrounds. Each of these images operates on the premise that the woman's difference, her culture, her sex and her individuality as a human being, are reduced and carefully arranged for consumption on purely Western (and male) terms. She is a stereotype who has no name. In many cases, even the cultural convention of her dress is appropriated in a clumsy conflation of the Western genres of nude painting and cheap pornography: a particularly popular category of postcard featured female subjects from cultures in which it is, or was, customary for women to be bare-breasted, allowing the Western colonial viewer to consume her nudity without any of the moral taboos associated with looking at pornography. These photographs are now relics of history, but they illustrate impulses that continue to persist in other, subtler, forms.

As a way of seeing, the exotic is still very much alive in the practice of Western photojournalism and documentary photography, and there is a huge demand for it, particularly as traditional ways of life in tribal and indigenous cultures all over the world are under threat from globalization, environmental degradation and industrial/economic expansion. 'Capturing' such cultures while they are still in existence

has been a motivation for many photographers, but arguably the value of this kind of photography is often outweighed by the damage done through objectification, 'othering' and, in some cases, even outright exploitation.[9] When a photographer is drawn to a subject primarily on the basis of difference rather than identification with another human being, they are likely to create photographs that invite the same response from viewers – especially if they neglect to contextualize their imagery with a rounded view of their subjects as people with names and personal histories, who operate in specific political, social and economic conditions. Whatever the photographer's conscious intention, such images will inevitably reduce, simplify, distance and 'other' the subject, perpetuating age-old power imbalances in a newer, more socially acceptable guise.

The camera of the colonized

Postcolonial studies is an academic field that considers the legacies of colonialism across a very diverse range of perspectives. Broadly speaking it is concerned with examining the history of colonialism from the point of view of the colonized subject, seeking, in a sense, a retrospective redistribution of power. In the case of photography, this has involved an interest in practices that break established patterns in which the colonized subject is looked at but cannot look, and is represented but denied the power to represent. This revisionist history has opened up entire indigenous canons of photography that have been unrecognized or ignored by dominant accounts of the medium. Across India, for example, photography has a history that is inseparable from British influence but that includes strong and unmistakably Indian 'voices'. The list of these voices is long (as an introduction to the subject, see the writing of Christopher Pinney detailed in the further reading list below), but one of the most distinctive is Raghubir Singh.

Singh is an important figure within the colonial and postcolonial histories of Indian photography not only because of his photographs but also because of the political self-awareness shown in the writing which has accompanied and contextualized his practice. In *River of Colour*, his final book (published in 1998), Singh includes a long written introduction that presents his entire career as a continual negotiation with the Western photographic influences that have pervaded his country and his medium. Personally acquainted with many of the leading figures of Western photography, he was well placed to comment on the differences in attitude, motivation and aesthetics that set them apart. Singh spent a formative week with Henri Cartier-Bresson in Jaipur in 1966, and also worked for a time with Lee Friedlander, whom he felt was too interested in the 'abject', having an aesthetic interest in poverty that was peculiarly Western (another variation of 'the exotic' that persists well into the twenty-first century). He has much to say about the legacies of colonialism for Indian art and culture, and specifically how

the photography of the British administration brought with it a way of seeing that was utterly alien to Indian culture, being implicitly laden with Christian ideas about death that he saw as oppressive. It is futile, he writes, for the Indian photographer to try to conform 'to the Eurocentric Western canon of photography, in which the contemporary concepts of morality and guilt push aside the idea of beauty. Beauty, nature, humanism and spirituality are the four cornerstones of the continuous culture of India.'[10]

The thing that sets him apart most obviously from these other photographers, however, is his commitment to colour. Despite Cartier-Bresson's early influence on his work, Singh photographed from the beginning exclusively in colour, which represented for him an intrinsically Indian way of seeing: Western photographers 'know' colour through the mind, while Indians know it through intuition. One reason why he can be called a pioneer of colour photography is because, as he writes, Indian photographers simply 'cannot produce the angst and alienation' of American and European photographers such as Brassaï, Bill Brandt, Robert Frank or Diane Arbus. He argues that 'psychological empathy with black is alien to India,'[11] and even that Indians did not 'see' in black and white until the arrival of colonialism and photography: if Indians had invented photography, its history would have been completely different.

In his 1991 book *The Ganges,* an image of a 'pavement mirror shop' in Calcutta acts as a striking emblem of Singh's India. It is a street scene that demonstrates his eye for vibrancy and colour, without resorting to reductive stereotypes. Photographed closely and tightly framed, he uses the mismatched collection of mirrors being sold at the stall to fragment the picture plane, creating a compelling montage of pictures-within-pictures. Faces are layered over one another, some passing in front of the camera, others behind, reflected back at the viewer. These portraits include young and old, smartly dressed and poor, each absorbed in their own activity. One small mirror at the upper edge of the frame has caught the photographer himself – his reflection is the only element not sharply in focus. Each of the other vignettes is perfectly composed, the elements of colour and form impeccably balanced across the entire frame. Other pictures in *The Ganges* are elegant and lyrical, evoking a kind of 'magical realism' (associated with the literature and visual imagery of Latin America). But this picture presents a different facet of Singh's vision, charged with a frenetic energy and complexity that are still far removed from the 'exotic'.

Across India and the whole of the formerly colonized world, photographers continue to negotiate the legacies left behind by British (and other colonial powers') ways of seeing, not only in how they and their communities might represent themselves in its aftermath but also in some cases by questioning the nature of photography itself as it has been handed to them.[12] We might even say that the very idea of the camera as a tool of power is inseparable from these particular histories of its use. By beginning to align it with other subject positions, political priorities and aesthetic forms, postcolonial photographic practice, as well as contemporary research into indigenous photography of the colonial period, has the capacity for profound disruption of existing power structures.

Legacies of the colonial gaze: representing famine

Curiosity about the world and the impulse to document threatened cultures are not, of course, the only contexts in which contemporary Western photographers engage with non-Western subjects. Much more frequent and high profile is the coverage of humanitarian stories. From breaking news of natural disasters to longer-term charity campaigns, humanitarian photojournalism raises the stakes of ethically responsible representation because of the huge potential for regression into stereotypes of victimhood. The coverage of African famine by Western photojournalists has proven in particular to be a minefield of stereotypes and entrenched visual cliché, because it is an area in which so many questions of power and representation collide.

Famine, especially in Africa, has its own unmistakable iconography. The visual cues of the emaciated black body, empty eyes, distended belly, tears and 'flies on eyes' are its hallmarks. David Campbell has argued that this iconography 'should be roundly condemned as simplistic, reductionist, colonial and even racist'.[13] Imagery such as this (as seen in Figure 5.5) is implicated, he says, within the legacies of

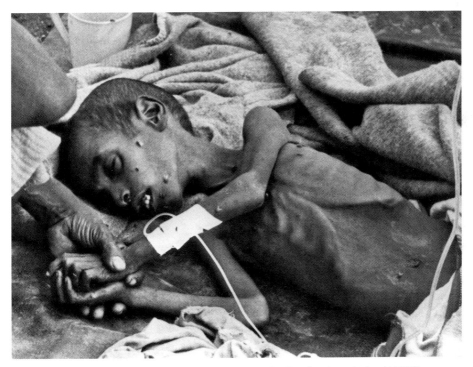

Figure 5.5 Finn Frandsen, November 1984, Ethiopian famine victim (AFP/Getty Images).

colonialism not by any association with the exotic as such but because it perpetuates a stereotypical power relationship between helpless, dysfunctional Africa and the rich, compassionate West:

> The message is that someone is suffering, and that we should be sympathetic to his or her plight and moved to do something. However, the lack of contextual support means that viewers are most likely to regard action to alleviate suffering as coming from outside. Indigenous social structures are absent and local actors are erased from these images. There is a void of agency and history with the victim arrayed passively before the lens so their suffering can be appropriated. This structuring of the isolated victim awaiting external assistance is what invests such imagery with colonial relations of power.[14]

Associated with these colonialist attitudes is the tendency, all too visible in the British tabloid press, of representing Africa as a whole, undifferentiated continent defined by famine. Beyond simple ignorance, this is a throwback from an era in which Africa was 'the dark continent': a vast and mysterious mass awaiting exploration only by the brave. Even the more innocuous misconception of the whole of Africa as suffering a perpetual state of starvation is a destructive stereotype that photography often does little to dispel. Sometimes called the 'Live Aid Legacy', this view is associated

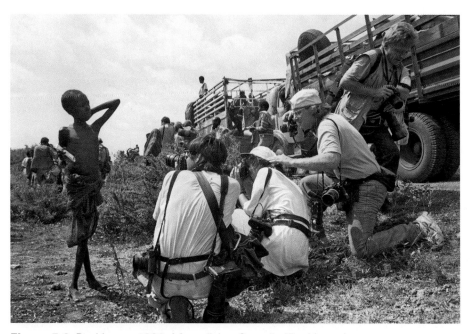

Figure 5.6 Paul Lowe, 1992, Mogadishu, Somalia (Paul Lowe).

Paul Lowe's photograph highlights the media circus surrounding a malnourished boy during 'Operation Restore Hope', the American intervention in Somalia following the overthrow of its president.

in particular with the devastating Ethiopian famine of 1984 (Figure 5.5), which prompted British celebrities led by Bob Geldof to mount a high-profile publicity campaign that succeed in raising a large amount of money in a short amount of time, but resulted in a long-lasting distortion of Africa in the British public imagination.[15]

The very uncomfortable idea of the famine victim being 'arrayed passively before the lens' is illustrated in this photograph (Figure 5.6) taken by Paul Lowe in Somalia in 1992.

By taking a few steps backwards, Lowe has been able to capture the troubling nature of the media presence in this part of Somalia, where famine has become a story to be pursued and starving children are hunted like prizes by the waiting press.[16] Of course, the press is an industry that is necessarily supplied by photographers doing their jobs, and though he has stepped outside it for a moment to show us the bigger picture, Lowe is himself, as a white European journalist, part of the scene he is documenting. A pragmatic interpretation must also take into account the utilitarian argument that photographing famine (which is in this particular case directly associated with political chaos and injustice) is a means to an end. International awareness, emergency fundraising and the political pressure that can be put on governments by effective photographic coverage are all arguments in favour of photography that does not shy away from representing famine in a clear and uncompromising way. History has shown that the photographic coverage of famine in the news media does have the power to effect change, and can be seen, in humanitarian and political terms, as part of the solution. The question of whether this justifies the perpetuating of stereotypes that are (in Campbell's words) 'simplistic, reductionist, colonial and even racist', remains open. It is one that photojournalists and news editors must negotiate on their own terms, arriving at a critically informed position that sits as comfortably as is possible within the parameters of their professional practice and conscience.

Race and representation in modern Britain

On 22 June 1948, the *SS Empire Windrush* sailed into the Port of Tilbury, United Kingdom, carrying 490 Jamaican men and two women (Figure 5.7). At this time, when the Second World War had greatly depleted the male working-age population of Britain, an open-door immigration policy was in place allowing free passage for any colonial subject from one part of the British realm to another. Though people from all parts of the world had been living and working in Britain for many years prior, this was a watershed moment, marking the beginning of modern multicultural Britain. This is partly because of the numbers of people involved – as these men settled and were in many cases eventually joined by their families, whole neighbourhoods (most

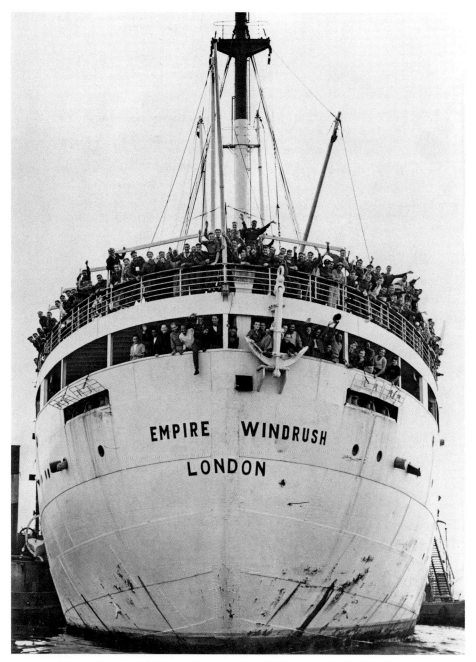

Figure 5.7 Jones, 22 June 1948, *SS Empire Windrush* arrives at Tilbury Docks (Daily Herald Archive/Getty Images).

famously the Brixton area of South London) quickly developed strong West Indian identities. But it is also because of how these communities were represented. Not only did the cultural and demographic landscape of Britain's cities begin to change from

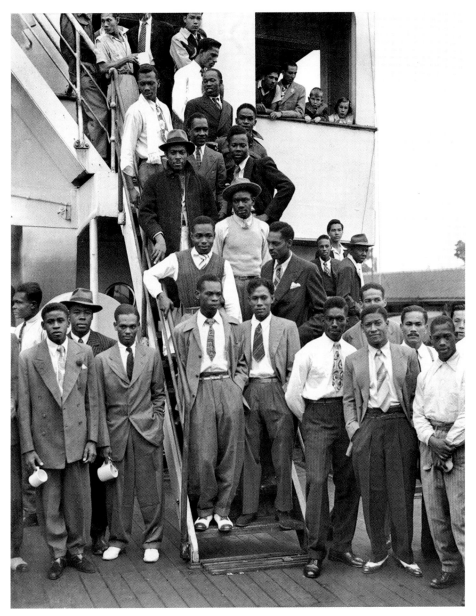

Figure 5.8 22 June 1948, Jamaicans disembarking *SS Empire Windrush* (Planet News Archive/Getty Images).

this moment on but there was also a profound shift in perceptions of the relationship between Britain and its formerly colonized subjects. People of colour, who were previously only seen in picture books and postcards from the other side of world, perceived as exotic, strange and in most cases inherently inferior, were now neighbours and co-workers.

This uncomfortable adjustment can be read into the photographic coverage of the time, including press photographs of the arrival of the *Windrush* itself. The media coverage of the event had a high profile, introducing Britons in a most literal way to their new neighbours and a new era. Figure 5.8 shows a group of passengers as they disembark the ship. On the whole they appear smartly dressed and sophisticated, and while there is an understandable air of apprehension about what might await them (the stiffly posed young man in the oversized suit, far left foreground, personifies this in an especially poignant way), many of the facial expressions and much of the body language convey self-assurance, agency and a readiness to participate in British life as equal, self-determining citizens. Consider the gaze of the man standing about half-way up the stairs, in the hat and dark coat with upturned collar, and compare it with the gazes of the Andamanese men in Figure 5.1. In both cases, they look squarely into the camera lens and, by extension, squarely at the viewer. But their subjectivity is constructed so differently by these two photographs that their gazes impact the viewer in completely different ways. In the earlier image, the subjects have been stripped of their agency and power by the camera, and if their collective gaze makes any direct address to us as viewers it is one that evokes discomfort, self-consciousness or, for some, even the vaguely guilty recognition of a problematic system of oppression. By contrast, the other seems figuratively to say, 'You may photograph me and you may look at me, but it will be on my own terms, and in looking right back at you I assert my presence as an equal.' These gazes, and the viewers' own surveying gaze, also have different meanings today than they would have at the times when either photograph first appeared in the British public sphere. In 1948, this photograph of the *Windrush* passengers would for ordinary Britons come as something of a shock. These men have arrived from the Caribbean and not from Africa, but because they are black, colonial imagery of the 'dark continent' was at the time the only readily available frame of reference. Considering that the only photographs of people of colour that many Britons had been accustomed to seeing looked like Figures 5.1–5.4, above, we can begin to understand why the multicultural history of Britain has been so fraught, and how much misunderstanding and outright racism is attributable to misuses of photography.

The fate that awaited many of the *Windrush* immigrants and their families was not as bright as they might have hoped. To this day, British Afro-Caribbean communities are among the most underprivileged and economically deprived in the country, and accounts of everyday prejudice and institutional racism are still commonplace. Brixton, the South London neighbourhood in which many of the immigrants settled, and other urban neighbourhoods have repeatedly seen riots sparked by race-related police brutality (most notably in the early 1980s and mid-1990s), and as in the United States, such violence has been a feature of news headlines well into the twenty-first century. In the late summer of 2011, following the shooting dead by police of Mark

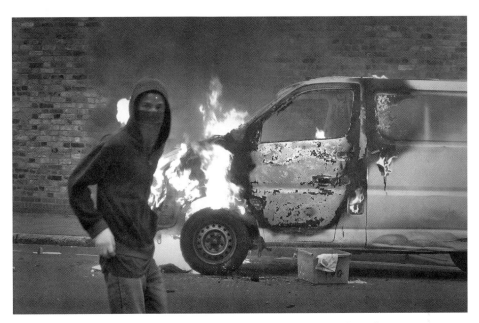

Figure 5.9 Peter Macdiarmid, 8 August 2011, A hooded youth walks past a burning vehicle in Hackney, London (Getty Images).

Duggan, a young black man in Tottenham, North London, a wave of rioting spread across the capital and beyond with a ferocity that mystified political leaders and local communities. Over an extraordinary six-day period, whole neighbourhoods were engulfed by violence – businesses were smashed and looted, vehicles overturned and set alight, police were overrun and five people lost their lives. Though Duggan's shooting was the initial catalyst, people on all sides of the political spectrum agree that these were not 'race riots' as such (One *Daily Mail* reporter called it 'an equal-opportunity crime wave'[17]). Some saw the disturbances as mindless vandalism and opportunism carried out by 'hooligans' in need of discipline, while to others they represented a cry for help from a disenfranchised generation in need of hope, not punishment.

People from a whole range of ethnic backgrounds were involved in the 2011 riots, but the great majority of them were young and from working-class or unemployed families. Social housing estates like the Pembury in Hackney, East London, became pressure cookers of violent energy, and, as in many of the other locations where the riots erupted, the vast majority of Pembury residents are black. Images like this one taken by photographer Peter Macdiarmid (Figure 5.9), of hooded and masked young black men, became emblematic of Britain's sudden social crisis. It is crucially important to talk about pictures like this in a context of race, but it is also difficult: this is a real photograph of a real crime. Whether or not this young man is responsible for

setting the vehicle alight, he was there. A great many of the rioters were young black men, and the taking or publishing of this picture is not a misrepresentation. However, photographs like this one add to a pattern of negative representation of black youth that is arguably endemic in the British press, and this pattern informs wider (majority white) society's cultural reception of this picture, feeding existing preconceptions and stereotypes in a way that goes beyond the specifics of August 2011. Adding to the complexities involved in the discussion of the photograph, it is again important to note the way in which not only race but also the factors of age, gender and economic background intersect here to create a particular kind of racialized subject. His various identifying characteristics – he is not just black but he is also a black male youth from a social housing estate – are not simply added together; rather, they multiply one another in a potent matrix of stereotype and judgement.

In approaching this photograph or any other media image, it can be helpful to consider what, as it were, the picture is 'inviting' viewers to believe. What are the instant, knee-jerk responses that the picture stimulates? What does it 'do'? (These questions are worth asking mainly because they are likely to identify the prevailing interpretation of the picture, whatever the facts or the intention of the photographer.) For example, the photograph seems to infer that this young man has set fire to this van. He has covered his face to avoid being identified, has been caught out by the photographer and is poised to run away. According to the analytical method set out by theorist and semiotician Roland Barthes involving 'denotation' and 'connotation',[18] the denoted meaning of the picture is that a van is on fire and there is a young, black, masked man nearby. The connoted meaning is that he started it. But this interpretation is not just informed by the picture itself. It is informed also by the history of patterns and stereotypes set out above. The audience is arguably conditioned by such stereotypes to assume that this man is guilty and to judge him accordingly.

But let us look more closely, beyond the initial 'invitation' of the image as prompted by its prevailing frames of reference, and consider what evidence is actually presented. The van is extensively charred, suggesting that it has been burning for some time. This either means that the man in the picture did not start the fire or that he started it some time ago and stayed nearby, or returned later to the scene of the crime, either of which is unlikely. The masking of his face by definition means that his expression is difficult to read, but the look in his eyes is ambiguous. Is he to be feared, or is he afraid? Just as a photographer's own political views are likely to be revealed in the composition of their pictures, so a viewer's interpretation of an image is always informed by their pre-existing political views. This becomes a completely different photograph depending on whether you are disposed more generally to see the rioters as dangerous or vulnerable, lawless or lost – to say nothing of perceptions regarding race.

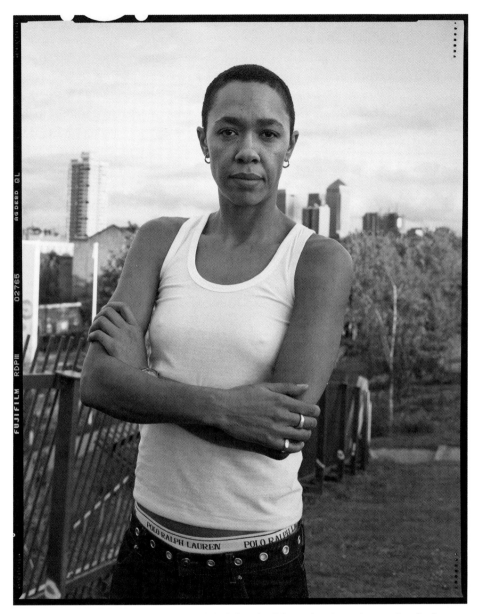

Figure 5.10 Lola Flash, 2003, 'dj kinky' (london) from [sur]passing series (Lola Flash).

This picture is from a series made by Lola Flash as part of a long-term project on the impact of skin pigmentation on black identity and consciousness, and specifically the complex legacy of historic pressure on mixed-race people to 'pass' as white. Her subjects are posed against urban skylines in London, New York and South Africa, and represent a 'new generation, one that is above and beyond 'passing.'

The experience of being black in modern Britain, and expressions of black popular culture in particular, has been an important subject within postcolonial studies. It also, in large part, prompted the inception of British cultural studies, a school of thought initiated in the 1960s by Stuart Hall. Hall, a Jamaican-born social theorist and member of the 'Windrush generation', wrote prolifically and influentially about British multiculturalism and what it meant to be black in Britain. The scope of his work went far beyond any individual medium or cultural practice, but in one particular 1990 article for *Ten8* magazine, he considered the role of photography in the British Afro-Caribbean community, writing that, long after the fall of empire, there was still an urgent imperative to be conscious of the systems of representation that have excluded black people from picturing their experiences, identities and everyday realities, and to contest the visual stereotypes that perpetuate inequality and racism. For black photographers as well as for black subjects in front of the camera (Figure 5.10), the challenge is still, in Hall's words, 'how best to contest dominant regimes of representation and their institutionalisation, and the question of opening up fixed positions of spectatorship'.[19]

Further reading

On power

Foucault, Michel. (1980). *Power/Knowledge*. Edited by Colin Gordon. London: Harvester Wheatsheaf.
 On photography and the (general) politics of representation
Berger, John. (1972). *Ways of Seeing*. London: Penguin (chapters 2 and 3, pp. 36–64).
Kennedy, Liam. (2016). *Afterimages*. Chicago: University of Chicago Press.
Moeller, Susan D. (1999). *Compassion Fatigue: How the Media Sell Disease, Famine, War and Death*. London: Routledge.
Rosler, Martha. (2004). 'In, Around and Afterthoughts (on Documentary Photography)'. In *Decoys and Disruptions: Selected Writings, 1975–2001*. Cambridge, MA, and London: MIT Press, pp. 151–206.
Ross, Susan Dente, and Paul Martin Lester (eds) (2011). *Images That Injure: Pictorial Stereotypes in the Media*. Santa Barbara, CA: Praeger.
Solomon-Godeau, Abigail. (1994). 'Inside/Out'. In *Public Information: Desire, Disaster, Document*, edited by Kirk and Simpson. San Francisco: San Francisco Museum of Modern Art, pp. 49–61.
 (1994). *Photography at the Dock: Essays on Photographic History, Institutions and Practices*. Minneapolis: University of Minnesota Press.
Tagg, John. (1988). *The Burden of Representation: Essays on Photographies and Histories*. London: Macmillan.

On postcolonial representation and race

Bailey, David, and Stuart Hall. (1998). 'The Vertigo of Displacement'. In *The Photography Reader*, edited by Liz *Wells*. London: Routledge, pp. 380–386.

Edwards, Elizabeth. (1994). *Anthropology and Photography, 1860–1920*. New Haven: Yale University Press.

Edwards, Elizabeth. (2001). *Raw Histories. Photographs, Anthropology and Museums*. Oxford: Berg.

Lutz, Catherine, and Collins, Jane. (1993). 'The Photograph as an Intersection of Gazes: The Example of National Geographic'. In *Reading National Geographic* (Chicago: University of Chicago Press), pp. 187–216.

Mirzoeff, Nicholas. (2011). *The Right To Look: A Counterhistory of Visuality*. Durham, NC: Duke University Press.

Pinney, Christopher. (1998). *Camera Indica: The Social Life of Indian Photographs*. Durham, NC: Duke University Press.

Pinney, Christopher (ed.) (2003). *Photography's Other Histories*. Durham, NC: Duke University Press.

Said, E. W. (1995). *Orientalism: Western Conceptions of the Orient*. London: Penguin.

Singh, Raghubir. (2006). *River of Colour: The India of Raghubir Singh*. New York: Phaidon.

On the iconography of famine

Campbell, David. 'The Iconography of Famine'. In *Picturing Atrocity: Reading Photographs in Crisis*, edited by Geoffrey Batchen, Mick Gidley, Nancy K. Miller and Jay Prosser (London: Reaktion Books), pp. 79–92.

Lowe, Paul, and A. A. Gill. (1998). 'The End of the Road', *Sunday Times Magazine*, 31 May, pp. 28–42.

6

Ethics

Chapter summary

In some ways, moral and ethical issues are implicit in each chapter of this book. The fundamental moral questions about how we relate to others and what rights the photographer has vis-à-vis their subjects, and vice versa, in turn inform and shape the ethics of representation. From this we can debate and explore the challenging questions generated by a range of concerns, including the ethics of aesthetics, the ethics of subjectivity and the ethics of bias, commercialization and market economies. Because of the high political stakes involved in much of photojournalism's traditional subject matter, moral and ethical considerations must be at the heart of the photojournalist's decision-making process, from their very deepest motivating impulses through to the split-second choice of where to point the camera and how to frame what they see. But there are some questions that stand apart as being of particular importance in the eyes of photographers and viewers alike, and this chapter will consider them, if not answer them. Primarily, these are questions about manipulation and staging, the picturing of violence and the nature of photographic witnessing.

Manipulation and staging

In March 2015, the World Press Photo organization took the historic step of withdrawing a first-place award given to Italian photographer Giovanni Troilo in the Contemporary Issues Story category of its photography competition. Troilo's story, titled 'The Dark Heart of Europe', documents the Belgian town of Charleroi, which, according to the photographer, epitomizes the economic and social problems endemic throughout Europe at this moment in history. Shortly after Troilo won the prize, questions arose regarding the veracity of some of his caption information, and the World Press Photo committee ultimately took the decision to strip him of the award when it was demonstrated that one of his pictures had been taken not in

Charleroi but in a different town. World Press Photo director Lars Boering said in a statement,

> The World Press Photo Contest must be based on trust in the photographers who enter their work and in their professional ethics. We have checks and controls in place, of course, but the contest simply does not work without trust. We now have a clear case of misleading information and this changes the way the story is perceived. A rule has now been broken and a line has been crossed.[1]

This controversy precipitated a storm of debate within the photojournalism community regarding the need for a reconsideration of ethics within the profession. The central issue cited by many in this debate was the proliferation of digital technologies that increasingly seemed to be blurring the lines between acceptable and unacceptable kinds of manipulation. But, interestingly, the case that prompted this debate in the first place was not about image manipulation at all, and even less about modern photographic technology – it was a case of old-fashioned dishonest captioning. Having said that, the call for some kind of new, overarching ethical 'code' had been made, and there was an interesting array of responses to this call, to say nothing of where it might actually lead. There is, and has been for some time, a variety of 'codes of ethics' specific to photojournalistic agencies and organizations, such as the National Press Photographers Association. World Press Photo does not have one of its own, but in 2014 it commissioned David Campbell to write a detailed research report, titled 'The Integrity of the Image', which 'is not designed to impose or recommend standards that organizations should adopt', Campbell says, but 'to record the standards that organizations might hold or practice'.[2]

For some, the question of manipulation is the defining one when it comes to photojournalism and ethics. And for others, the term 'ethics' is, or should ideally be, synonymous with 'rules' – some defining code by which the limits of a photographer's intervention in the appearance of their pictures might be settled objectively and for all time. But, as with many ethical questions, the closer we look at the specifics of what this might mean, the more unlikely the possibility becomes.

There are plenty of historical examples of the manipulation of photography for deliberately deceptive purposes: Soviet and Nazi leaders removing from group photographs people who had fallen out of favour with their regimes, for example. Figure 6.1 shows a photograph of Joseph Stalin posing next to Nikolai Yezhov, then an official of the Soviet Secret Police, on a visit to the Moscow-Volga Canal in July 1937. Figure 6.2 is the same view, in which Yezhov has been removed following his trail, torture and execution in 1940.

This is a famous example, not of photojournalism but of political propaganda in which photography has been used to illustrate the kind of historical rewriting that was a feature of the Stalinist regime, and in particular the haunting figure of the 'unperson': one who has ceased to exist not only in the present as a human being but

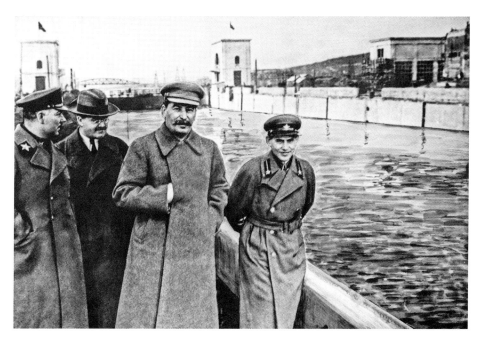

Figure 6.1 USSR. People's Commissar (Narkom) for Defense of the Soviet Union Kliment Voroshilov; Chairman of the Council of People's Commissars of the Soviet Union Vyacheslav Molotov; Secretary of the Communist Party of the Soviet Union Joseph Stalin; and People's Commissar (Narkom) for Internal Affairs (NKVD) Nikolai Yezhov (L-R) visit Moscow-Volga Canal. 12 July 1937 (Sovfoto/Getty Images).

also in all accounts of the past. Here is something beyond mere deception, though, revealing instead a shockingly idealistic belief in photography's power to somehow change historical reality itself. Ethically speaking, cases such as this are fairly clear-cut, usually because the value systems that gave rise to them are now seen as unambiguously immoral. Figure 6.3 is a picture taken one year before, by Dorothea Lange on assignment for the Farm Security Administration in California. The subject is Florence Owens Thompson, photographed with her children in a portrait that has come to symbolize the Great Depression for many Americans, evoking ideals of resilience, nobility and the universal human spirit. This is a good example of an 'iconic' photograph, which is immediately familiar to viewers all over the world, but readers may not have seen this version of it before.

In preparation for a gallery exhibit in 1941, after her already famous picture had been in circulation for five years, Lange took the decision to remove a thumb, visible here in the bottom right-hand corner, which she believed to be distracting. The retouched version is the one that has since 'gone down in history' as the definitive 'Migrant Mother'. This historical detail prompts questions about documentary objectivity, aesthetic values and, some might argue, ethics. Lange's act of manipulation, benign as it might seem, would be a rule-breaker in the terms of the World Press

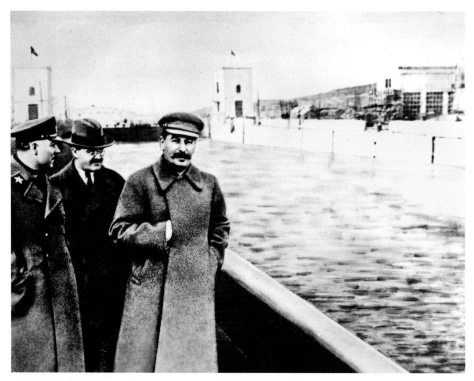

Figure 6.2 Vorochilov, Molotov, Joseph Stalin poses at the shore of the Moscow-Volga Canal, in 1937 in this manipulated picture. In the original picture Nikolai Yezhov was standing on the right. Yezhov was the senior figure in the NKVD (the Soviet secret police) under Stalin during the period of the Great Purge. After Yezhov was tried and executed his likeness was removed from this image between 1939 and 1991 (AFP/Getty Images).

Photo competition (photographers have been disqualified for similar omissions[3]). The very same technique had been used in the removal of Nikolai Yezhov, and though it was done for very different reasons, looking at the two examples side by side we might ask how a rigorous system for drawing a line between them could possibly be established. The contingent nature of the rules that we seek to apply to photojournalism can be explored by considering in a little more detail the following two examples:

(1) On 5 August 2006, Reuters news agency distributed a picture by Lebanese freelance photojournalist Adnan Hajj, with the caption, 'Smoke billows from burning buildings destroyed during an overnight Israeli air raid on Beirut's suburbs August 5, 2006. Many buildings were flattened during the attack.' The photograph showed a wide-angle, elevated view of the Beirut cityscape overwhelmed by thick grey smoke. But there was a problem. Almost immediately after it was released, online viewers began commenting on the strange appearance of the smoke, recognizing the hallmarks of Adobe Photoshop's 'clone stamp' tool. Realizing, too

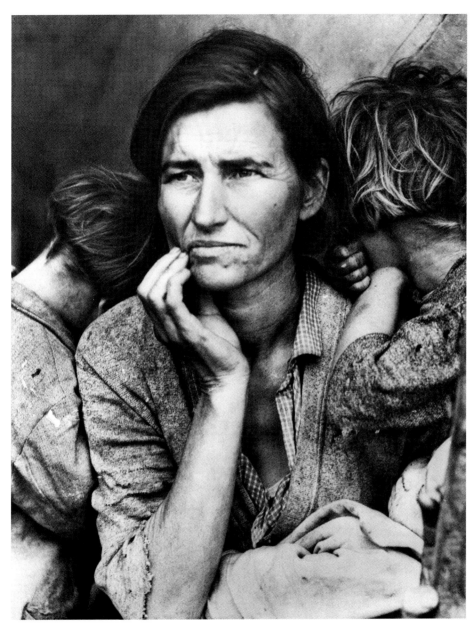

Figure 6.3 Dorothea Lange, 1936 Migrant Mother (unedited version) (Bettman/Getty Images).

late, that Hajj had deliberately (and poorly) exaggerated the volume of smoke in his picture in direct violation of their editorial policy, Reuters issued a 'Picture Kill' notification – the news agency equivalent of a product recall – apologizing for the mistake, and a statement withdrawing all of the photographer's previous work from their archives.

(2) In 1968 Don McCullin was in Vietnam for the *Sunday Times,* covering the war that would launch his career. In the aftermath of the battle of Hue, one of the bloodiest episodes of the war, he photographed the body of a North Vietnamese soldier. In the foreground, beside the man's body, is a scattering of personal possessions. As well as a small pouch of bullets, there are photographs of loved ones and a hand-written note. McCullin is open about the fact that this was the single incident in his career when he interfered with a scene before photographing it. 'I saw his body being looted,' he says, 'picked over by these Americans who called him a gook, and when they kicked his stuff away and left, I thought, no, this is not right.'[4] He decided to 'speak' for the dead man by arranging the humble mementos of his personal life in a way that would impact the viewer most directly. This included turning the photographs face up and aligning them with the camera's point of view.

Here are two situations in which a photographer intervened to control the appearance of an image beyond what they found in front of them. One resulted in shame and retribution, while the other is celebrated as a reflection of the photographer's humanity. One was manipulated after the photograph was taken, the other before. One freely admitted his intervention, while the other did not. But ethically speaking, are they really so different? Both photographers were motivated by personal agendas in a context of war, using their work to emphasize acts of violence that they saw as unjust. Both created scenes that are in a sense fictional, but using elements that were already present and 'real' (one duplicating them, the other moving them around). Both are exaggerations rather than outright falsehoods.

This is not to suggest either that McCullin should be judged for what he did or that Hajj should not have been punished for professional misconduct, but to draw attention to the instability of the systems that we often use to decide what is real and what is not, and therefore what is ethical and what is not. To return to the language used by World Press Photo director Lars Boering, above, we often feel we know when a line has been crossed, but it can be very difficult to try to draw that line in advance. In the words of Sarah Kember, manipulated photographs pose a threat not to our perception of reality itself but rather to 'our investments in photographic realism'.[5] What often makes these debates so vociferous is not a desire for the 'truth' but a longing for photography to anchor our place in the world and create objective certainty where there can be none. In this sense photographs are like fetish objects, and our investment in them often has more do with habit and tradition than we might like to admit. Photographers have been disqualified from photojournalistic awards and competitions for exaggerating the colour saturation in their pictures, for example, but it would be unheard of to apply the same judgement for the use of black and white film, which is much further from the 'reality' of normal vision but is taken for granted simply by virtue of history and convention.[6]

McCullin's intervention also raises the question of 'staging' – a kind of manipulation that takes place before a photograph is taken, by influencing the elements

of a scene, rather than afterwards in the darkroom or the digital editing process. It is a kind of manipulation that is much more difficult to arbitrate for a variety of reasons, from its technical untraceability to the relative, subjective and very human conditions of a photographer's participation in the world which they photograph. There is, in the professional viewpoint of many photographers, an accepted prerogative to alter the scene in front of the camera not in order to deceive but more fully to represent the reality of a situation. For Alfred Eisenstaedt, covering the V-J Day celebrations in New York City in 1945, for example, there was no question of dishonesty in his decision to ask a sailor to embrace a nurse so that he could make a picture that conveyed what was for him the true nature of that time and place. Though there are a variety of versions of this story (including one in which the sailor was walking down the street kissing a number of different women, and was captured by the photographer in the process), the revelation that the famous 'Times Square Kiss' may not have been a spontaneous moment, but a constructed one, is for some viewers enough to spoil its authenticity and discredit it as an historic document of any kind. But for Eisenstaedt, having the vision and skill to construct such symbols was simply his job, and was no more artificial than the choice of where to position himself, what to omit in the framing of a scene or which camera to use. In the words of David Levi Strauss, 'the truth is that every photograph or digital image is manipulated, aesthetically and politically, when it is made and when it is distributed'.[7]

Assertions that photography should be 'real', 'true' or 'unmanipulated' depend completely on what we consider to be 'reality' in the first place. Reality is, of course, highly subjective, but the expectations often put upon photojournalism are rooted in a way of thinking that does not make much allowance for this. Positivism, or belief in 'the unproblematic existence of an observable external reality and a neutral, detached and unified observing subject', is the system of thought on which most accepted rules about photojournalistic editing and manipulation are predicated.[8] There is a kind of double paradox here: we want reality to be depicted in a fixed and stable way, when it is in fact endlessly unstable and contingent, and we want a system of rules for that depiction which is clear and universal, but photography is a social and cultural language, not simply a mechanical process, and so trying to contain it within such a system is, as the saying goes, a bit like herding cats.

Picturing violence

In the introduction to his 1998 book, *Body Horror*, John Taylor sets out his position on the visibility of violence and death in the press. This is an ethical question that, unlike the previous ones, is generally the preserve of photo editors rather than photographers. He argues that

governing or censoring the publication of news photographs has implications for knowledge in liberal democracies. Certain kinds of deliberate gaps in the photographic record not only shape the meaning of terrible events but also imply gaps in knowledge filled by news that does not disturb so much as settle minds.[9]

Unlike discussions that involve seemingly clear codes of ethics or universal editorial policies, decisions regarding the representation of human death and bodily violence are, more often than not, treated according to a kind of situated ethics – judged on the specifics of their own social and political contexts, or the subjective intuition of individual editors.

The aftermath of the September 11 attacks, for example, brought this sharply into focus. There was a striking range of responses to the deluge of horrific imagery that made its way onto picture desks around the world at that chaotic time, as editors had to decide what to publish and what to shield from public view. Jim Rutenberg and Felicity Barringer of the *New York Times* wrote, 'not since the Oklahoma bombing or the crash of a helicopter in Mogadishu, Somalia, have newspaper editors and television producers had so many images available that show the graphic deaths and dismemberments of Americans'.[10] Erik Sorenson, president and general manager of MSNBC, asked the question, 'When does realistic coverage of a tragedy cross the line into exploitation?', ultimately arguing that 'there were plenty of images that told the story without all of the gore'. David Westin, president of ABC News, put it a different way: 'the question is, are we informing or titillating and causing unnecessary grief? Our responsibility is to inform the American public of what's going on and, in going the next step, is it necessary to show people plunging to their death?' Ed Kosner, editor in chief of the *New York Daily News*, which had caused controversy days earlier by printing a picture of a severed hand, said simply, 'you can't do the story without doing the story. It's no time to be squeamish.' Commonly accepted standards of taste are the most obvious explanation for the almost complete invisibility of human bodies in the US news in this instance. At such a delicate time, it is understandable that editors were motivated by sensitivity, especially given the risk of viewers recognizing the remains of loved ones, perhaps even before having been notified of their deaths.[11]

Taylor and others have observed a tendency for British and American press editors (unlike those in other parts of the world) to adhere to a kind of gradient in the publication of violent imagery, running from local to distant, in which it is more common to see photographs of foreign or non-white casualties than local or white ones. This is changing, and, due not least to the increase in 'citizen photojournalism', in which photographs submitted by people already at the scene can allow for much more immediate coverage, violence is more visible than it used to be. But despite notable examples in recent years, such as the coverage of the Boston marathon bombing in 2013, which was relatively graphic in its picturing of injury, it is more common practice to picture a scene of death only after the bodies are out of sight. Most of the horror of these images lies in imagining either what has gone

before or what is outside the frame. But it is sometimes difficult to discern between the dishonest and the considerate. It is also difficult to discern between common decency in the face of grief, and manipulation for questionable political ends. This is the point that Taylor is making when he talks about potentially dangerous 'gaps' in knowledge and in the photographic record of violent events. The 1991 Gulf War is sometimes cited as one such episode, in which political motivations had a direct bearing on the openness of the press. So carefully stage-managed was this short and violent war that soon afterwards the philosopher and cultural theorist Jean Baudrillard wrote a book titled *The Gulf War Did Not Take Place*, a radical critique of the war's media representation, arguing that the war had been abstracted and sanitized to the point that it was practically fictional.[12] American audiences in particular were confronted not with direct visual evidence of the huge numbers of US military or Iraqi civilian deaths, but with impersonal, mechanical views that presented the war as a series of precision 'surgical strikes' in which there was virtually no human involvement at all, let alone 'collateral damage'. This was the first war that had ever been broadcast, seemingly in its entirety, via television. CNN provided rolling televised coverage, but the kind of imagery that dominated this coverage led to the war's being nicknamed 'The Nintendo War': infrared cameras mounted on

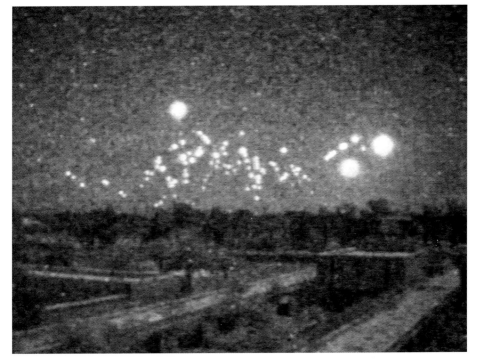

Figure 6.4 Low-light video camera shows tracer fire from anti-aircraft guns on 22 February 1991 in Baghdad, Iraq. The video was shot from the hotel room of CNN correspondents who remained in Baghdad during the Gulf War. (CNN/Getty Images).

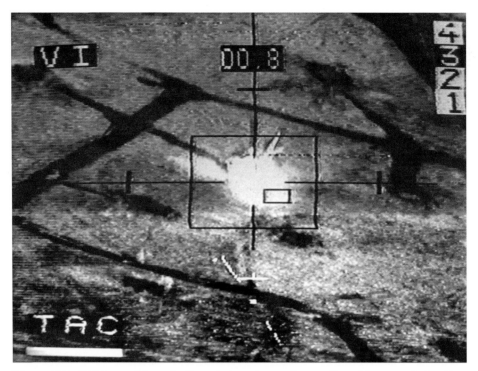

Figure 6.5 Still from video of a French Jaguar attack on a Kuwaiti target during the Gulf war in Kuwait on 18 January 1991 (0851/Getty Images).

unmanned drone aircraft showed missile strikes as nothing more than showers of pixelated green light (Figures 6.4 and 6.5). Orderly charts and maps illustrated the unfolding of the war as if it were a game that could not be lost, and when military personnel were pictured, they were silhouetted against sunsets, resting or training in the quiet of the desert.

But one incident came close to breaking this facade, when photographer Kenneth Jarecke witnessed the aftermath of a massacre of retreating Iraqi soldiers by American pilots on the road to Basra on 26 February 1991. Jarecke photographed the charred remains of a driver in his vehicle, one of hundreds whom the Pentagon later admitted had been deliberately burned alive. In Britain, the picture was printed by *The Observer* newspaper, but in the United States it remained invisible. In the photographer's own words,

> No one would touch my photograph. The excuse was that it was too upsetting, that people didn't want to look at that kind of thing anymore. The truth was that the U.S. press collaborated in keeping silent about the consequences of the Gulf War and who was responsible.[13]

This is a case in which the intuitive ethics of the photographer – to reveal uncompromising and brutal truths – who believes himself to be acting in the interests of the public and their right to knowledge, are in conflict with a much larger and

more complex apparatus, comprising the American state, military and media. It is not straightforward to separate the strands of investment, agenda and ideology that make up this apparatus, or even to separate it from Jarecke himself. But this kind of censorship is what Taylor has in mind when he argues that public squeamishness is never a politically or ethically viable excuse for keeping violence hidden. More specifically, as others including Elaine Scarry have also argued, images of this kind must be made visible in order not only for the public to be adequately informed but also for them to share in a general process of accountability for military action taken on their behalf.[14] When this possibility is withheld, the very fabric of a democratic society is weakened. Baudrillard goes further, implicating us in our own deception. The media's sanitization of the Gulf War was only possible, he says, because as audiences, 'we prefer the exile of the virtual … to the catastrophe of the real'.[15]

The moral value of witnessing

Many photographers, their representatives and their critics see 'witnessing' as a key feature of their role. For Peter Howe, a former picture editor at *Life* magazine, who has worked with many of the most significant photographers, 'the job of the photojournalist is to witness those things that people don't want to think about. When they're doing their job right, they are taking photographs that people don't want to publish by their very nature.'[16] Tom Stoddart published *I-Witness*, a monograph of his images from the world's trouble spots, and a recent Reuters multimedia presentation is simply entitled *Bearing Witness: Five Years of the Iraq War*[17] and claims that 'this is their testimony – bearing witness to ensure the story of Iraq is not lost.' The ability of the photojournalist to position their material across a range of outlets is key to their relevance today. Their resourcefulness and determination to first obtain the images and then to distribute them means that they remain in a privileged position above other sources of imagery. Despite the occasional interjections of amateur 'citizen journalists' such as 7 July 2005 bombings in London or the unearthing of trophy pictures as at Abu Ghraib prison, Iraq, in 2004, it is the professional photojournalist who remains the single most significant agent of testimony in contemporary visual discourse, creating the visual testimony that forms indelible evidence that these things happen. As such, their output forms a vital defence against ignorance, revisionism and attempts to deny the existence of abuse. As Julianne Newton warns, 'challenging the credibility of visual reportage is a dodge: If we do not believe an image, we do not have to deal with its message.'[18] Photographs can thus serve as anchoring points of civic discourse, providing visual locators of the existence of abuse and atrocity that cannot be so easily ignored. Errol Morris, the documentary filmmaker who extensively explored the surroundings to the Iraq torture case, explains,

even if photography doesn't give us truth on a silver-platter, it can make it harder for us to deny reality. It puts a leash on fantasy, confabulation and self-deception. It provides constraints, borders. It circumscribes our ability to lie – to ourselves and to others. Pictures provide a point around which other pieces of evidence collect.[19]

The role of the photographic witness is often inextricably linked to a desire for social change and improvement. From the work of Jacob Riis and Lewis Hine onwards, the concept of 'shining a light' into dark places to eradicate injustice has been linked to the evidential force of the photographic image. Many photographers echo these sentiments. Susan Meiselas maintains that she feels part of a 'tradition of encounter and witness – a 'witness' whose work has been based on a concern about human rights violations'. Meiselas asserts a widely held position, that there is a forensic aspect to the images produced in human rights work, stating that for her the 'essence of documentary photography has always had to do with evidence … when you are working with evidence – say, when you are digging up grave sites – you don't want people to think that it's conceptual art, an installation, or that it's just invented'.[20] However, this role of witness is complex, and Meiselas articulates some of the self-reflexivity necessary in this role in her understanding of the potential problems in the act of witnessing, arguing that 'the other side of "witness" is that we do intervene, and we intervene by the fact of our presence in a particular place. We change how people see themselves sometimes and how others may come to see them. I'm also concerned about how we see ourselves in the process of our role as witnesses.'[21] In this she highlights the ongoing dilemma for photographers of suffering: the interplay between the desire to engender a social good – the ending of exploitation, discrimination or extermination – with the desire not to expose the victim to further unnecessary suffering, either in the performative act of being photographed or in the reperformative act of displaying that image to an audience. The potential ethical reward for exposing the injustice visually therefore has to be balanced against the potential ethical penalty of revictimization.

The depiction of violence and suffering is therefore caught in a paradox of representation. The more degrading or acute the trauma, the more the potential subject might be seen to be revictimized by the act of representation and the less able they might be to give active consent to such an act. However, from the point of view of the social and moral good that witnessing might entail, the more violent that trauma becomes, the more valuable and important it becomes that the trauma is witnessed. This is the continual dilemma of the witness to atrocity: the more desperate and debased the story, the more significant it becomes and the more necessary and likely it is to be reported. Images of suffering, trauma and atrocity are therefore deeply problematic, in that they potentially create a tension between form and content and are often accused of revictimization, compassion fatigue, exploitation and the aestheticization of suffering. How to resolve this dilemma has been a major question for critics and practitioners alike. The role of witness, and in particular the concept of bearing

witness, may offer a coherent and morally supportable position that answers many of the critiques of the genre already explored.

Deriving from the Old English word meaning knowledge or testimony, a 'witness' has first-hand knowledge about an event in a sensory capacity, either through sight, hearing, smell or touch, and can certify in some capacity what may or may not have occurred. An eyewitness is a person who was directly able to observe the event; such testimony is commonly held to be more valuable and believable than that of a secondary witness whose testimony is considered to be hearsay. The expert witness is someone who by virtue of their qualifications or professional experience is able to comment on or elucidate a piece of evidence, either validating it or discounting it according to what is perceived to be a sound basis for judgement. The testimony provided by witnesses is central to the production and validation of knowledge about events, but the evidential nature of such testimony is often suspect, especially under close cross-examination. Certain witnesses are seen to be trusted more than others. Conclusions are then based on reviewing the testimony of one or more witnesses who are trusted or not trusted to varying degrees, creating a 'network of witnesses' who are ranked according to their credibility. For the moral philosopher Avishai Margalit, this generates a 'hierarchy of witnesses', comprised of 'different people we trust and mistrust with respect to different things'.[22] This integrity of the witness must be separated out from the concept of the truthfulness of the testimony, as truth is perhaps less important in the context of witness testimony than authenticity. What can be called the authenticity of subjectivity operates here, such that what is sought from a witness is a personal account of an event.

However, the visual is often afforded a sense of cultural primacy in this regard. That is, seeing something is felt to be more valuable than hearing it. This perhaps contributes to the sensitivity demonstrated towards the photograph as a witness because it operates as a visual, spatial and temporal prosthetic, giving the opportunity to see things from places and times that the viewer is unable to see for themselves. As humans are limited in their ability to personally observe events, they are heavily reliant on information about the world that is conveyed to them by the testimony of others. By the simple nature of the concept, the eyewitness' testimony must be fragmented and partial. One cannot be in more than one place at one time; one cannot observe an event from multiple viewpoints simultaneously. Any eyewitness testimony by default must be a testimony of absence as much as presence, a testimony that excludes other possible vantage points as it validates the one vantage point of the eyewitness him or herself. Together with the authenticity of subjectivity, the fragmentation of eyewitnessing becomes central to the argument about the role of photography in documenting atrocity that it is as much about the absences that it reveals as the presences that it frames.

The photograph thus carries a certain kind of testimony about past events. This is a multiple testimony, in that it offers the viewpoint and experience of the photographer

but also describes the subject photographed. The image itself then also has its own testimonial history, as it is circulated and exchanged, published and presented, and critiqued and commented upon. Images potentially go beyond the testimony of the photographer or the subject; they in a sense obtain their own independent testimonial function. They provide evidence that such an event happened to such a person at such a place and time, but they can go beyond that, representing an archetypal event. They can bear witness to a class of events, such as the plight of refugees worldwide, as well as to a specific event itself, such as the fall of Srebrenica. Their testimony thus arguably transcends the immediate moment and becomes something more about human nature and history, about the propensity to cause harm to others. Eyewitness testimony has long been afforded the highest level of authority in testimony, but it is also often the most critiqued form in terms of its subjectivity and necessarily limited evidential base.[23]

A proxy witness can be considered as someone to whom the rights of the witness have been transferred by a victim who is unable to bear witness themselves, or who wishes to share the burden of witnessing by delivering their testimony to a third party. The right to present the testimony of the primary witness as authentic victim is transferred to the proxy, who thus assumes the same claims to legitimacy as the original victim. This is a vital axis of transference in terms of the role of the journalist or photographer in representing the experiences of others, as it endows upon the reporter a sense of moral obligation and purpose to act as such a proxy witness, effectively becoming a prosthetic for the actual witness. This is a significant point, as a subject can be at once a victim and a witness; they can demand that their testimony be heard, but without a means to address the external audience this right is nullified. The reporter thus serves as the proxy witness. They are present largely because of a set of professional concerns rather than practical ones, but they represent possibly the best chance that the subject has for their testimony to be heard on a larger scale. This returns to the idea that the act of witnessing (like the act of photographing) is performative; it demands an audience.

At its heart, the act of bearing witness has a moral content that differentiates it from the evidential nature of judicial witnessing; it is concerned more with acknowledgement of the suffering of the victim and the need for justice than it is with necessarily achieving such justice through legal enforcement. As such, it is bound up with memory, remembering and respect more than factual accuracy. It involves an exchange between victim, witness, testimony and audience that implies a demand for moral restitution, even if such restitution simply consists in maintaining the sense of the victimhood in the present. Barbie Zelizer defines bearing witness as an 'act of witnessing that enables people to take responsibility for what they see',[24] whilst for communications theorist Carrie Rentschler it has an almost physical dimension, with witnessing becoming a 'form of bodily and political participation in what people see and document'.[25] The psychologist and Holocaust survivor Dori Laub, writing of his experiences interviewing other Holocaust victims, concurs that bearing witness

is, at its essence, a collaborative, communicative, performative act, noting that 'testimonies are not monologues; they cannot take place in solitude. The witness are talking to somebody.'[26] The philosopher Jeffrey Blustein argues that an act of abuse is a form of message to the victim and to society in general, such that

> serious moral wrongdoing does not just violate the rights of the victim to non-interference. It is also a communicative act that expresses this: you (the victim) are of no account, morally speaking, or do not count as much as I do, and you may be used in whatever way I see fit.[27]

Bearing witness can therefore counteract this violation by confirming the status of the victim as a member of society with moral rights. Giving the victim representation restores the victim as worthy of attention. In doing so, the witness asserts the universality of victimhood, the possibility that it could happen to any one of us. The act of witnessing itself is therefore intrinsically morally valuable, even if it lacks an audience that knows about it. The focus of the debate thus shifts away from any potential value witnessing may have in altering the audience's engagement with the issue and onto the potential value of the act of witnessing in and of itself, divorced from any positive or negative byproducts. Ariella Azoulay argues that the 'duty to watch as spectators is at the same time both the duty to resist injury to others who are governed and the duty to restore the civilian skill of spectatorship: to be an addressee of this injury, to produce its meaning as injury, and to continue to address it'.[28] That this 'sober hope' is necessary in scenarios of extreme distress and suffering is evidenced by the experiences of many Holocaust survivors, as this account from the Warsaw Ghetto explains: 'A great deal more of the bearing of witness was done without such hope for immediate results, indeed with often only a slight hope that the record would itself survive. The duty to memory – to universal memory – prevailed.'[29] The testimony then becomes a symbolic statement that retains its relevance long after the atrocity has passed into history. The photographic image, with its ability to encompass both referential and imaginative elements, is unusually well suited to perform such a symbolic role. Its durable, material persistence, allied with its mobility through space and time, allows it to become a focal point around which the ethics of memory can coalesce.

The moral gaze

At this point it will be useful to explore how the act of seeing itself can be categorized in terms of its moral value. The film theorist Vivian Sobchack, whose categorization of differing types of the 'gaze' of the camera in documentary film aligns with the ideas proposed by Bill Nichols and Taylor,[30] has suggested a more theoretical presentation of how the act of witnessing an event might be understood in terms of its ethical stance. The moral position of the observer is therefore affected by their ability to intervene and

the degree of their professional involvement, and can be assessed variously as 'acciden-tal', 'helpless', 'endangered', 'interventionist', 'humane' and 'professional or 'clinical''. The obvious categorization of the photojournalist would at first glance appear to be that of the 'professional' gaze, that Sobchack describes as 'technical and machine like com-petence in the face of an event which seems to call for further and human response'.[31] Nichols maintains that the responsibility of the professional is to the 'greater good', a responsibility that absolves him or her from the contrary responsibility as a human to intervene, such that the civic 'right to know' is 'best served by letting events take their course, even events planned specifically as media events from the start'.[32] In add-ition, the photojournalist could clearly fall into the category of the 'endangered' gaze, whereby sharing the same hazards as the subject imparts a certain moral legitimacy.[33] However, upon closer reflection on these categories, it could be argued that depend-ing on circumstance a photojournalist's stance could fall into any one of the potential 'gazes'. Indeed, examples abound. Eddie Adams's photograph of the street execution of a suspected Viet Cong could be categorized as both 'accidental' and 'helpless' in that when he raised his camera to his eye to follow the similar movement of Lieutenant Colonel Nguyen Ngoc Loan's pistol to the head of Nguyen Van Lam, Adams expected him just to threaten the prisoner, a tactic that was common in the conflict. The pho-tographer was thus an accidental and helpless witness to the killing. Probably the cir-cumstance that engenders the most debate is that of the interventionist gaze, that is to say, should there be a point at which the camera is lowered and the operator breaks through the 'fourth wall' into the action itself. Many instances of this moral dilemma are well documented, and the debate around whether a journalist should intercede in a situation has been extensively explored by Paul Lester (1996), amongst others. Rather than attempting to provide a blanket ethical code for intervention, it might then be more fruitful to investigate individual situations where the photographer has been faced with a choice to intervene or not, and the subsequent consequences of that act. Adams was unable to act because the whole scenario played itself out so quickly, but there are other examples of public executions, notably that of prisoners killed by sol-diers of the Pakistani army in a football stadium in 1973, where several photographers felt that their presence was being exploited by the army and left, whilst others stayed to document the killings. Describing how he reacts to moments when he is faced with the difficult decision of whether or not to intervene, James Nachtwey explains how his role as a journalist justifies his presence and therefore lessens his responsibility because there are generally others there who are better qualified to give assistance:

> But most often, when there's a soldier wounded, they're tended to by their own com-rades or a combat medic, in which case my getting into it would be superfluous. My job is to record it and communicate it. And I stick to that except in those cases where I'm the only one who can make a difference – if there isn't someone there to help or there aren't enough people to carry the wounded to a safe place … When it's clear to me that I'm the one person who can make a difference, I put down my camera.[34]

This defence is one to which other photographers have laid claim as well, and whilst it does not absolve the photographer of all responsibility towards the immediate suffering of their subject, it does create a morally complex question. What should be the journalist's role in intervening directly in situations of harm? Should there be a Kantian imperative that one must take action in every case, or conversely that to preserve one's journalistic independence and integrity, one should never take action? It is worth considering what Nachtwey has to say on the subject of covering famines:

> when we're photographing victims of starvation, we're not just walking away from them and leaving them there without food or help. We're photographing the famine victims in feeding camps and feeding centres that have already been established by humanitarian organizations. They are already being helped as much as they can be helped at that time. If there has ever been a time when I've discovered someone during a famine who was not at a feeding center, who couldn't reach it or couldn't find it, I would take them myself. And I think any journalist would.[35]

Indeed, far from behaving like voyeurs who encourage acts of violence that would otherwise have not occurred, photographers have actively intervened into situations when it seems appropriate. In an article in *News Photographer*, Hale and Church cite seventeen instances of the `Helping Hands' of photographers who downed their cameras to assist those in need.[36] Nick Ut's picture of the naked Kim Phuc suffering from the effects of napalm burns at first sight appears to have all the detachment of the professional gaze, but the television footage of the event shows Ut downing his cameras as Kim approaches, taking her in his arms and soothing her burns with water from his bottle.[37] Ut then went on to befriend Phuc and was instrumental in her obtaining medical treatment and subsequently gaining asylum in Canada.[38] This case is perhaps the most extreme example of another common trend, that of the intervention of the journalist after the traumatic event to rescue the victim, but there are many more. For example, the American photographer, Chris Hondros,[39] photographed an Iraqi child whose parents had been shot by US troops who mistook the car they were travelling in for a suicide bomber. He then later intervened to evacuate the child to the United States for treatment[40] In addition, closer research into many of the situations of public executions, for example, reveals that they were not isolated events staged merely for the cameras but were usually a part of a wider, more systematic pattern of violence. The lack of response of the soldiers accompanying Lieutenant Colonel Nguyen Ngoc Loan to his summary dismissal of Nguyen Van Lam was explained by one of the men, who reportedly claimed that 'he does this all the time'.

However, it is in the 'humane gaze' that photojournalism may find its greatest potential for justification. Nichols characterizes it as an 'extended subjective response to the moment of death or process of death that it depicts' that 'stresses a form of empathic bond across the barrier between the living and the dead (or those whose

death is imminent and those whose death is, as yet, unforeseen)'.[41] This bond creates a reversal of the 'helpless gaze'. Instead of being unable to offer any succour, the 'humane gaze' allows subjective emotions to 'stream outward, toward the dead or the dying'.[42] This flow of humanity from the photographer toward the scene produces a 'structure of feeling', creating an ethical space where the photographer's emotional response projects onto the subject and is then reflected back onto the viewer. This externalizing of the author's emotions into a concentrated form, that of the photograph, heightens the potential for the viewer to connect with the viewed, providing a 'dramatic enactment of specific positionings, postures and gestures that communicate emotional reactions instantly' that then 'create interactions that become circuits for emotional exchange'.[43] As Taylor argues,

> The presence of imagery and reports means that forgetting or refusing to see them becomes a deliberate choice, a conscious act of choosing ignorance above knowledge. There is a big difference between never finding out and choosing to forget: the latter involves the recognition, and then the spurning, of unwelcome information. Body horror provides this service in public spheres of controversy, with photographs relaying evidence of what has been for people to judge for themselves.[44]

This feedback loop is a vital part of the communication; the humane gaze of the photographer becomes the humane gaze of civic society, from whom the subject demands an emotional response. Once seen, it cannot be ignored. Azoulay's argument for the civic value of photography is again relevant here. She asserts that what she terms the 'civil contract of photography' binds together all the agents in the production and dissemination of the image in a form of moral contract, such that 'in the political sphere that is reconstructed through the civil contract, photographed persons are participant citizens'.[45] Judith Butler's concept of grievable and ungrievable lives is also extremely useful at this juncture. The non-recording or recording of a life, the witnessing or non-witnessing of a life or the testimony or non-testimony to a life can thus be one way to determine whether a life is grieved or not, or has the capacity to be grieved. The photographic image's relation to time, both in terms of time past but also time preserved into the present, allows it to act as the perfect marker to acknowledge a grievable life:

> Is this quality of 'absolute pastness' that is conferred on a living being, one whose life is not past, precisely the quality of grievability? To confirm that a life was, even within the life itself, is to underscore that a life is a grievable life. In this sense the photograph, through its relation to the future anterior, instates grievability.[46]

For Newton, such a visual testimony is also an act of remembrance, such that 'not being seen is a violation. To have died such a death and be unseen is like another death, akin to having never existed.'[47] If such acts of abuse are consciously not recorded for fear of extending the abuse, then surely that act of non-representation

is at least as cruel as representation itself. Indeed, even if the image depicts a moment when the victim has been failed by wider social forces, it can still perform a vital ethical function. As Wendy Kozol argues, 'visual encounters that stage a confrontation with moral failure can themselves foster an ethics of recognition of the humanness of others while contending with the spectator's own gaze'.[48] The results of media witnessing may also not be immediately apparent, and they might make their influence felt in tangential ways on the viewer. Zelizer maintains that audience engagement

> might have no pragmatic effect on action yet still be meaningful for people. Surprisingly, it might lead nowhere obvious in the short term yet play a part in moving people over time. Generating variant interpretations, vigorous debates, and contingent and imaginary conversations, engagement appears to have proceeded here on different terms, even when the accompanying informational detail might have been expected to shut down its corresponding interpretive flux.[49]

Bearing witness to abuse therefore has a significant and worthwhile moral purpose that remains valuable even if no immediate action is taken as a result of the testimony provided.

Further reading

On picturing violence

Azoulay, Ariella. (2012). *The Civil Contract of Photography*. Cambridge, MA: MIT Press.

Baer, Ulrich. (2002). *Spectral Evidence: The Photography of Trauma*. Cambridge, MA: MIT Press.

Batchen, Geoffrey, Mick Gidley, Nancy K. Miller and Jay Prosser (eds) (2011). *Picturing Atrocity: Reading Photographs in Crisis*. London: Reaktion Books.

Butler, Judith. (2009). *Frames of War: When Is Life Grievable?* London: Verso.

Didi-Huberman, Georges. (2008). *Images in Spite of All*. Chicago: University of Chicago Press.

Kamber, Michael. (2013). *Photojournalists on War*. Austin: University of Texas Press.

Kozol, Wendy. (2014). *Distant Wars Visible: The Ambivalence of Witnessing*. Minneapolis: University of Minnesota Press.

Lester, Paul (ed.) (1996). *Images That Injure: Pictorial Stereotypes in the Media*. Praeger: Greenwood.

Lester, Paul. (1991). *Photojournalism: An Ethical Approach*. Hillsdale, NJ: Lawrence Erlbaum.

Linfield, Susie. (2010). *The Cruel Radiance: Photography and Political Violence*. Chicago: University of Chicago Press.

Perlmutter, David D. (1998). *Photojournalism and Foreign Policy: Icons of Outrage in International Crises*. Westport CT: Praeger.

Reinhardt, Mark, Holly Edwards and Erina Duganne (eds) (2006). *Beautiful Suffering: Photography and the Traffic in Pain*. Chicago: University of Chicago Press.

Sontag, Susan. (2004). *Regarding the Pain of Others*. London: Penguin.

Stallabrass, Julian (ed.) (2013). *Memory of Fire: Images of War and the War of Images*. Brighton: Photoworks.

Taylor, John (1998). *Body Horror: Photojournalism, Catastrophe and War*. New York: New York University Press.

Zelizer, Barbie. (2010). *About to Die: How Images Move the Public*. Oxford: Oxford University Press.

On manipulation and staging

Campbell, David. (2014). 'The Integrity of the Image', World Press Photo, November, http://www.worldpressphoto.org/sites/default/files/docs/Integrity%20of%20the%20Image_2014%20Campbell%20report.pdf.

Kember, Sarah. (2003). 'The Shadow of the Object: Photography and Realism'. In *The Photography Reader*, edited by Liz Wells. London: Routledge.

Mitchell, W. J. T. (1994). *The Reconfigured Eye: Visual Truth in the Post-Photographic Era*. Cambridge, MA: MIT Press.

Newton, Julianne. (2000). *The Burden of Visual Truth: The Role of Photojournalism in Mediating Reality*. London: Routledge, pp. 202–15

Ritchin, Fred. (2008). *After Photography*. New York: W. W. Norton.

On witnessing

Frosh, Paul, and Amit Pinchevski (eds) (2009). *Media Witnessing: Testimony in the Age of Mass Communication*. London: Palgrave Macmillan.

Margalit, Avishai. (2002). *The Ethics of Memory*. Cambridge, MA: Harvard University Press.

Nichols, Bill. (1991) *Representing Reality: Issues and Concepts in Documentary*. Bloomington: Indiana University Press.

Sobchack, Vivian. (2004). 'Inscribing Ethical Space: Ten Propositions on Death, Representation, and Documentary', in *Carnal Thoughts: Embodiment and Moving Image* Culture. Berkeley: University of California Press.

Zelizer, Barbie. (1998). *Remembering to Forget*. Chicago: University of Chicago Press.

7
Aesthetics

Chapter summary

The relationship between the content of photojournalistic images and their aesthetic form is a continuing point of debate. This chapter considers the various aesthetic strategies deployed by photojournalists and their impact on the ethics of the practice as well as on its storytelling function. Henri Cartier-Bresson's concept of the 'decisive moment', for example, has shaped the methodologies of countless photojournalists. The implications of this are explored here, as well as other developments such as the identification in the 1980s of the 'New Photojournalism', in which a more subjective, less descriptive approach was adopted by photographers such as Susan Meiselas and Gilles Peress. This leads to a discussion of the shifting relationships between documentary photography, the gallery space, book publishing and photojournalism. As with the previous discussion of changing technologies, each of these different aesthetic choices has crucial conceptual and cultural implications for the understanding of photojournalism.

'The taint of artistry'

In her 2003 book *Regarding the Pain of Others*, Susan Sontag writes that 'for the photography of atrocity, people want the weight of witnessing without the taint of artistry'.[1] Her remark points towards a tension that often colours the discussion of photojournalism, particularly when it comes to the photography of war. Sontag's view – and she is not alone – is that the best photojournalism can and should be firmly dissociated from 'art' by a commitment to a kind of plain, unadorned, anti-aesthetic 'truth'. In recording situations of grave suffering or injustice, the photographer must resist the pull of aesthetic refinement, and especially of beauty, because these things are 'equated with insincerity or mere contrivance.'

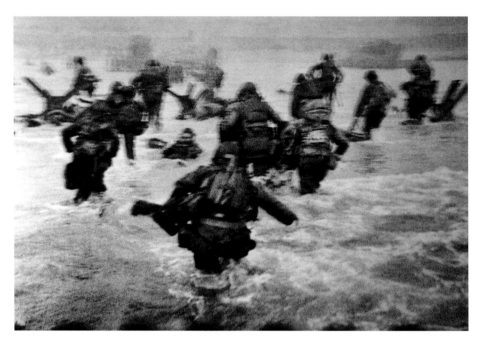

Figure 7.1 Robert Capa, 6 June 1944, US troops assault Omaha Beach, Normandy, France. (International Center of Photography/Magnum Photos).

A photographer who is often held up as an exemplar of this kind of 'pure witnessing' is Robert Capa. Among his most celebrated work is the small handful of photographs he brought back that were taken at Omaha Beach on 6 June 1944, scene of the first wave of the D-Day landings at Normandy (Figure 7.1). Capa was the only photographer present to record this most pivotal moment of the Second World War. His photographs show US troops waist-deep in the surf, struggling towards shore at impossibly close range: Capa is not only bearing the 'weight of witnessing' but he is bearing great personal danger too. Most of the pictures are blurred, shaky and seem very hastily composed, or not consciously composed at all, but rather snatched from a sequence of events that was chaotic, fleeting and terrifying. Capa was, these images seem to say, too busy staying alive and getting the story to worry about anything as superficial as composition or even focus. They have gone down in history as the definitive representation not only of this particular event but also of what 'war photography' in general should look like. Rough, hasty, unself-conscious, these are the qualities that, according to Sontag's logic, give these and all good conflict photographs their integrity – as if aesthetic failure is the mark of their authenticity.

But this is only part of the story. Capa is rightly famous for his fast-paced 'frontline' conflict photography – one of his other most well-known images is of a Spanish militiaman supposedly at the split-second of death during a gunfight, purportedly taken without even looking through the camera's viewfinder[2] – but he also knew perfectly well how to compose images of great aesthetic sensitivity and elegance even under pressure. His overquoted mantra 'if your pictures aren't good enough,

you're not close enough' is usually understood to refer to proximity to danger and action, but a closer look at the rest of his oeuvre indicates that he is just as likely talking about emotional closeness and identification with the humanity of his subjects. His coverage of the 1938 aerial bombing of Barcelona, for example, is full of poignant, sensitive, portrait-style images of civilians negotiating their daily lives. Here, even the quintessential war photographer shows us that trying to draw a line between photojournalism and 'art' is at best a difficult exercise. And the story of the Omaha Beach pictures is more complicated, too. On that day Capa took four rolls of film and made 106 exposures, but, as the story goes, in the rush of the aftermath a darkroom technician at *Life* magazine's London office overheated the film, destroying all but eleven of the negatives. Who knows what pictures were in those lost rolls? Maybe there were some perfectly composed views, or maybe not, but the chances are that if Capa and *Life*'s editorial team had had the full 106 to choose from, the images that now make up the remaining 'Magnificent Eleven' would have remained on the cutting-room floor. An accomplished photographer such as Capa would surely have recognized that for the most part, they are simply not conventionally 'good' photographs. It is an accident of history that has made them famous, and in turn helped secure the idea of a separation between aesthetics and authenticity in photojournalism.

Art, aesthetics, beauty

Some photojournalists take it for granted that their work is inseparable from art and even see it as a mark of esteem for an image to be given that label. For them, the implied definition of art itself is associated with a kind of compositional skill or beauty that amplifies, rather than 'taints', the meaning of their work. For others, the label of 'art' is firmly rejected and taken as antithetical to their purposes. In both cases, however, there can be a slippage between the terms 'art' and 'aesthetics', which are not the same thing.

As a field of philosophical enquiry, aesthetics has, since Greek antiquity and through to the writings of G. W. F. Hegel, been closely bound up with ideas of beauty. For Plato and Aristotle, beauty meant harmony, unity, order and symmetry, all of which can be read directly as principles of pictorial composition. In more recent times, aesthetics came to be defined on a more abstracted level extending beyond the visual arts, referring to the quality of feeling or sensory experience that an object or text evokes.[3] Postmodern aesthetic theory, in contrast, has at times been preoccupied with a rejection of the close traditional relationship between art and beauty, recognizing that the role of art is to disrupt and agitate rather than to appease our sense of order with objects that are 'aesthetically pleasing'.[4] Whatever the modern, postmodern or contemporary academic definition of aesthetics, however, its earliest

associations with formal beauty have stuck, and when the word is used in relation to photography, this is what is usually meant.

On the question of beauty and photography, the great American photographer Robert Adams writes, 'why is form beautiful? Because, I think, it helps us meet our worst fear, the suspicion that life may be chaos and that therefore our suffering is without meaning.'[5] This points very precisely to the function served by beauty in much photojournalism: to create order where there is indeed chaos. Some of the most famous (or 'iconic') photojournalistic images are those that take disordered and senseless events (the Vietnam War, the Great Depression, terrorist attacks) and render them orderly by means of formal composition (Figures 7.2 and 7.3). These images tend to have such strong cultural appeal because, as Adams suggests, they give us hope, beyond the specific circumstances depicted, for the world at large and for ourselves. The problem with

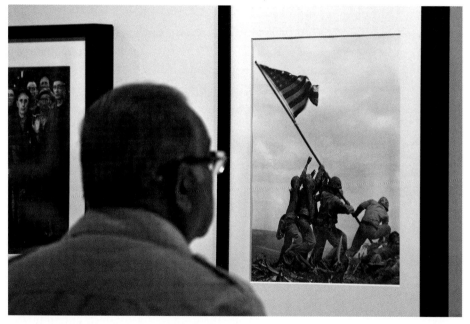

Figure 7.2 Gabriel Bouys, 30 April 2013, A visitor looks at Joe Rosenthal's *Raising the Flag on Iwo Jima*, in Rome (Getty Images).

Joe Rosenthal's famous photograph of the flag raising at Iwo Jima, Japan, 1945, is an image that has become 'iconic' by virtue of a combination of elegantly arranged formal qualities with potent cultural symbolism. In the manner of Cartier-Bresson's 'decisive moment', both of these factors have come together to form an ideal photographic composition. In such cases, the aesthetic power (which here is also political power), transcends the actual photographed moment such that any 'truth value' it might hold as a document is eclipsed; its value becomes instead symbolic, representative of a whole range of powerful abstractions including victory, patriotism, masculinity, glory and cooperation.

this, however, which has something to do with Sontag's complaint against 'artistry', is that it is often, at best, a convenient semi-fiction. One of the reasons why beauty is such a fraught concept in relation to photojournalism is because presenting the world beautifully often involves simplifying it, or even distorting it beyond all recognition.

Differing accounts of whether or not photography can, or should, aspire to the status of 'art' have circulated since photography's earliest days. Rarely featured within these discussions, however, is any attempt to accurately define what art *is*. They tend to be driven instead by reductive assumptions and even (for those who feel that the values of art are in opposition to the values of journalism) prejudice. A brief rundown of characteristics that are routinely perceived to set photojournalism apart from art might include

- aesthetic value (understood to mean formal beauty);
- subject matter (some subjects belong to the realm of art; others do not);
- intention (it's art if the artist says it's art);
- location (it's art if it's put in an art gallery);
- captioning (as above, the language and discourse that surround an image dictate its reception);
- commercial value (photography within the 'art market' is valued very differently from that in the editorial market); and
- objectivity versus subjectivity (the former belongs to photojournalism, the latter to art)
- reality versus fantasy (as above)
- directness versus obscurity (photojournalism is readily 'readable' and easy to understand; art is esoteric, nuanced, and obscure).

This list is by no means intended to be taken seriously as a set of definitions. On the contrary, it highlights the precariousness of such attempts at categorization. Applying this list to any actual images will hopefully demonstrate this fairly easily, showing how quickly knee-jerk ideas about the relative territories of art and photojournalism begin to disintegrate when we really interrogate them.

Form and function

The story of early photography's relationship to art, and specifically to painting, is dominated by two main strands of debate. On the one hand, there were those who saw the arrival of photography as signalling the death of painting: what use was the skill of the painter or draughtsman when the camera could make infinitely more accurate depictions of the world instantaneously? Some viewed this as a tragedy, while for others it represented a new era for painting, setting it free from the figurative representation that had dominated it for centuries and making way for a whole

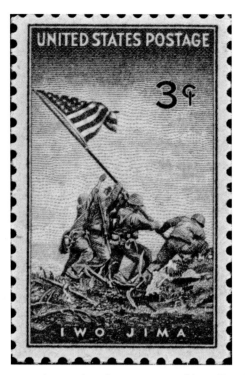

Figure 7.3 Postage stamp honouring the conquest of Iwo Jima island, 1945, depicting four marines raising the flag of the United States (reproduction photo by Joe Rosenthal) (De Agostini Picture Library/Getty Images).

new era of abstraction, impressionism and expressionism. On the other hand, there was the question of whether photography could ever hope to be called art in itself. If photography was a purely mechanical process, a passive imprint of reality, this then was the antithesis of art: no creativity, no autonomous vision or skill could be associated with it. The group that did most to resist and disprove this position were the pictorialists. Pictorialism was an international movement that thrived from the end of the nineteenth into the early decades of the twentieth century, promoting a style of photography that sought to manipulate, stylize and intervene in the photographic process in every way possible as a means of demonstrating the creative hand of the photographer at work. They overlaid their pictures with shadow and fog, painted their negatives with expressive brushstrokes, made use of soft focus, dramatic lighting and complex processes that resulted in varied mid-grey tones. Their subjects were predominantly romantic, sentimental and nostalgic, above all indicating a desire not only to compete with the creativity of painters past but also to formally imitate them using photography (Figure 7.4).

One of pictorialism's most influential American proponents was Alfred Stieglitz. As well as being a photographer, he was a well-connected curator and editor of

Figure 7.4 Henry Peach Robinson, 1863, *Autumn* (SSPL/Getty Images).

Camera Work magazine, who spent the early years of the twentieth century energetically promoting the association of photography with other art forms such as poetry and painting as well as his strong ideas about what set art photography apart from the 'snapshot' and other, less refined forms (epitomized by the mass popularity of Kodak and its advertising slogan, 'You Press the Button, We Do the Rest'). Everything changed for Stieglitz, however, when on board a voyage to Europe in 1907, he experienced, by his own account, a kind of photographic epiphany that challenged his entire view of photography's relationship to painting.

On board the *Kaiser Wilhelm II*, he looked down from the upper deck to the 'steerage' filled with lower-class passengers, most of whom were making the return journey from America after a failed attempt at building a new life (Figure 7.5). Here was a picture of social inequality, human drama and pathos, but Stieglitz was captivated most of all by its formal perfection:

> The scene fascinated me: a round straw hat; the funnel leaning left; the stairway leaning right; the white drawbridge, its railings made of chain; white suspenders crossed on the back of the man below; circular iron machinery; a mast that cut into the sky, completing the triangle. I stood spellbound for a while. I saw shapes related to one another – a picture of shapes, and underlying it, a new vision that held me: simple people; the feeling of ship, ocean, sky.[6]

This 'new vision' was all about photography's unique capacity to bring together such formal perfection with a capturing of social reality. What we might now call the

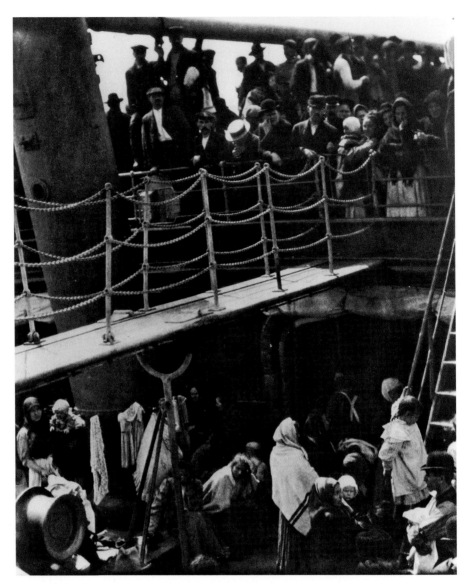

Figure 7.5 Alfred Stieglitz, 1907, *The Steerage* (Getty Images).

documentary value of this picture – the clear insight it gives into a social reality, which it captures and presents in a single frame – is made possible only by the play of geometric forms and details that so struck Stieglitz when he stood on the deck. This medium specificity – the thing that photography could do that no other medium could – was, as far as he was concerned from that moment on, the new standard for photographers. No social reality could be fully communicated without aesthetic perfection, and no truly beautiful photograph could avoid revealing some profound truth about the world. This, not the imitation of any past imagery or style, as the pictorialists had believed, was photography's purpose.

Though Stieglitz would never have identified himself as 'photojournalist', this example is a pivotal one in terms of understanding photojournalism and aesthetics. In complete contrast to Sontag's dismissal of lofty formal values that might 'taint' or compromise photography by obscuring its capacity to bear witness, what Stieglitz had struck upon and committed to promoting from this moment onwards was the impossibility of ever separating formalism from 'truth value'. The symbiotic combination of a commitment to communicating social reality on the one hand with the skill to create striking and memorable pictures on the other (whether this is called 'artistry' or not) has been the photojournalist's objective and the viewer's expectation ever since.

The decisive moment

In 1952, Cartier-Bresson wrote,

> To me, photography is the simultaneous recognition, in a fraction of a second, of the significance of an event as well as of a precise organization of forms which give that event its proper expression.[7]

This is the 'decisive moment'. In a sense, it is an articulation of the very same principle of photography's medium specificity that *The Steerage* had first epitomized forty-five years earlier. Cartier-Bresson had co-founded Magnum Photos (alongside Capa, David Seymour, William Vandivert and George Rodger) in 1947. This, together with the publication of his book *Images à la Sauvette* (translated for the English-language edition as *The Decisive Moment*), and his extraordinary skill as a candid observational photographer of social and political subjects all over the world, have secured his legacy for many as a 'godfather of photojournalism'. Like Stieglitz, Cartier-Bresson was famously dogmatic in his views regarding what good photography was and was not. He almost exclusively used a 35mm Leica rangefinder camera, in black and white, shooting mostly with the standard 50mm lens, and never with a flash. He almost never cropped or manipulated his images in any way, believing that the whole work of framing and composition should take place not in the darkroom or any kind of 'post-production' but in the viewfinder, in the 'fraction of a second' that separated the true photographer from the rest. He shot instinctively, but always aware that the aesthetics of the image were inseparable from its meaning and its emotional impact (Figure 7.6).

Cartier-Bresson's concept of the decisive moment, in which form and function are inseparable and upon which the whole weight of photographic meaning rests, has been profoundly influential among subsequent generations of photographers, and photojournalists in particular, because of its association with action. The idea that the visible world is filled with latent opportunities for the photographer to create an image that combines form and content in a perfectly constructed statement about a precise moment of time is a compelling one, and a goal to which successive generations of photographers have aspired, even as others have sought to deconstruct it and

Figure 7.6 Henri Cartier-Bresson, 1933, Seville, Andalucia, Spain (Magnum Photos).

challenge it. But as a concept, it has often been misunderstood. As John Szarkowski put it in 1966, 'the decisive moment is not a dramatic climax but a visual one: the result is not a story but a picture'.[8] It is perhaps ironic, given the territorial impulses that sometimes drive photographers to separate 'art' from 'photojournalism', that Cartier-Bresson, founding father of modern photojournalism itself, first trained as a painter and spent his most formative years steeped in the influences of the Parisian surrealist movement, finally rejecting photography at the end of his career in favour of a return to drawing and painting. Rigid and dogmatic as he was about the rules of 'good' photography, this shows that, ultimately, Cartier-Bresson's commitment was not to any specific category of picture making but to finding the combination of form and function that could capture the unique truths offered up by the visible world, moment by moment. 'People think far too much about techniques,' he wrote, 'and not enough about seeing.'[9]

The 'aestheticization-of-suffering critique'

Nowhere is the debate surrounding photojournalism and aesthetics more vehement than in relation to the depiction of human suffering. Poverty, famine, illness, violence

and pain are the territory of photojournalism, but their representation is fraught with ethical tensions. Debates about the 'aestheticization' of suffering have attended photojournalistic and documentary work for decades, in a discourse often held entirely separate from that of art and its boundaries, though the two are, of course, deeply connected. In the late 1980s, the writers and artists Martha Rosler and Allan Sekula, along with critic and historian Abigail Solomon-Godeau, were the most prominent voices in critiquing the work of photographers who, in their opinion, made the ugliness of suffering too beautiful. This attitude became so influential at that time, writes David Levi Strauss, that 'it became virtually impossible to defend documentary practice'.[10] To summarize, the argument was that, to represent the suffering of a human being in an overtly aestheticized manner results in readings that tend to be counterproductive to the values of documentary or journalism, doing a disservice to individual subjects' experience by transforming it into a image that, depending on its context of viewing, merely appeases the viewer and exalts the photographer. Another influential critic, Mieke Bal, writing about James Nachtwey's famous 1993 image of a starving Sudanese man, writes that 'beauty distracts, and worse, it gives pleasure – a pleasure that is parasitical on the pain of others'.[11] Strauss argues that this critical attitude resulted for several years in a kind of representational paralysis: if photographers were to be condemned for treating suffering subjects with the compositional skill and aesthetic value that were the hallmark of their profession, how could these subjects be photographed at all? And more importantly, how then could their suffering ever be brought to a public attention that might lead to its relief or at least bear witness to its injustice?

The photographer who is perhaps cited more often than any other in discussions about the 'aestheticization of suffering' is Sebastião Salgado. Salgado is a prolific and celebrated Brazilian photographer who has spent his career capturing great heights of beauty and depths of human suffering the world over. He is revered by many for the majesty and dignity that he affords to his subjects even in the midst of starvation, exploitation and illness. Adamant in calling himself a photojournalist and not an artist, Salgado is very sure of the category in which he sees his own work, but he is a somewhat controversial figure because the questions of form, function, intention and categorization surrounding his work are so complex. However bleak the subject matter, it is hard to talk about Salgado's work without using the word 'beauty'. For some observers and critics, this beauty does a disservice to the people in his photographs. One of his most well-known bodies of work, *Sahel: The End of the Road*, shows human beings on the very edge of survival (Figure 7.7). Following the lethal combination of drought and war that had spread across East Africa in the early 1980s, Salgado spent months in collaboration with the charity Médecins Sans Frontières (or Doctors without Borders), photographing displaced families from Ethiopia, Chad, Mali, Eritrea and Sudan as they crossed the desert in search of shelter and food. For some, this work, despite its humanitarian agenda, went too far in transforming the desperate suffering of real people into a vision of transcendent, timeless, even breath-taking

Figure 7.7 Sebastião Salgado, 1984, Korem Camp, from *Sahel: The End of the Road* (Sebastião Salgado).

aesthetic appeal. One of the most scathing of these critics was *New Yorker* columnist Ingrid Sischy, who wrote,

> Salgado is far too busy with the compositional aspects of his pictures – with finding the 'grace' and 'beauty' in the twisted forms of his anguished subjects. And this beautification of tragedy results in pictures that ultimately reinforce our passivity toward the experience they reveal. To aestheticize tragedy is the fastest way to anesthetize the feelings of those who are witnessing it. Beauty is a call to admiration, not to action.[12]

In this same article, Sischy highlights several of the other points of criticism that tend to be associated with the photography of suffering, identifying Salgado as guilty of them all: the pervasive use of religious imagery that invites a passive or redemptive reading of social injustice; the reductive transformation of individuals into universal symbols; the exaltation of the photographer above his subjects; and the distraction of attention away from content and onto form. Finally, there is the accusation that his images invite viewers into an attitude of self-indulgence, whereby we might end up congratulating ourselves for looking at such horrors when in fact the pictures are doing more to evoke pleasure in us than revulsion or outrage at the injustices that they depict.

Of course, this is just one side of the argument. Another view – and one which is much more widespread, especially outside the small circles of professional photography criticism – is that Salgado's aesthetic approach does not exploit his subjects but raises them up, affording them great dignity and respect and demonstrating

the resilience of the human spirit even in the most dire of circumstances. In this view his men, women and children are symbols, and they do transcend the reality of their circumstances: this is the very point and the value of his photographs, not an ethical failure. Rather than 'anaesthetizing', this is beauty that draws our attention to subjects from whom we might otherwise look away, holding it and causing us to engage with questions of social justice, environmental degradation and inequality in a media environment so saturated with imagery (much of it decidedly unbeautiful) that we rarely stop to look unless we are presented with something truly remarkable.

Authorship and affect

In March 1993, close to Ayod village in South Sudan, South African photojournalist Kevin Carter encountered a little girl. Naked, emaciated and tiny, she was struggling to crawl down a dirt road towards a United Nations feeding centre that had been set up nearby to aid victims of the famine that had engulfed the region. There are differing accounts of exactly what happened next, but the prevailing one is that when Carter saw a vulture land a few feet behind the girl, he crouched down to compose his picture, waiting patiently in hopes that the bird would spread its wings, amplifying the symbolic power of the scene. After twenty minutes in this position he gave up waiting, took his picture, chased the bird away and left. The resulting photograph has become somewhat legendary within popular and critical histories of photojournalism, partly because of the haunting poignancy of its subject but also because of the story that surrounds its making. The picture was published in the *New York Times* later that month, and met with a strong reaction from readers, hundreds of whom wrote to the paper asking what the fate of the girl had been. No one knew for sure the answer to this question, but witnesses say she was subsequently taken to the aid station, where she was fed and cared for. Soon, however, attention turned towards the photographer himself. How could he have failed to help the child instead of selfishly focusing on his own professional agenda (to get the best picture)? Surely this made him as much a predator as the vulture? The criticisms only intensified when the picture was awarded a Pulitzer Prize the following year. Was this worth a child's life? Within three months of winning the prize, Carter committed suicide. Witness to an unimaginable amount of violence in his short career (he died at the age of 33), it seems that a whole range of hurts and stresses had led him to this breaking point, but we can only assume that the legacy of the vulture and the starving girl had taken a special toll on him: one short encounter in which the weight of responsibility embodied by photojournalism had become too much to bear. And the weight of this responsibility then became the weight of public opinion: a case in which media coverage and public discussion regarding the ethical

and political obligations of the working photojournalist were misplaced onto one specific individual rather than being attributed to collective practices that extend to audiences themselves.

It is a story about ethics in photojournalism, but it is also one about aesthetics. Indeed, it shows, albeit in especially loaded terms, how closely related the two always are. The length of time for which Carter paused, ostensibly allowing the child to suffer for the sake of his prize photograph, is not a measure of inhumanity (Carter and his colleagues had been given strict instructions not to touch famine victims for fear of spreading disease) but a direct reflection of his beliefs regarding the role of photography in society. It represents a conviction that photographs, when presented and circulated in the public sphere via a free press, have a direct impact on events in the world. Whether this is in terms of emotional engagement, political influence, humanitarian intervention or simply 'raising awareness', most photojournalists are motivated at least to some degree by the belief that their work is in real terms worth a certain amount of cost to their own safety or well-being, and occasionally even that of their subjects. It is a means to a greater end. And if a mediocre photograph of a starving child, taken in the right place at the right time, might prompt real change of some kind, then a great one can be expected to be even more effective. Carter's vision of the perfect photograph – a vulture with wings outstretched, dwarfing the child even more dramatically than it already does – surely motivated him on an aesthetic level, as a professional photographer accustomed to framing and composing pictures instinctively, almost without thought. But even if thoughts about the political and social consequences of this decision were not present in his mind as he was lining up this photograph, they were there in the background, part of the mix of motivations, beliefs, instincts and experiences that drove him to work in the way he did. This is what we mean when we argue that, in one way or another, a photographer's political beliefs are always manifest in the aesthetic decisions they make: conscious or unconscious, premeditated or not, the form their pictures take reveals as much about the photographer as they do about the subject. More often than not, aesthetic decisions are ethical ones.

A new photojournalism?

In 1981, Rosler wrote an influential and famously scathing essay called 'In, Around, and Afterthoughts (on Documentary Photography)'.[13] In it, she questions many of the assumptions that had grown up around photojournalism (she uses the term 'documentary' in a way that is broadly interchangeable with photojournalism in this context) in the years preceding. These include the idea that a photographer can ever work as a detached observer without ego or bias, and that a photograph's meaning is independent from the economic and institutional

contexts through which it is encountered. One of her most striking arguments is that for even the most responsible humanitarian photographers, the social and political context of the time, combined with the frequently limited visual language of social documentary as a genre, mean that their work is too often doomed to perpetuate the economic status quo rather than disrupt it or effect any genuine change of attitude amongst viewers. She mentions the work of early-twentieth-century photographers Jacob Riis and Lewis Hine (though she qualifies her views on him later), whose social reform projects depicting the most vulnerable members of American society did not represent a genuine desire for the kinds of systematic reform that would address this poverty but rather an appeal to the consciences and charitable impulses of middle-class viewers who were deeply invested in a status quo in which the poor were destined to be poor and the rich were rich because they were deserving. Within this framework, audiences could look at photographs of exploited child labourers and impoverished immigrants on Manhattan's Lower East Side with a mixture of compassion and fascination, offer charity or even campaign for reforms to the law, without the comfortable order of their own lives being directly challenged at all. This kind of indulgence or mutual flattery between photographer and viewer is part of the same system that is being criticized by Sischy and others who voice concern about the aesthetic appeal of photojournalism. As long as we are being invited to admire great photographs, we are not really seeing the world at all, and certainly not being prompted to change anything.

In another essay, called 'Wars and Metaphors', Rosler explores some of these same critical questions by means of an in-depth discussion of the work of the photographer Susan Meiselas. Reviewing Meiselas's 1981 book, *Nicaragua*, on the Sandinista revolution of 1979, it is on the whole an endorsement of the photographer's commitment, skill and resourcefulness as well as of her resistance to exoticizing her subjects or converting them into spectacle: 'a standard trick of most war photography and much human-interest reportage'.[14] However, for Rosler, the book's form, and in particular its use of colour, ultimately limits its journalistic function by aligning it with the values and institutions of art. Noting that, 'at first sight it looks like the catalogue for an art show', she goes on to say that, 'unfortunately, the design, organization, and possibly the overall conception of the book, which presumably were intended to deepen their appeal to the audience for photo books – essentially an art audience – mar the book's reportorial work'. For Rosler, Meiselas's aesthetic choice (to use colour over black and white film) results in inviting the wrong kind of interpretation. In a similar vein to her previous critique of photojournalism more generally, her conclusion is that Meiselas's own integrity and skill as a photographer are overshadowed by the context of publication and viewing, because the values of art are in opposition to those of photojournalism. In short, she argues, 'as "art" takes center stage, "news" is pushed to the margins'.[15]

This same project by Meiselas was the subject of another influential essay from the 1980s, by *New York Times* art critic Andy Grundberg. His interpretation of it is different, naming Meiselas among a group of her contemporaries (including fellow Magnum photographers Alex Webb and Peress) whom he called the 'New Photojournalists'. By using this term, Grundberg is identifying a move towards what is sometimes today referred to as 'conceptual documentary'. He sees Meiselas, Webb, Peress and others approaching their work in a new way, from a more overtly personal, subjective point of view, resulting in photographic projects that are complex, multilayered and enigmatic, not easily offering up their meanings or messages in the way that a previous generation of *Life* and Magnum photographers like Capa or W. Eugene Smith had done:

> Meiselas's book has an unsettling effect. The pictures looked like art – and especially like the colour art photographs of William Eggleston, whose work the Museum of Modern Art had exhibited five years earlier. But they were of distinctly non-art subjects; indeed, they were highly charged politically … Because of this combination, the pictures seemed to float away from the established moorings of photojournalism. Instead of condensing an event in a way that explained it, Nicaragua made the Sandinista revolution seem complicated and ineffable.[16]

It is worth questioning what Grundberg means when says that the pictures 'looked like art' – for an art critic this seems like a reductive thing to say (recalling our provocative list of reductive definitions, above) – and even more so, what he would define as an 'art' versus a 'non-art' subject. Reactionary definitions of these terms are at the root of much misunderstanding within the history of photography and of the knee-jerk dismissal of much that is valuable. But setting these questions aside, he correctly observes that, because there is no place in the existing press for photography that is 'complicated and ineffable', work such as this 'is to be found in books and exhibitions as frequently as it is reproduced in news'.[17] Books and exhibitions allow more space, both literally and figuratively, for complex and experimental ideas. And in the case of many of the New Photojournalists, this complexity was precisely the point: it indicated a frustration – even an ethical objection – to easily digestible photostories that reduced wars and revolutions to tidy twelve-picture magazine spreads. Peress's book *Telex: Iran* (1984) is an account of another revolution, also taking place in 1979, this time in Iran. As a body of work, it is so rooted in the photographer's own sense of disorientation that it offers almost no 'information' about the events at all in a journalistic sense, but as a document of experience it is deeply evocative (Figure 7.8). Some have argued that it is more honest to present confusion in the face of such complex political world events than to claim the authority to explain them – and, recalling Rosler's critique, even that this is something photography should never claim in any circumstance.

In her own practice, Rosler is known for work that seeks ways to overcome the problems of documentary that she has so stridently criticized, attempting to undermine the

Figure 7.8 Gilles Peress, 1979, Street scene reflected in a mirror, Tehran, Iran (Magnum Photos).

systems that would make her, as it were, part of the problem (Figure 7.9). One example of this is her 1974–75 work *The Bowery in two inadequate descriptive systems*. The subject of this work is poverty: specifically, the Bowery neighbourhood of New York City, famous at that time for the 'down-and-outs' and 'drunks' who populated its streets. But it is also a work about the limits of documentary photography. By choosing to avoid the usual representational strategy of photographing 'victims', with all the baggage that involves, she combines photographs of unpopulated urban locations with printed text, both of which – as she acknowledges in the title of the work – are inadequate, making the viewer aware of how little we can hope to understand in the face of such a complex subject. One of the most significant things to note about this body of work is that in order to adequately address this kind of subject, which she acknowledges would typically fall within the genre of documentary or photojournalism, she has had to step completely outside of these genres and into the realm of art. Though *The Bowery in two inadequate descriptive systems* is about social inequality and urban degeneration, it is a conceptual artwork, which by definition must be encountered on totally different terms from photojournalism, within a totally different discourse, amid a totally different set of audience expectations. On the one hand, we might say that, given the work's particular aesthetic and its deliberately obtuse mode of address, art is the only 'descriptive system' that can accommodate the political points that she wants to make (even though it is still, as such, inadequate). On the other hand, this work can also be read as a critique of the art institutions in which it is designed to be displayed. Given her argument that the

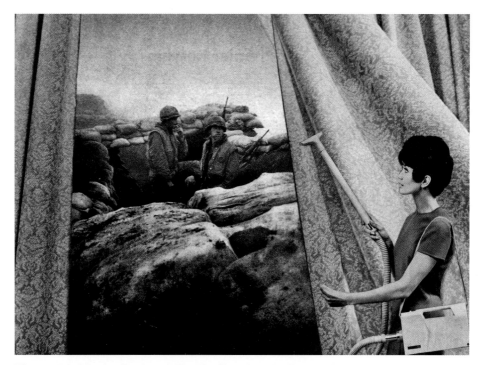

Figure 7.9 Martha Rosler, 1967–72, *Cleaning the Drapes* from the series 'House Beautiful: Bringing the War Home' (Scala).

This image is from Martha Rosler's House Beautiful: Bringing the War Home series, dated c. 1967–72, in which she comments on America's involvement in the Vietnam War (called the 'Living Room War' because of its prevalence on televisions in homes across the nation). She builds her visual critique by combining images of American casualties taken from *Life* magazine, with imagery from *House Beautiful* magazine. The series fits into a long tradition of artists appropriating photographs to create political montages that gain their force from dramatic juxtapositions of imagery.

values of art typically cause the values of news to be 'pushed to the margins', perhaps *The Bowery* ultimately exists to provoke dialogue with the work of other photographers found on the gallery wall.

The contemporary sublime

The late twentieth and the early twenty-first century have seen a whole new generation of photographers moving towards the gallery space as the most fitting location for work that, to use a bit of a cliché, poses more questions than it answers: about war, environmental degradation, politics and consumerism. Adam Broomberg and Oliver Chanarin, Simon Norfolk, Alfredo Jaar, Luc Delahaye, Edmund Clarke and

Edward Burtynsky have all responded to the limits of photojournalism as a genre by moving from this framework into new spaces where the complexity, and sometimes the uncomfortable nature, of their subject matter can be explored without restriction. In these spaces, the terms of photojournalism and documentary photography themselves can also become the subjects of critique. The fact that this space is most often the art gallery is, as Grundberg pointed out several decades ago, more a question of functional pragmatism than of intention or identity on the part of these photographers. It is a question of space. For example, Jaar's series of installations in response to the Rwandan genocide includes a pile of one million slide transparencies (each one symbolizing a death) displayed on top of a huge lightbox. As well as being a powerful indictment of the violence itself, this work is intended to draw attention to the failure of conventional photojournalistic representation: no photograph or photostory in a newspaper could give a sense of the scale of this atrocity. Jaar has located his work within the spaces and discourses of art not because he wants to be identified as an artist but because this is the only location that can accommodate his message, either conceptually or practically. The price that is sometimes paid for this level of freedom, as Grundberg also points out, is accessibility. Even when there is no entry fee, art galleries are in most cultures exclusive spaces. They carry associations of economic and educational privilege which make them seem off-limits to a great many people, regardless of what might be found inside. Add to this the complex nature of work like Jaar's and others, in which meaning is not stated simply, and this inaccessibility is compounded. A frequent complaint against such an approach is that it is elitist – complicated for its own sake, posturing and appealing only to an intellectual minority. Part of Jaar's point is that his subject is near impossible to grasp: it is incomprehensible, and photography that seems to package and explain it neatly for us (according to our previous definition of aesthetics) is disingenuous. He is among a group of photographers who have weighed up these questions of accessibility and impact and judged the sacrifice to be worthwhile.

A further aspect of the 'art versus photojournalism' debate is epitomized in the work of Delahaye. A multi-award-winning former Magnum photojournalist, Delahaye's work was included in the 2011 exhibition *New Documentary Forms* at the Tate Gallery, London, as one of a group of photographers whose work finds its home in the gallery space because of the ways in which their political engagement with their subjects is expressed aesthetically. Tate curator Simon Baker writes that Delahaye's choice of large-format in his work on the Israel-Palestine conflict is integral to his message: 'these deliberate, formal approaches seem to suggest that what contemporary visual culture lacks are images of political and social consequence that can bear a sustained look'. Like all the work in the exhibition, this is different from the 'snapshot aesthetic' of traditional photojournalism because it invites us 'to reflect carefully on subjects that perhaps we are accustomed to seeing only fleetingly, and

understanding superficially, before moving on'.[18] The most sensational thing about Delahaye for many in the photography world, however, is the amount of money for which his work has been bought and sold. His series titled *History* consisted of thirteen 1.1 x 2.3 metre panoramic prints which, when displayed in a New York art gallery in 2003, were on sale for $15,000 each.[19] Some said that this made Delahaye a commercial sell-out, and by extension, that this kind of commercial self-interest is what most fundamentally constitutes the difference between artists and photojournalists. According to this argument, the art market is no place for the subjects which Delahaye deals with (the trial of Slobodan Milosevic; the 9/11 attacks; Palestinian refugee camps). He seems willingly to have courted this kind of controversy, talking openly about the moment when he ceased to be a photojournalist and became an artist. If nothing else, his work is a reminder that the social readings and effects of photography can never be separated from their economic conditions.

When photojournalism crosses into the artistic or the self-consciously aesthetic realm, it often does so by means of – or in response to – the quality of 'the sublime'. As an idea within art and philosophy, the sublime is closely associated with the history of aesthetics. Indeed, it can be understood as a category within it. Formulated in relation to contemporary art by Jean-Francois Lyotard in the 1980s, but originally expressed in its most influential form by Edmund Burke (in 1757) and Emmanuel Kant (in 1790), the sublime essentially refers to experiences that evoke an equal measure of fear and delight. More complex and nuanced than either the beautiful or the horrible, sublime experiences impact us because they challenge our limits of understanding, forcing us to face our own inadequacy, mortality and helplessness. Simon Morley explains,

> The concept of the sublime became important in the eighteenth century when it was applied in relation to the arts to describe aspects of nature that instil awe and wonder, such as mountains, avalanches, waterfalls, stormy seas or the infinite vault of a starry sky. Today, however, rather than nature the incredible power of technology is more likely to supply the raw material for what can be termed a characteristically contemporary sublime. Awe and wonder can quickly blur into terror giving rise to a darker aspect of the sublime experience, when the exhilarating feeling of delight metamorphoses into a flirtation with dissolution or the 'daemonic'.[20]

It is not difficult to bring to mind photojournalistic images that evoke awe and wonder on the one hand, while showing us horrible aspects of the world on the other. For some photographers, the realization of this dual power has led them to make deliberate use of 'the contemporary sublime', often for politically motivated reasons (Figure 7.10). This might mean, as in the case of Delahaye and others, making huge canvas-like prints designed to overwhelm the viewer, using richly exaggerated colour saturation or even making deliberate reference to the visual language of 'history painting' in order to draw audiences' attention to issues such as environmental

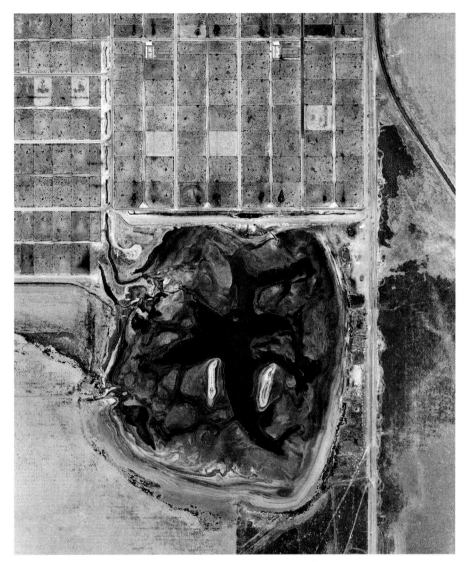

Figure 7.10 Mishka Henner, 2013, Coronado Feeders, Dalhart, Texas (Mishka Henner).

For this project, Mishka Henner has used satellite imagery to build extraordinary aerial views of 'feedlots' used in industrial-scale beef production in the United States. The grids in the upper part of the image are pens containing the cattle, and the shape occupying the lower part is a 'lagoon' of the animals' waste. The work is an example of the 'contemporary sublime' because it uses the awe-inspiring and shocking scale afforded by Henner's god-like satellite viewpoint to present an environmental critique of these agricultural practices that would not be possible using more conventional photographic approaches.

devastation, the effects of mass consumption or the modern military-industrial complex. Sometimes the most effective way of communicating subjects like these is by abandoning the traditional values of journalism and making way for something a little more transcendent.

Of course, drawing on the power of the sublime is not the only means by which contemporary photographers transfer the concerns of photojournalism into the gallery space. It is just one of many aesthetic strategies (Rosler's approach, for example, is completely different). One of the most important features of the contemporary digital environment in which photographers now find themselves is the space it offers for 'genre bending': the routine abandonment of traditional boundaries. At the very least, work like this should make us pause before ascribing to hasty definitions of what art is, which subjects 'belong' to art or to photojournalism, where we draw the boundary between the two and, most importantly, perhaps, why we would want to draw such a boundary at all.

Further reading

On photojournalism versus art: defining genres

Cotton, Charlotte. (2014). *The Photograph as Contemporary Art*. London: Thames and Hudson.

Cramerotti, Alfredo. (2010), *Aesthetic Journalism: How to Inform without Informing*. Bristol: Intellect.

Fried, Michael. (2008). *Why Photography Matters as Art as Never Before*. New Haven, CT: Yale University Press.

Grundberg, Andy. (1990). 'The New Photojournalism and the Old'. In *Crisis of the Real: Writings on Photography*. New York: Aperture, pp. 184–90.

Nair, Parvati. (2011). *A Different Light. The Photography of Sebastio Salgado*. Durham, NC, and London: Duke University Press.

Soutter, Lucy. (2013). *Why Art Photography?* London: Routledge.

Strauss, David Levi. (2012). 'The Documentary Debate'. In *Between the Eyes: Essays on Photography and Politics*. New York: Aperture, pp. 3–11.

On the aestheticization of suffering

Pollock, Griselda. (2011). 'Photographing Atrocity: Becoming Iconic?' In *Picturing Atrocity: Reading Photographs in Crisis*, edited by Geoffrey Batchen, Mick Gidley, Nancy K. Miller, Jay Prosser. London: Reaktion Books, pp. 151–22.

Reinhard, Mark, Holly Edwards and Erina Duganne. (2007). *Beautiful Suffering: Photography and the Traffic in Pain*. Chicago: University of Chicago Press.

Sischy, Ingrid. (1991). 'Good Intentions', *The New Yorker*, 9 September, pp. 89–95.

Sontag, Susan. (2003). *Regarding the Pain of Others*. London: Penguin.

Strauss, David Levi. (2014). 'Troublesomely Bound Up with Reality: On the Aestheticization-of-Suffering Critique Today'. In *Words Not Spent Today Buy Smaller Images Tomorrow: Essays on the Present and Future of Photography*. New York: Aperture, pp. 130–5.

On aftermath photography and the technological/contemporary sublime

Campany, David. (2003). 'Safety in Numbness: Some Remarks on the Problem of "Late Photography"'. In *Where Is the Photograph?*, edited by David Green. Brighton: Photoworks.

James, Sarah. (2013). 'Making an Ugly World Beautiful'. In *Memory of Fire: Images of War and The War of Images*, edited by Julian Stallabrass. Brighton: Photoworks, pp. 12–15.

On aesthetics and beauty

Adams, Robert. (1981). *Beauty in Photography: Essays in Defense of Traditional Values*. New York: Aperture.

Morley, Simon. (2010). *The Sublime*. London: Whitechapel, Documents of Contemporary Art.

8

A Network of Trusted Witnesses

Chapter summary

We began this book by noting that critical discussion of photojournalism has for decades tended to be characterized by a kind of defensiveness and suspicion regarding its power. There is, for the aspiring photojournalist, much 'baggage' to contend with: many ethical pitfalls, clichés and stereotypes to be avoided. We have discussed the 'problem' of beauty in photojournalism; the legacies of colonial ways of seeing; the dangerous lure of the exotic; the radically different audience expectations encountered within different contexts and discourses; and how, even before a photographer sets out to reveal any truth about the world, they must grapple with a spectrum of ideas about what 'truth' even means. In addition, there are clearly still significant imbalances in the representation of women and those from the majority world within the profession of photojournalism itself that must be addressed. In order to account for the critical, ethical and theoretical concerns that pertain to the work of photojournalists today, it has been necessary at some points in this book to adopt a position of caution in relation to photojournalism's power that could be (and in our teaching experience, sometimes has been) interpreted as somewhat paralyzing: if there are so many things to get wrong, how can we get it 'right'? With so many potential pitfalls, maybe it is better not to take any pictures at all. This chapter presents a rationale for the value of photojournalism as a vital part of civic discourse.

The creative stance

Not all of our readers are, or will become, photographers. But it is important, in addressing this group in particular, to state that critical scepticism, while an essential part of a photographer's education, is inseparable from creativity. Creativity is a tricky term in relation to photojournalism. As discussed in Chapter 7 on aesthetics (and 'the taint of artistry'), it is sometimes seen as an ethical imperative that the creative input

of the photographer should be minimized in order to make room for greater object-ivity. We have discussed in various ways the problematic notion of objectivity, and how an emphasis on it can lead to confusion, ideological manipulation or worse. But rather than lamenting the impossibility of pure objectivity or focusing on an alarmist suspicion of its claims, it should be affirmed that letting go of objectivity represents a great liberation. Relinquishing the rigid ideals of indexicality, realism and the purity of truth means making room for the photographer: the individual with a point of view, embodied politics, personal history and vision. This is what is meant by cre-ativity: the authorship of the person behind the camera, who has something to offer. This book's intention has been to provide a breakdown of the issues, challenges and (to use this overused word once more) pitfalls of photojournalism. By necessity, then, implicit in all that has been said is the mandate for the working photographer to find the strategies, ways of seeing, forms of investigation and representation that, in line with their own individual subjectivity, make a way forward and forge a response to what they see. In response to these critiques, now more than ever, we believe that the work of the photojournalist should be underpinned by a foundation of considered thought which combines the immediacy of the journalistic imperative with the rig-our of deep and extensive research, and then adds the personal vision of the photog-rapher, all mediated by a worked-through and developed ethical stance. In this sense, this is a critical book as opposed to a practical one. We have at times drawn attention to the work of photographers whose own vision has led them to photograph in ways that, to a greater or lesser extent, overcome problems of representation or witnessing, but it is not a book about how this should be done. That is the unwritten final chapter, and it has as many different versions as there are photographers.

As well as creativity, there is another factor that can not only enable photogra-phers to persist in a climate of scepticism about their work but also allow viewers – or let us call them witnesses – to respond to the flow of images that populate the landscape of news and current affairs without succumbing to 'compassion fatigue' or cynicism. This is, simply, a belief in the capacity of photojournalism to effect change. This belief has been at the heart of photographers' careers since the end of the nineteenth century. It has been held instinctively by readers and viewers for just as long, and, at various points throughout the medium's history, it has been proven correct in clearly discernible ways. This is why we end with a discussion of what are, to us, some of the key characteristics that make photojournalism a force for continued social transformation in real terms, in the modern world. In the cur-rent era, when a digitally networked corporate media economy vies for attention with millions of independent social media users and the huge array of small- and medium-sized independent platforms in between, the space occupied by photojour-nalism, and the expectations placed upon it, have changed in almost every way. Far from having its potency diluted by these endless waves of visual information, or from losing ground as its traditional economic models are changed beyond

recognition, photojournalism can be seen in this new landscape as offering a particular kind of perspective that has arguably not been possible in previous eras, and that is characterized first and foremost by the very same phenomenon that has led to all these other changes, and that is connectivity. We present an account of this new model for photojournalism's impact by considering it mainly, here, in the context of extremes: situations of the greatest injustice, violence and abuse, in which the stakes for intervention and change are the very highest.

A common critique of photojournalism is that it relies on stereotypes, generating tropes of representation that repeat across a range of scenarios and situations. Chapter 5 of this book has explored the dangers of this, and considered the urgent consequences of mishandling photography's power to shape cultural and social perceptions of human beings. Arguably, however, when approached with an awareness of historical pitfalls and an engaged critical consciousness, this capacity to repeat recognizable visual themes can be understood in a different way. Rather than necessarily contributing to cliché and negative stereotyping, it can be viewed as a form of patterning, analogous to the techniques of triangulation discussed earlier in regard to human rights investigation. Mass atrocity in modern conflict follows a similar pattern across continents, nations and epochs, with the same techniques of attacks on civilians recurring time and time again. By treating each instance as its own unique occurrence, but then relating that to the wider context of other similar occurrences, patterns and similarities can be established as well as differences and anomalies. Constellations of images emerge, and by working with and thinking with photographs, the viewer can begin to build up their own interpretation of the event and the consequences for action that might be drawn from it. Each image is a moment, a single temporal and spatial fragment, but taken together, multiple fragments of vision can be used to triangulate reference points by which the photographer, the curator or the viewer can develop an argument or understanding of what took place and why, and create a space in which the implications of the event can be imagined and thought through.

Photographs of trauma can create an imaginative, emphatic space in which the audience is invited to bear witness to the event, and is thus made aware of the moral import of their relationship to it. The audience is thus invited to participate in the response to such atrocity, demanding that their position as a bystander be addressed. Photographers can then be seen as providing multiple data points of the evidence of acts of atrocity occurring in similar ways in broadly similar situations – the abuse of civilians, mass graves, the suffering of children and so on. This patterning can work both at the level of a particular event, situation, story or at a higher level of categorization. Similar images of comparable situations can provide evidence that repeated types of abuse are occurring systematically across a range of contexts, establishing command responsibility for such actions at various levels too. For example, Fred Ramos's series of images *The Last Outfit of the Missing* (2013) of the clothing of

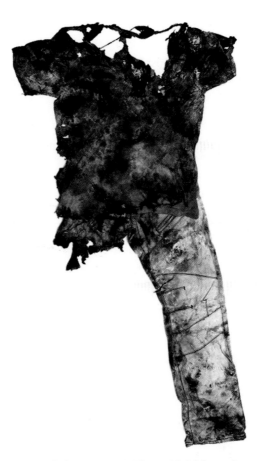

Figure 8.1 Fred Ramos, 1 February 2013 Time: 15:00 Location: outskirts of Apopa, San Salvador Gender: male Age: between 15 and 17 years old Time of disappearance: approximately one year previously. El Salvador has one of the highest homicide rates in the world, much of it gang related. In many cases, the only way of identifying murder victims is by the clothes they were buried in.

victims of gang violence in El Salvador (Figure 8.1) is strongly reminiscent of Ziyah Gafic's project *Quest for Identity*, on the personal objects exhumed from the mass graves of the victims from the Srebrenica Massacre in Bosnia in 1995 (Figure 8.2), which in turn echoes other bodies of work from previous generations. Whether this is the result of photographers consciously developing a visual language, refining and enhancing it, or operating independently and coming to the same conclusion, it is evidence that similar patterns of events can be found in similar global situations of abuse.

As explored earlier in the book, the overlapping communities of practice around photography inform one another in an ongoing debate. Through discussion of the various interactions between form and content, responses to certain situations and

Figure 8.2 Ziyah Gafic, *Quest for Identity*. Personal items recovered from the remains of the missing from the Srebrenica massacre in July 1995 are laid out on a mortuary table in the PiP Centre, Tuzla, Bosnia Herzegovina.

certain technologies can be developed, allowing for a form of collective engagement with questions of how to represent the world through the apparatus of the camera. Visual approaches and styles are developed collectively as one photographer experiments and explores an approach, their work then informing that of others who in turn further refine and expand on it in response to the visual question under investigation. Photojournalists can thus, for example, establish patterns of abuse on a global scale, highlighting the similarities across scenarios in both geographical and temporal space, and establishing that ultimately the command responsibility lies in a sense with society in general. Similar socio-economic forces can be seen in operation across a wide range of scenarios, and they generate broadly similar effects on civilian populations, which in turn generate broadly similar visual spectacles of suffering where the nuances of difference are often overwhelmed by the similarities of patterns

of abuse. Seen in this way, individual photojournalists each provide a piece of the puzzle. When their output is viewed collectively, from a critical distance, the picture established can give a comprehensive engagement with a given situation or, indeed, with more general social trends and patterns.

Drawing links between the use of rape as a weapon of war in Congo, Rwanda and Bosnia, for example, establishes that there is a pressing need for sanctions against such abuse to be developed at the level of global governance. Photojournalists can thus be seen as a network of trusted witnesses, collectively providing testimony and evidence from a wide and varied set of situations. The practice of photojournalists and documentary photographers arguably serves to enhance the moral memory of society by providing it with imaginative, emotional and evidentiary triggers to spur debate, discussion, retrospection, understanding and empathy. As David Campbell urges with regards to the representation of famine, 'We need to be less concerned about the presence of famine icons and more concerned about the absence of alternative, critical visualisations that can assist in capturing the poetical context of crises'.[1]

Photojournalists and documentary photographers thus operate in a network of relations that create an ecology and an economy of images,[2] stories, narratives, evidence and viewpoints. Individually, each practitioner produces their own unique interpretation and response to specific issues or events, often building up an expanded body of work on related themes over the course of a career or specific period of time. Collectively, all these various outputs generate a network of connected and related discourses that amplify and complement each other, providing multiple viewpoints and interpretations of the human condition that can expand a society's ability to know itself. By triangulating multiple visions, a viewer is able to engage in a more complex and nuanced understanding and interpretation of a situation. When taken together with other information sources, such as other media forms, a richer and more developed perspective can be obtained. This interconnected web of visual testimonies connects the viewer in the present to past and present moral events, constantly challenging the audience to determine whether it adheres to the call of 'never again', and demanding that it take action to prevent future abuses. The affordances of the Web allow for a more direct and interactive engagement between audience and witness that can potentially serve to amplify the impact of the testimony, by delivering it in a more targeted and focused way to people who are perhaps already moving along the trajectory from a passive to an active bystander. Photojournalism plays a significant but not independent role in this process, and it should not be seen in isolation. To expect photography alone to create significant social change is unrealistic, but taken as part of an ongoing process of informational exchange it can have a significant role in humanizing the other, and through imaginative engagement increase empathy and the desire to take affirmative action. Marcus Bleasdale sums up the potential of photography when combined with a strategic vision of how to affect change:

The lesson that I've learnt is that when we started all of this I naively thought the whole process would involve just one of these, that we should just be convincing bankers 'guys you should not be doing this', but what has happened is that role has widened to get the organisation to get more finance, it keeps up the awareness, although I still advocate that targeted dissemination is the most effective way of inducing change I'm more aware of the effectiveness of its just being an awareness tool.[3]

Photography therefore has the potential to imaginatively position the viewer in relation to the subject. As Erwin Staub argues, 'humanising others, seeing them in a positive light, makes it possible to create constructive ideologies that consider the interests of all groups'.[4] This form of engagement has demonstrated the greatest impact in generating empathy, more than other forms of connection. As Staub explains, 'imagining the other creates the most empathy, imagining the self in the situation somewhat less, and taking the role of an observer substantially less'.[5]

The work of individual photographers is supported and disseminated through a range of other 'image brokers'[6] that include editors, agency staff, gallery curators, book publishers, humanitarian organizations, critics and academics. Together, all these various stakeholders in the enterprise of photojournalism and documentary photography produce a further network of trusted sources of information and generate a community of practice whose domain is that of information and opinion about the pressing issues of the world. The economic motivation to produce work that can return a profit, or at least cover the cost of production in the short term, combines with the journalistic and humanitarian drive to generate a creative impetus to find stories that are original, untold or undiscovered, and to cover them in unique ways that will capture the imagination of the image brokers and hence the audience. The examples explored in this book, plus countless other significant and important bodies of work that bear witness to social issues that have been produced by independent photographers, often in spite of substantial obstacles, demonstrate that the role of the photojournalist and documentary photographer has been, and remains, a vital one in public democratic discourse. This important contribution to social witnessing depends on the ability of photographers to pay attention to situations and subjects that otherwise may pass unreported or unnoticed, and on photography's unique ability to pay attention to moments that would equally pass by without the gaze of the image-maker. Without these testimonies, most of which are unique and would not have existed without the presence of the individual photographer, society's sense of itself and its histories would be significantly lessened. By bearing witness to social injustices, photojournalists and documentary photographers individually and collectively form vital links in the chain of information about the world.

In a similar way, the actual images they produce operate in a networked fashion, individually and collectively generating connections and relations both within individual stories but also between stories, building patterns of relationships across

time and space. The images operate as social agents as well as do the photographers, amplifying the trust inherent in the photograph with the trust earned by the photographer by virtue of their demonstrating a commitment to ethical and journalistic integrity over a sustained period of time. The audience can therefore trust the photographer or the photograph, based on a calculation of the integrity of the context in which the work is encountered. The integrity of the photographer and their proxy (the photographic image) is vital in establishing them as reliable witnesses, whose testimony will be seen as credible and believable, shifting the onus of trust from the publication to the producer. The audience thus comes to identify with the author of the testimony rather than the media outlet that publishes it. This makes the moment of testimony more personal, more immediate and potentially therefore more affecting. Although institutions can collectively bear witness, the sense of personal testimony delivered without allegiance to a publication is significant. By foregrounding the individual's act of witnessing, the emphasis shifts from journalism to testimony. As Wim Wenders argues about the work of James Nachtwey, this generates a community that links the subject and the audience via the photographer and the image:

> Who are these 'others' on whose behalf James Nachtwey goes to war, so to speak? Are they just the subjects of his photos, the starving, the dying, the dead, the perpetrators, the sick, the injured, the sufferers, the horrified? Or don't these 'others' also include us, the viewers, the very moment we begin to get involved with one of his images? When he makes himself a witness, and stands by this task, doesn't he call us to the witness box as well? If this is indeed the case, then James Nachtwey creates a community between the subjects of his photographs and us, a community that we can't get out of so easily. He turns us into one humanity, not more and not less: Common humanity. The word 'compassion' takes on its original meaning. (In German it literally means 'sharing the suffering.') It doesn't connote condescension or 'pity', 'the pitying smile', but real empathy, when the suffering of others becomes ours as well.[7]

A 'gatekeeper organization' such as Reuters news agency affords the image the necessary veracity to be trusted, or the more individual authorship of a photographer from an agency such as Magnum or VII can be established by following their work across a range of situations in which they demonstrate their integrity. The audience can thus use its judgement to determine to what extent to trust the photograph or series of photographs and therefore to determine to what standard of evidence they pertain.

Liberated from the need to align with a mainstream publisher in order to disseminate their work, photographers therefore are able to present their testimony in a less mediated way, unfettered by the editorial control of the institution. Again, this positions the photographer as the focus of the witnessing act, emphasizing the personal nature of the testimony. Web-based platforms thus offer possibilities for photographers to deliver their testimony in the way they see most appropriate and effective, without the overt and covert agendas of mainstream media. They also offer more

rapid and effective feedback loops, as the data on traffic and usage is available directly to the photographer in a much more detailed and nuanced form than the simple circulation figures for a print publication. Again, this can offer valuable information and feedback on how to present work to gain the maximum impact and attention of the viewer. This in turn enhances the participatory process of witnessing by offering a greatly enhanced potential for the viewer to engage with the work in an active process of sense-making, as nonlinear interactive narratives can help the audience follow their own investigative journey through the work.

The photograph operates at the level of social as well as individual memory, providing a focal point around which the remembrance of past events can be preserved as significant in the present and project into the future. As Marianne Hirsch notes,

> More than oral or written narratives, photographic images that survive massive destruction and outlive their subjects function as ghostly revenants from an irretrievably lost past world. Photographs, analogue photographs in particular, are evidence of past presence. They have an indexical relationship to the object that was before the lens. But they also quickly acquire symbolic significance and thus they are more than themselves.[8]

Photography can operate as a form of social moral memory, encapsulating past traumas and atrocities into images that are mobile in time and space, and can act as symbols of society's failings to stand up to genocide and war crimes. The photograph bears witness to past atrocities in the sober hope that the present generation will not allow them to be repeated.

In turn, photography should not be seen in isolation, as if its effects, positive or negative, occur in a contextual vacuum, divorced from the impacts and effects of other related media and communication forms. It has to be seen as part of an ecology of evidence, where a variety of sources can be triangulated to provide a more nuanced interpretation of a situation. As Gilles Peress argues, this is when photography is at its most effective:

> If you ghettoize photography as 'photography,' you limit its conception as a means. I've always seen photography in a continuum – content on one side, art on another, and politics on the other. What's interesting about photography is when it locates itself at the convergence of various forms of expression and reality. I was never interested in what was happening within the defined territory of the medium, but instead, in the no-man's land between photography and other genres – literature, cinema, painting.[9]

It is frequently noted as a characteristic of the contemporary digital media environment that it allows, and in fact compels, photographers to consider the connectedness of their work to other forms and diverse audiences as part of its fundamental rationale. In other words, photography's contexts of viewing can no longer, as might have been the case during the mid-twentieth-century 'golden age' of the photo

magazine and agency, be taken for granted or considered an afterthought. But this imperative, far from being a novel feature of web-based modes of working, instead represents a return to some of the very earliest photojournalists' strategies and even values. We have already seen how the 'social reform' photography of Lewis Hine and Jacob Riis, among others, was inseparable either from its political agenda (child labour and housing, respectively), or its fully networked strategies of publication and viewing, which included carefully targeted print publications and magic lantern displays in which the narrative accompanying the images was tailored to special interest audiences in a range of individual circumstances. This holistic approach connects the earliest era of photojournalism to the present in two important ways: as well as the joined-up and thought-through 'connectedness' of its presentation, it recognizes photojournalism as more than a spectacle, in which (to recall the infamous critique of Martha Rosler) the injustices of the world are presented to disempowered neo-liberal audiences who are invited to respond as if they were watching a horror movie: frightened and disgusted but ultimately entertained, and certainly not prompted towards any kind of action or accountability.[10] Rather, it is an environment in which the image is understood to represent a mode of address that requires attentiveness and connection to the subject. In this new media environment, there is less and less scope for the criticism that photojournalism reduces, stereotypes and distances. Or at least, there is more and more space for it actively to resist these tendencies.

Journalism, documentary film, television, fiction and nonfiction writing, art, academic writing and reports from NGOs all have their own internal network of similar trusted witnesses, and also interlock and interweave with each other, reinforcing each other in a complex web of evidence, associations, interpretations and analysis. Photography plays a significant and vital role in this, but it does not operate alone. As Gary Knight explains, 'photojournalism, like other forms of mass communication is a small and useful tool and when it is used wisely in conjunction and collaboration with other media and with the support of public opinion it can make a contribution.'[11] The audience thus has multiple reference points across a range of media to utilize to make sense of a given situation.

However, the unique nature of the still photograph does give it a certain potential to operate at a different pace to other forms of media, slowing down the audience's attention and rewarding a more considered viewing, as Zelizer posits:

> Given the possibility that news, increasingly covered in real time, unfolds too quickly for people to come to grips with what it depicts, these images introduce a different mode of temporality into the news – a pause associated with the emotions, imagination, and contingency. [12]

The photograph thus serves as a unique artefact to connect past, present and future. As a technological prosthetic of vision, it is a durable, material object that represents

a moment in the past and preserves it into the future. The photograph exists in a temporally fluid state that can give the present viewer a connection with the past event. Peress sums up how

> photography, because of its stillness, provides a private moment in which people can sort out their own feelings from within, without the headlines of magazines, without the captions, without the univocalness of news images that have one meaning only. In those moments they can digest more complex images, and they can get to different kinds of ideas than they could through the 'prechewed' process of the media … As people look at pictures – complex pictures, pictures that are not unreal or univocal – there's a space that's being created. They cannot put a label on the image right away: 'This is this. This is That.' At some point they surrender to the image, and in the surrendering the images are unlocked to all kinds of ideas that exist between the moment of perception and the moment where you can put a label on perceptions and things.[13]

The photograph can 'flesh out' and thicken the relationship to past events and their locations, inscribing both place and time. The mobility of the photograph is key in this respect: as a tangible physical object it can be distributed quickly and easily both spatially and temporally. It can therefore rapidly transmit the experience of encountering a moment in the real world, sharing it with large numbers of people over an extended period of time. The photograph itself then can thus be thought of as a kind of witness, giving its own independent testimony as an agent in social discourse and debate. By actively appealing to the viewer's emotions and interpretations, such images invite a more complete response than simply pity, as they involve the audience in imagining how they would feel in such a scenario, what they would wish the world to do in response, and through compassionate engagement with the subject engender active feelings of protection, defence and solidarity rather than passive feelings of sympathy. In this way the stage is set for the audience to decide how to respond to the scene in front of them, and in doing so how to relate to those they view, so that, as Julianne Newton argues,

> images of human beings in pain or death can violate those persons if we discard our own humanity by turning away from theirs. But those images can sanctify life if we assume our full powers as sentient beings connecting with others. Then the issue becomes a most appropriate one: how best to act on those considerations. Therein lies the burden of viewing visual truth.[14]

The viewer then has to decide whether they are to be a voyeur or a witness, and then has to make an active choice between engagement and passivity, a choice that has clear moral implications. Once seen, such images demand a response from the viewer. The knowledge they impart that such a thing has occurred circumscribes their ability to claim ignorance of the facts as an excuse for a lack of concern or even action.

As this book has demonstrated, there are numerous instances in which individual photographers have produced important bodies of work that bear witness to serious issues. In the majority of cases, these bodies of work have been produced independently and often at great personal and financial risk to the photographer. Their production displays an element of moral courage in that the photographer has deliberately positioned himself or herself in harm's way in order to produce his or her testimony. The photographer has then sought to deliver this testimony in an authored, coherent form that through a variety of formal and aesthetic strategies seeks to present the content in ways that actively engage the audience in the process of sense-making and understanding of the situation. Each individual act of testimony is important and significant in its own right in terms of how it expresses a specific situation, but taken together they form an interconnected network of testimony about the world. Patterns of activity can be discerned, with similar strategies and forms being repeated in a variety of contexts. Photographers actively bear witness to the events of the world. The question remains what action will be taken in response.

Glossary of Terms

35mm Or '35mm format'; the term used for the most common 36×24 mm film used in analogue photography since the 1920s (and the corresponding camera in which it is used); favoured by many photojournalists because of its speed and portability. The term is still used in digital photography in which the digital sensor approximates these same dimensions, and to distinguish it from large and medium formats.

Abstraction In the visual arts, imagery made up of forms that do not have any representational quality. In photography this is complicated because all photographs are by necessity traces of referents in the world, but photography can be said to make use of abstraction when these referents are not easily recognizable, because of unusual viewpoints or extreme close-up, for example.

Agency Can refer to (a) a media organization such as Reuters, Agence France-Presse or Magnum Photos that gathers news reports and/or photographs and distributes them to broadcasters and the press, or (b) in philosophy and sociology, the capacity to act in a given situation and by implication to maintain ownership and/or control over one's own circumstances (for example, the way in which one is represented in a photographic encounter).

Aesthetics Historically a branch of philosophy concerned with form, beauty and taste. In photography, it most basically means *how an image looks*: its style and visual appeal.

Aestheticization A term used to describe the tendency of photography to make beautiful something that is inherently ugly or distasteful, such as human suffering.

Aftermath photography/late photography An approach to the coverage of conflict that involves photographing not the action of violence itself but the traces left behind, often in the landscape. Increasingly common since the early twenty-first century as a critical response to the limits of conventional war photography.

Analogue photography Traditional or non-digital photography which uses transparent film and a chemical developing process.

Anthropology The study of human society and culture.

Apparatus Sometimes refers to a machine or tool (such as a camera), but within critical theory – most notably in the work of Michel Foucault – to social and cultural systems through which power moves or is exerted. Examples include the press, prisons and educational institutions.

Aura The distinctive quality inherent in an 'original' artwork, which is lost or distorted in its reproduction. Discussed most famously by cultural theorist Walter Benjamin.

Avant-garde Literally translated from the French as 'vanguard' or 'advance guard': work that is groundbreaking, radical or at the cutting edge of its field.

Bearing witness Bearing the responsibility of seeing on behalf of others who are not present; the symbolic act not only of looking but also of acknowledging the significance of an event or experience.

Canon Within art, the definitive set of artists or artworks deemed culturally significant within a given period by leading experts or the dominant culture. Can arguably be applied in a similar way to the work of photographers. (Also a manufacturer of camera equipment.)

Caption Short text label accompanying a photograph, usually providing minimal facts such as date and location, but sometimes more detailed contextual or interpretive information.

Censorship Control of sensitive information, usually by official state bodies, or, in the case of self-censorship, by reporters, photographers or editors.

Citizen (photo)journalism News gathering, reporting and/or publishing by non-professional journalists and photojournalists.

Cliché Recurring statement or trope whose meaning is diminished through overuse, to the point where it is no longer taken seriously.

Conceptual (art) Art whose primary value lies in its concept rather than in its material form. Also called conceptualism, first defined by American artist Sol LeWitt in 1967.

Concerned photography Or 'social documentary' photography; a movement motivated by humanitarian concerns and often tied to campaigning objectives. Term associated primarily with Cornell Capa, who published an anthology of 'concerned photography' in 1968.

Connoisseurship Specialist expertise in the study of artworks or artefacts, and primarily in the appraisal of their cultural value.

Convergence media The interconnection of different forms of mediated information, usually in digital form. This refers to a range of phenomena, from the diversification of their practice by photographers into sound recording or video, to the simultaneous use of different platforms and information channels by users/viewers.

Compassion fatigue A diminishing of an audience's capacity for compassionate response resulting from overexposure to images or news of suffering.

Critical theory Critical thought aimed at challenging and destabilizing established knowledge, emphasizing that all knowledge is historically specific and therefore biased, and that objectivity is an illusion. It originated in Germany in the 1930s with a group of philosophers and social theorists known as the Frankfurt School.

Criticism Or 'critique'; beyond the commonplace meaning, of a negative statement about something, criticism here means the detailed appraisal of something (such as body of photographic work), seeking to interpret and analyse it in either positive or negative terms.

Decisive moment Associated with photographer and Magnum founder Henri Cartier-Bresson; the ideal photographed moment, in which all symbolic and formal elements of a scene are arranged and captured in such a way as to maximize the picture's meaning.

Denotation and connotation According to the semiotic theory of Roland Barthes, denotation is the surface or literal meaning signified within an image, whereas connotation is the level of meaning that is subjective or established by means of a shared set of interpretive associations within a given audience.

Discourse Broadly, a conversation, communication or exchange (written or spoken). Within critical and social theory, and most notably in the writing of Michel Foucault, discourse refers to 'ways of

constituting knowledge, together with the social practices, forms of subjectivity and power relations which inhere in such knowledges and relations between them'. This is rooted primarily in language, but, as a symbolic system, can be applied to photography as well.

Editing Within photography, editing has two meanings: first, the adjustment or manipulation of individual images (by means of digital software or darkroom techniques), and secondly, the selection and arrangement of individual images to form a series, such as in the process of creating a spread in a magazine or book.

Editorial photography Broadly speaking, refers to photography used in commercial press publications (newspapers or magazines) for any purpose other than advertising, but is often used to mean longer-form features or portraiture commissioned specifically by a publication, as opposed to 'news'.

Embedding Or embedded journalism; the practice of attaching journalists or photojournalists to military units in armed conflicts. Access and protection are granted by the military in exchange for the control and often censorship of information and images. First instituted by the US military during the 2003 invasion of Iraq, it is now common practice in both the US and British military.

Ethics Standards of right conduct based upon a shared system of principles, often pertaining to a specific field of practice, such as medicine, business or journalism. Ethics is a field of philosophical study.

Exotic From the Greek *exotikos*, 'foreign', which in turn comes from the prefix *exo*, meaning 'outside'; exotic has two aspects: on the one hand distant and/ or strange, and on the other, striking and attractive because unfamiliar. Calling a person exotic is problematic because it reduces them to the status of a novelty,

but it is also ambiguous, because it does this by flattering their distinctive qualities.

Famine iconography Commonly recognizable visual cues or signifiers denoting famine, which are reductive and often associated with Western preconceptions of Africa, such as visibly malnourished black women and children, distended bellies and 'flies on eyes'. Also refers to the stereotypical representation of Africa as a single, homogenous entity or country; perpetually starving and infantilized.

Fine art Art which exists on a level distinct from any practical application or function, purely for the purpose of expression, beauty or conceptual engagement with a subject. Fine art photography is generally seen as distinct from commercial, journalistic, documentary, amateur or any other genre.

Full bleed Design format in which a photograph is printed to cover an entire page (or double-page spread) from edge to edge, without gaps or borders.

Gaze Most basically, a form of looking that implies particular intent or intensity. In discussions of photography, the gaze refers to the particular perspective or subject position of the person looking. This can mean the gaze of a subject as pictured within a photograph; the implied gaze of the viewer who looks at the photograph; or any constellation of the above.

Humanitarian photography Photography made with a particular humanitarian agenda in mind, usually of suffering caused by war or other humanitarian disasters.

Icon(ic) Originally, 'icon' has a religious meaning, referring to a picture that not only depicts a sacred subject but also carries sacred and even supernatural qualities within its physical form. The word is now used widely to refer to any image that has become sufficiently well known or culturally important that it

transcends its referent and stands in a symbolic way for abstract notions (such as victory, injustice or love). Examples of photojournalistic images that have gained 'iconic' status include Nick Ut's *Napalm Girl* (Vietnam, 1972) and Steve McCurry's *Afghan Girl* (Pakistan, 1984).

Iconography As above, 'iconography' can be a general or collective term for religious icons, but it is also the name used for a branch of art history that studies the content of an image in order to interpret its meaning. Within certain genres, a picture's iconographic elements are understood to mean certain things (See 'famine iconography').

Identity politics Political issues arising from, or shaped by, a person's identity or membership of a certain social group. Most often refers to the theorizing or the expression of issues faced by marginalized groups, as in the case of feminism and black civil rights.

Ideology A key term in literary, cultural and film studies, rooted in the writings of Karl Marx and Friedrich Engels, who define ideology as the ideas of the ruling class, imposed on the whole of a society. Usually this is to some degree a distortion of reality, developed into a comprehensive system of belief that presents the artificial as natural, thus making it more likely to be universally accepted.

Imperialism Rule and control by means of colonization, such as in the case of the British empire. The term is also used to refer to attitudes that implicitly or explicitly remain, affecting power relationships between cultures long after colonial rule has ended.

Indexical(ity) In semiotics, the index is a sign that has a direct link to the subject. Objects depicted in photography are thus said to have an indexical link to their referent in the world, and this is used to strengthen claims for photography's status as evidence or 'truth'.

Indigenous In reference to people; those who originate historically from a particular region, and their distinctive culture. Also called Tribal Peoples, First Nations Peoples, and Native Peoples.

Informed consent In photography; the process of gaining permission to reproduce a person's image, either before or after their photograph has been taken, usually by the signing of a form called a model release.

Intervention A situation in which a photographer participates in or deliberately alters the scene being photographed, rather than remaining a neutral observer.

Large format Photographic process that uses film (or glass plates) measuring 102x127mm or larger. This was the format used in much of the earliest photography, but it is sometimes still used by contemporary photographers for aesthetic reasons, such as its high resolution.

Leica A camera manufacturer whose 35mm film camera, invented in the 1920s, was made famous through its use by Henri Cartier-Bresson.

Magnum Photos Influential co-operative photojournalism agency founded in 1947 by Henri Cartier-Bresson, Robert Capa and others.

Majority World A term used in preference to 'third world' or 'developing world' in describing much of Asia, Africa and Latin America; so called because it comprises most of the world's population.

Manipulation In photography; alterations made to a photograph in 'post-production', using digital software or darkroom techniques, either for aesthetic reasons or to change the meaning of an image. See 'editing'.

Medium format Photographic process that uses film (or a digital sensor) measuring 60x60mm.

Morality Morals, or morality, is the framework of principles that inform one's personal decisions about right and wrong. It is closely related to *ethics,* but is generally understood to be more abstract, subjective and/or based in personal interpretation of religious teachings, as opposed to a formalized or explicitly recognized system.

Multicultural(ism) There are many slightly different definitions of this term, but generally speaking, the coexistence of people from a range of different cultures, nationalities or ethnicities within the same community.

Multimedia The presentation of content using a range of different media or forms at once, usually via a digital platform, such as still photography combined with sound. See 'convergence media'.

Narrative A story or account in which events are presented in a meaningful sequence.

New Photojournalism Term coined by critic Andy Grundberg in the 1980s, referring to documentary photography characterized by a personal or subjective 'take' on a subject and therefore presented outside of mainstream news channels, in books or galleries.

Object In photography; the thing or person photographed (as opposed to the *subject*, which has a more nuanced meaning).

Objectify To photograph a person in a way that implicitly reduces them to the level of an object or stereotype and denies their individuality, such as in the case of sexual objectification or exoticism.

Objectivity Lack of bias, prejudice, subjectivity, agenda or personal point of view.

Other Anyone who is not the 'Self'; also a critical term used to define that which is outside the dominant majority. 'Otherness' (adj.) is the state of being different or alien, and 'Othering' (vb.) is the

process of depicting a subject in a way that emphasizes their difference from the norm.

Orientalism 'The Orient' is a historic term used by Europeans to encompass Middle Eastern, South Asian, African and East Asian cultures in a broad and reductive way. Orientalism is an attitude or way of seeing which perpetuates reductive stereotypes and colonial power relationships. This interpretation originates with Edward Said's influential book *Orientalism* (1978), in which he traces the colonial origins of perceptions of 'the East' as being exotic, backward and uncivilized.

Photoessay/photostory A sequence of photographs arranged to form a narrative, supplemented by text captions and/or a longer piece of accompanying text. A format originating from news magazines of the 1930s such as *Life*. Also called a photostory.

Photoshop Image editing software produced by Adobe Systems, introduced in 1988. Its ubiquity and accessibility have led to the term becoming a verb, 'to photoshop'. 'Photoshopping' is almost wholly synonymous with digital photo editing and manipulation.

Pictorialism Influential photographic movement of the late nineteenth and early twentieth centuries, in which creative manipulation was emphasized and nostalgic, romantic and atmospheric subjects dominated.

Positivism A philosophical theory which proposes the existence of a stable, measurable external reality that can be understood based on the sensory experience of a neutral, objective and unified observer. Problems arise when this is taken beyond the realm of empirical science and adopted as a way of understanding photography, which can presuppose neither a stable external reality nor an objective point of view from which to observe it.

Postcolonialism Or postcolonial studies; an academic discipline/field of study concerned with the legacies of colonialism and imperialism. It takes different methodological approaches as it responds to diverse cultural practices and subjects: history, art history, literary studies, media studies, film studies, anthropology, critical theory, sociology and others.

Press Usually a generic term for magazines and newspapers (in reference to the printing presses used to produce them), but sometimes refers to the news media more broadly, including television news.

Reportage Broadly synonymous with journalism, but in the case of photography refers to topical news photography (or photojournalism) as opposed to longer-form documentary approaches.

Rhetoric In the words of Aristotle, 'the faculty of observing in any given case the available means of persuasion'. Rhetoric is historically the art of spoken and written discourse, with an emphasis on the various techniques used to influence an audience. Visual rhetoric, connected to the concept of visual literacy, can be seen to fit Aristotle's definition equally well, and, as a framework for the study of images, is concerned with audiences' contextual response rather than their aesthetic response.

Semiotics The study of how meaning is constructed, with an emphasis on signs and symbols as components of meaning. Traditionally most closely associated with the study of linguistics, in which language is analysed as a construction made up of signs, semiotics has also been applied to visual images and to photography in particular, most famously by Roland Barthes.

Staging The deliberate and artificial enactment of a scene for the purpose of photographing it. This can very elaborate and premeditated, or can involve simply the manipulation of some elements within an existing scenario, such as asking someone to move or perform a certain gesture.

Stereotype A generalized assumption or judgement about a certain type or group of people. Stereotypes can be either positive or negative, rooted in fact or total misconception, but they are always reductive.

Subject In photography; can refer to the connoted meaning or theme (i.e. 'subject matter'), or to a depicted person who is of interest on the basis of their individual qualities as a human being, as opposed to as a more generalized 'object'. There are thus ethical and political dimensions to the distinction between 'subject' and 'object'.

Subjectivity The element of a person's experience which is acknowledged to be personal, individual and specific (thus, non-objective). Subjectivity accounts for likes and dislikes, and also for why different photographers will make completely contrasting images of the same thing. Critical theorists, however, especially those influenced by Lacanian psychoanalysis, distinguish subjectivity from the concept of the autonomous individual. They argue that subjectivity forms in and through the currents of culture, social structures and politics within which the subject is located.

Surrealism A diverse movement of artists and intellectuals originating in Paris in the 1920s, encompassing painting, photography, poetry, film and literature. Preoccupied with the workings of the unconscious mind, dreams and with 'making strange' the day-to-day world. 'Surreal' in common parlance usually means weird, dreamlike or fantastical.

Surveillance The monitoring of behaviour and information. Can be covert or overt; by governments, corporations or individuals; for the purposes of protection, coercion, maintaining discipline, security, or intelligence gathering.

Utilitarian(ism) An ethical principle holding that the most ethical action is the one that results in the greatest good (or utility) for the greatest number of people.

Visual literacy The ability to interpret visual information with the same level of comprehension and criticality as is conventionally associated with 'reading' written text.

Voyeurism Literally: to gain sexual gratification from looking at something. More commonly, the word does not have overtly sexual connotations but refers to any form of gratification involved in looking, often covertly, and often in a context that implies an exploitative relationship to the subject/object.

Wire service News agency that packages and sells news to newspapers, television and radio. Copy and/or photographs are 'wired' to subscribers, formerly by teletype, now via the internet or satellite transmission.

Notes

Preface: Using This Book

1 Anastasia Taylor-Lind, (2016), 'How a Lack of Representation Is Hurting Photojournalism', *Time Lightbox,* 4 May, http://time.com/4312779/how-a-lack-of-representation-is-hurting-photojournalism/.

1 What Is Photojournalism?

1 Frank Luther Mott arguably introduced the term 'photojournalism' in 1924. He was a major early influence in photojournalism education, introducing the first photojournalism class which was taught at the University of Iowa during his tenure.
2 The Reuters agency was established in 1851 by Paul Julius Reuter in Britain at the London Royal Exchange, and is one of the largest news agencies globally. The AP is a not-for-profit news cooperative formed in the spring of 1846 by five daily newspapers in New York City. The AP is owned by its contributing newspapers, radio and television stations in the United States, all of which contribute stories to the AP and use material produced by its staff journalists and photographers. Agence France-Presse (AFP) is an international news agency headquartered in Paris. Founded in 1944, it is the third largest in the world (after the AP and Reuters).
3 The ASX Team, (1972), 'Monkeys Make the Problem More Difficult – A Collective Interview with Garry Winogrand', *Image Magazine,* January, http://www.americansuburbx.com/2012/01/interview-monkeys-make-problem-more.html.
4 James Nachtwey, http://www.jamesnachtwey.com/.
5 David Campbell, (2015), 'Securing the Credibility of Photojournalism', *Lens Culture,* https://www.lensculture.com/articles/david-campbell-securing-the-credibility-of-photojournalism-new-rules-from-world-press-photo.
6 Howard Chapnick, (1994), *Truth Needs No Ally* (Columbia: University of Missouri Press), p. 13. Howard Chapnick was the founder of Black Star, a leading photojournalistic agency, and was instrumental in developing the careers of many photojournalists including James Nachtwey, the Turnley brothers and Christopher Morris.
7 Julianne Newton, (2000), *The Burden of Visual Truth: The Role of Photojournalism in Mediating Reality* (London: Routledge), p. 56.
8 Susan Sontag, (1977), *On Photography* (London: Penguin Books), p. 69.

9 Ibid., p. 69.

10 Wendy Kozol, (2014), *Distant Wars Visible: The Ambivalence of Witnessing* (Minneapolis: University of Minnesota Press), p. 12

11 Gilles Peress to Paul Lowe, (2008), interview, New York.

12 Peter Burke, (2001) *Eyewitnessing, The Uses of Images of Historical Evidence*, London: Reaktion Books p. 23.

13 Alan Trachtenberg, (1989), *Reading American Photographs: Images as History Mathew Brady to Walker Evans* (New York: Hill and Wang), p. xiv.

14 Martha Rosler, (2004), *Decoys and Disruptions: Selected Writings, 1975–2001* (Cambridge, MA: MIT Press), p. 209.

15 Newton, and Bill Nichols, (1991), *Representing Reality: Issues and Concepts in Documentary* (Bloomington: Indiana University Press).

16 Gilles Peress and Carol Kismaric, (1997), 'Gilles Peress by Carole Kismaric', *Bomb* magazine, Spring, http://bombmagazine.org/article/2033/gilles-peress.

17 Peress to Lowe, interview.

18 Ismail Küpel, (2015), 'We Spoke to the Photographer Behind the Picture of the Drowned Syrian Boy', interview with Nilüfer Demir, *Vice* magazine, 4 September, http://www.vice.com/en_uk/read/nilfer-demir-interview-876.

19 See Jennifer Good (2015), 'An Action Research Intervention Towards Overcoming "Theory Resistance" in Photojournalism Students', in Theresa Lillis, Kathy Harrington, Mary R. Lea and Sally Mitchell (eds), *Working with Academic Literacies: Research, Theory Design* (Fort Collins, CO: WAC Clearinghouse and Parlor Press), pp. 55–64.

20 bell hooks, (1994), *Teaching to Transgress: Education as the Practice of Freedom* (London: Routledge), pp. 59 and 61.

21 John Berger, (1972), *Ways of Seeing* (London: Penguin), p. 7.

22 While something of a generalization, the 'we' (and 'us') implied here refers to those who operate as viewers and participants in digitally networked and technologically advanced societies. It is not meant to be exclusive in this sense, but to acknowledge phenomena that we assume the vast majority of our readers take for granted within their own daily experience.

23 Nicholas Mirzoeff (2002), *The Visual Culture Reader*, 2nd ed. (London: Routledge), p. 4.

24 Roland Barthes, (1977), *Image Music, Text,* trans. Stephen Heath (London: Fontana Press), pp. 18–28.

2 History and Development of Photojournalism

1 Roger Fenton (1855), 'Letters from the Crimea', 4 and 5 April, http://rogerfenton.dmu.ac.uk/.

2 Ibid., 24 April.

3 For an account of the controversy, see Eroll Morris (2007), 'Which Came First, the Chicken or the Egg?', *New York Times Blog*, 25 September, http://opinionator.blogs.nytimes.com/2007/09/25/which-came-first-the-chicken-or-the-egg-part-one/?_r=0. Fenton was replaced in the Crimea by James Robertson and his then-assistant, Felice Beato, who made a series of photographs that showed in a much more explicit way the destruction of the war. Beato went on to become in many ways the first archetypal photojournalist, as he travelled widely across Asia, working in India, China, Japan, Korea, Sudan and finally Burma, mostly on self-financed trips that were funded by the sale of prints and albums back in England. Beato made arguably the first images of dead bodies when he photographed the Secundra Bagh after the killings of 2,000 rebels by the Ninety-Third Highlanders and the Fourth Punjab Regiment in November 1857. Beato arrived in Lucknow in March 1858 in the aftermath of the Indian Mutiny, after hearing. This image was also possibly staged, with some accounts claiming that Beato moved the skeletons of the Indian victims of the fighting from their mass gravesite into the photograph. Again, this questions the ethics of representation, as contemporary descriptions of the affair do describe skeletal bodies scattered in front of the temple at some point, even if this was before Beato probably arrived.

4 Jacob Riis (1901), *The Making of an American*, available from http://www.wwnorton.com/college/history/give-me-liberty4/docs/JARiis-Making_an_American-1901.pdf, p. 146.

5 Ibid., p. 147.

6 Theodore Roosevelt (1901), 'Reform through Social Work: Some Forces That Tell for Decency in New York City', *McClure's Magazine,* March. Reprinted in Judith Mitchell Buddenbaum and Debra L. Mason (eds) (1999), *Readings on Religion as News* (Ames: Iowa State University Press), p. 187.

7 Lewis W. Hine (1999), *Great Images of the 20th Century: The Photographs That Define Our Times*, edited by Kelly Knauer (New York: Time Books), p. 82.

8 Lewis W. Hine (1909), 'Social Photography: How the Camera May Help in the Social Uplift', *Proceedings of the National Conference of Charities and Correction at the Thirty-sixth Annual Session held in the City of Buffalo, New York, June 9–16, 1909*, edited by Alexander Johnson (Fort Wayne, IN: Press of Fort Wayne), p. 357.

9 He initially used the compact plate Ermanox camera, which allowed shooting in low light because of its fast f2 lens, later switching to the 35mm roll film Leica in 1932.

10 Peter Hunter, (2011) *Erich Salomon, photographer*, http://www.comesana.com/english/salomon.php

11 After the Nazis seized power, Salomon fled to the Netherlands, but was arrested in 1943 and sent to Auschwitz, where he died on 7 July 1944.

12 Robert Capa famously advised Cartier-Bresson, 'Watch out for labels. They're reassuring but somebody's going to stick one on you that you'll never get rid of – "the little surrealist photographer". You'll be lost – you'll get precious and mannered. Take instead the label of "photojournalist" and keep the other thing for yourself, in your heart of hearts.'

13 Henri Cartier-Bresson (1997), *American Photo*, September/October 1997, p. 76.

14 By 1944 it was the only survivor of the twelve independent illustrated news magazines that had existed in Germany in 1939, and with the fall of Nazi Germany in 1945, regular production ended.

15 Department of Photographs, (2000), 'Photojournalism and the Picture Press in Germany', *Heilbrunn Timeline of Art History*. The Metropolitan Museum of Art, http://www.metmuseum.org/toah/hd/phpp/hd_phpp.htm.

16 Michael Hallet, (2005), *Stefan Lorant: Godfather of Photojournalism* (Lanham, MD: Scarecrow Press), p. 70.

17 This was Luce's third magazine, after the weekly newsmagazine *Time* started in 1923, followed by the business magazine *Fortune* in 1930.

18 Henry Luce, (1936) *A Prospectus for a New Magazine*, http://life.tumblr.com/post/ 17551327132/to-see-life-to-see-the-world-to-eyewitness

19 Lee Miller became Man Ray's assistant in Paris in 1929, and was part of a circle that included Pablo Picasso, Paul Éluard and Jean Cocteau. For more details, see Phillip Prodger, (2011), *Man Ray / Lee Miller: Partners in Surrealism* (London: Merrell).

20 The soldier was one of the guards in one of the watchtowers around the camp known as Tower B. According to the US Army investigation into the incidents at Dachau, he was one of several guards who surrendered to soldiers of the Forty-Second Infantry Division, but who were subsequently executed and their bodies thrown into the moat. The IG report into the incident noted that 'After entry into the camp, personnel of the 42nd Division discovered the presence of guards, presumed to be SS men, in a tower to the left of the main gate of the inmate stockade. This tower was attacked by Tec 3 Henry J. Wells 39271327, Headquarters Military Intelligence Service, ETO, covered and aided by a party under Lt. Col. Walter J. Fellenz, 0-23055, 222 Infantry. No fire was delivered against them by the guards in the tower. A number of Germans were taken prisoner; after they were taken, and within a few feet of the tower, from which they were taken, they were shot and killed' (Office of the Inspector General of the Seventh Army, 8 June 1945, Scrapbook pages.com, http://www.scrapbookpages.com/DachauScrapbook/ DachauLiberation/GuardTowerB.html).

21 Luc Delahaye's image of a fallen Taliban soldier has a similar impact on the viewer; the figure lies almost as if asleep, and the framing and scale of the image position the body as an object of contemplation.

22 Sharon Sliwinski (2011), *Human Rights in Camera* (Chicago and London: University of Chicago), p. 101.

23 Russell Miller (1999), *Magnum: Fifty Years at the Front Line of History* (London: Pimlico), p. 43.

24 Ibid., p. 44.

25 Janina Struk (2004), *Photographing the Holocaust: Interpretations of the Evidence* (London: I. B. Tauris), p. 129.

26 Barbie Zelizer (1998), *Remembering to Forget* (Chicago: University of Chicago Press), p. 204.

27 *Daily Telegraph,* 21 September 1945.

28 Hannah Caven (2001), 'Horror in Our Time: Images of the Concentration Camps in the British Media, 1945', *Historical Journal of Film, Radio and Television* 23(3), p. 280.

29 Ibid., p. 231.

30 Sliwinski, p. 88.

31 Ibid., p. 100.

32 Siobhan Murphy, 2006, 60 Seconds: Philip Jones Griffiths Metro Newspaper 17 May 2006 http://metro.co.uk/2006/05/17/60-seconds-philip-jones-griffiths-79620/

33 http://photoquotations.com/a/291/Philip+Jones+Griffiths

34 Getty bought more than fifty companies including online library iStockPhoto. com for $50m in 2006, high-end agency Photonica for $51m in 2005, and UK citizen media agency Scoopt for an undisclosed sum in 2007. Getty itself has changed hands several times since its founding. It was sold in 2008 to US private equity firm Hellman & Friedman for $2.4bn, and then sold again in 2012 to the Carlyle Group for $3.3 Billion. See http://www.guardian.co.uk/media/2008/feb/25/mediabusiness.digitalmedia, and http://venturebeat.com/2012/08/15/getty-images-acquired/.

35 In 1995 Corbis bought the Bettmann Archive collection, which included the pre-1983 photo library of United Press International, and in 1999, the company acquired Sygma, then the largest news photography agency in the world, expanding Corbis's portfolio beyond 65 million images. It acquired Demotix in 2012. Ironically, Corbis was itself bought by the Chinese consortium Visual China Group (VCG), which in turn licensed Getty to distribute Corbis's images globally. See http://connection.ebscohost.com/c/articles/9510312188/gates-owned-corbis-corp- buys-bettman-archives; http://www.bjp-online.com/british-journal-of-photography/news/2224878/corbis-acquires-demotix; and http://www.bjp-online.com/2016/01/bill-gates-sells-corbis-to-getty-via-chinese-consortium/.

36 Martin Bell, (2006), 'If You Ask Me: Martin Bell', *UK Press Gazette*. 13 November, *Press Gazette*, http://www.pressgazette.co.uk/if-you-ask-me-martin-bell/.

37 Gary Knight to Lowe, (2010), interview. The concept that there is a 'universal language of photography' can of course be questioned, as Allan Sekula does in his influential essay 'The Traffic in Photographs' (1981), *Art Journal* 41(1) However, the use of the concept by Gary Knight is indicative of how photographers and journalists make assumptions about their audiences and their responses to media content. It does clearly indicate an expectation of an interpretive model from the audience that aligns with the photographer's worldview.

38 Ibid.

39 Peress to Lowe.

3 The Single Image and the Photostory

1 David Hockney, in Lawrence Weschler (2008), *True to Life: Twenty-five Years of Conversations with David Hockney* (Berkeley: University of California Press), p. 6.

2 W. J. T. Mitchell (1994), *Picture Theory: Essays on Verbal and Visual Representation* (Chicago: University of Chicago Press), p. 282.

3 Eduardo Cadava (1997), *Words of Light: Theses on the Photography of History* (Princeton: Princeton University Press), p. xvii.

4 Wilson Hicks (1973), *Words and Pictures (The Literature of Photography)* (New York: Arno Press).

5 W. Eugene Smith, in Ben Maddow (1985), *Let Truth Be the Prejudice: W. Eugene Smith, His Life and Photographs* (New York: Aperture).

6 See Harold Evans's introduction in Don McCullin (ed.) (2003), *Don McCullin* (London: Jonathan Cape), p. 13.

7 For a fuller account of this argument, see Robert Hariman and John Louis Lucaites (2007), *No Caption Needed: Iconic Photographs, Public Culture, and Liberal Democracy* (Chicago: University of Chicago Press), p. 290.

8 Sischy, Ingrid (1991), 'Good Intentions', *The New Yorker*, 9 September, pp. 89–95.

9 Susan Sontag (2003), *Regarding the Pain of Others* (London: Penguin), p. 71.

10 Two examples of this are Shannon Stapleton's photograph of the body of Father Mychael Judge from September 11, 2001, called *The Ground Zero* Pietà, and the most widely reproduced of the 2004 'Abu Ghraib photographs' – the image of a hooded detainee with arms outstretched in a pose which many have associated with the Christian crucifixion.

11 Writing about the event, Horst Fass describes Adams's excitement after shooting the image: 'Eddie had made a stop at his hotel, then meandered slowly into the office, as was his habit. He hid his excitement under a cloak of slight, feigned boredom – but headed straight to the editing lightdesk. Yes, I had selected the right first four pictures – but Eddie wasn't happy. Of course, like all of us, he wanted the whole sequence radioed out to the world to tell the full story. He had to wait for another day – in those days it took 20 minutes to transmit a single photo, which often had to be repeated – and the single radiotelephone circuit to Paris, shared with UPI, was closing down after three hours.' Fass also goes on to relate how this execution was not an isolated incident, although the subsequent images gained none of the notoriety or publication of Adam's. He noted that in the 'days after Adams' execution photo, Vietnamese photographers competed with a whole horror scenario of similar events. AP's Le Ngoc Cung came up with a heartbreaking sequence showing a South Vietnamese soldier sharing a sandwich and water from a canteen with a Vietcong prisoner. The last pictures show how he shot him. Dang Van Phuoc, also roaming the city for AP, had photos of diehard Vietcong dragged from the ruins and then summarily shot.' Horst Fass, (2004), 'The Saigon Execution', *Digital Journalist*, October.

12 Robert Hariman and John Louis Lucaites (2007), *No Caption Needed: Iconic Photographs, Public Culture, and Liberal Democracy* (Chicago: University of Chicago Press), p. 1.

13 Ibid., p. 21.

14 Ibid., p. 88.

15 Barthes, p. 98.

16 Susan D. Moeller, (1999), *Compassion Fatigue: How the Media Sell Disease, Famine, War and Death* (London: Routledge), p. 38.

17 Other examples are Don McCullin's photoessay on the Battle for Hue in the *Sunday Times Magazine* or Larry Burrows's '*Yankee Papa 13*' in *Life Magazine*, 16 April 1965.

18 Glenn Willumson (1992), *W. Eugene Smith and the Photographic Essay* (Cambridge: Cambridge University Press). For extended examples of the genre, see also work in Mark Richards et al., *Magnum Stories*.

19 Hariman and Lucaites, p. 2.

20 Nichols, (1989), p. 255.

21 Hariman and Lucaites, pp. 93–136.

22 Ibid., p. 128.

23 Ibid., p. 39.

24 On a personal level, the usage of one of the author's images of a man breaching the Berlin Wall with a pickaxe in November 1989 is a case in point. In addition to being used as a conventional illustration of the event at the time, the photograph was subsequently sold as a stock image a further sixteen times, including to *Business Traveller* magazine to illustrate the opening up of economic possibilities in the East; to *Classical Music* magazine to be used in an article about the orchestras from Eastern Europe undercutting those in the West; to Greenpeace for use in an advert campaigning against the polluting of Soviet-style factories; and to the Conservative Party in the United Kingdom for use in a campaign ad with the slogan 'Say no to Socialism: This man did.' As an example of how an image can be appropriated by an end user at odds with its original author's intentions is the request to use a photograph by Yuri Kozerev of *Time* of the launching of a Dragon wire-guided missile by US forces in Iraq by the manufacturer of the warhead for an advertisement promoting their weapon system. The offer was refused.

25 Peress to Kismaric.

26 Lynda Nead, (2007), *The Haunted Gallery: Painting, Photography, Film C.1900* (New Haven, CT: Yale University Press), p. 184.

27 Ritchin, p. 102.

28 Ibid., p. 104.

29 Ibid., p. 108.

30 Ibid., p. 104.

31 Ibid., p. 108.

32 Ibid., p. 133.

33 Ibid., p. 133.

4 Photojournalism Today

1 Heather S. Hughes (2008), 'Cutting Corners Cuts at the Heart of What Motivates Photojournalists', 22 April, *Black Star Rising*, http://rising.blackstar.com/cutting-corners-cuts-at-the-heart-of-what-motivates-photojournalists.html.

2 David Campbell (2014), 'How Photojournalism Contributes to Change: Marcus Bleasdale's Work on Conflict Minerals', David Campbell Blog, 14 January, http://www.david-campbell.org/2014/01/14/photojournalism-contributes-change-marcus-bleasdales-work-conflict-minerals/.

3 Clayton M. Christensen (2011), *The Innovator's Dilemma: The Revolutionary Book That Will Change the Way You Do Business.* rpt. edn. New York: Harper Business.

4 Pew Project for Excellence in Journalism (2009), *The State of the News Media*, http://www.stateofthemedia.org/2009/.

5 Charlie Beckett (2008), 'Can We Trust the Internet? (new book)', London School of Economics, 30 October, http://blogs.lse.ac.uk/polis/2008/10/30/can-we-trust-the-internet-new-book/ http://blogs.lse.ac.uk/polis/2008/10/30/can-we-trust-the-internet-new-book/.

6 Brian Storm (2009), 'Long-Form Multimedia Journalism: Quality Is the Key Ingredient', *Nieman Reports*. Spring, http://www.nieman.harvard.edu/reports/article/100937/Long-Form-Multimedia-Journalism-Quality-Is-the-Key-Ingredient.aspx http://www.nieman.harvard.edu/reports/article/100937/Long-Form-Multimedia-Journalism-Quality-Is-the-Key-Ingredient.aspx.

7 Nick Smith (2006), 'A British Photographer Finds Disturbing Beauty in War-Blasted Landscapes', *Charleston City Paper*, 11 January, http://www.charlestoncitypaper.com/charleston/visual-arts-zwnj-ego-trip/Content?oid=1103455.

8 See their blogs at http://edkashi.com/blog/, http://davidalanharvey.tumblr.com, http://instagram.com/edkashi.

9 See Vaughn Wallace (2012), In the Eye of the Storm: Capturing Sandy's Wrath, *Time Magazine*, 30 October, http://lightbox.time.com/2012/10/30/in-the-eye-of-the-storm-capturing-sandys-wrath/#1 http://lightbox.time.com/2012/10/30/in-the-eye-of-the-storm-capturing-sandys-wrath/ - 1%5B11.

10 Oliver Laurent (2014), 'VII Photo Rises to Challenges of Changing Photographic Landscape with Dynamic New Agency Model', *British Journal of Photography*, 21 May, http://www.bjp-online.com/2014/05/vii-photo-rises-to-challenges-of-changing-photographic-landscape-with-dynamic-new-agency-model/.

11 Gary Knight to Lowe (2009), interview.

12 Anthony Suau to Lowe (2016), interview.

13 Marcus Bleasdale to Lowe (2007), interview.

14 Ibid.

15 Campbell.

16 Storm.

17 Photovoice (2009), *Statement of Ethical Practice*, March 1, p. 2.

18 Smith.

19 School of Journalism, University of Missouri (2008), 'Journalism School to Recognize 134 Graduates during Fall Commencement', 16 December, http://journalism.missouri.edu/2008/12/journalism-school-to-recognize-134-graduates-during-fall-commencement/.

5 Power and Representation

1 Edward W. Said (1995), *Orientalism: Western Conceptions of the Orient* (London: Penguin).
2 Michel Foucault (1980), *Power/Knowledge*, ed. Colin Gordon (London: Harvester Wheatsheaf).
3 Michel Foucault (2003), *The Birth of the Clinic: An Archaeology of Medical Perception*, trans. A. M. Sheridan (Abingdon: Routledge).
4 Catherine Lutz, and Jane Collins (2003), 'The Photograph as an Intersection of Gazes: The Example of *National Geographic*', in *The Photography Reader*, ed. Liz Wells (London: Routledge), pp. 354–73.
5 For a discussion of the approaches adopted by photographers to overcome these challenges, specifically in relation to war, see Liam Kennedy (2016), *Afterimages* (Chicago: University of Chicago Press).
6 Aline Gubrium and Krista Harper (2013), *Participatory Visual and Digital Methods* (Walnut Creek, CA: Left Coast Press).
7 Andrea Lee (2014), 'Notes on the Exotic', *The New Yorker*, 3 November, http://www.newyorker.com/books/page-turner/notes-exotic.
8 Cynthia H. Enloe (2000), *Bananas, Beaches and Bases: Making Feminist Sense of International Politics* (London: University of California Press), pp. 42–4.
9 An example that has caused controversy in recent years is photographer Jimmy Nelson's project *Before They Pass Away* (Krefeld: teNeues, 2013).
10 Raghubir Singh (2006), *River of Colour: The India of Raghubir Singh* (New York: Phaidon), p. 14.
11 Ibid., p. 10.
12 See Sara Blokland and Asmara Pelupessy (eds) (2011), *Unfixed: Photography and Postcolonial Perspectives in Contemporary Art* (Heijningen: Jap Sam Books).
13 David Campbell (2011), 'The Iconography of Famine', in *Picturing Atrocity: Reading Photographs in Crisis*, edited by Geoffrey Batchen, Mick Gidley, Nancy K. Miller and Jay Prosser (London: Reaktion Books), p. 88.
14 Ibid., p. 84.
15 Eldis.org (2002), 'The Live Aid Legacy: The Developing World through British Eyes', http://www.eldis.org/go/home&id=18982&type=Document#.Vc9AfkJVikq.
16 The metaphor of the famine victim as hunted prey is carried further in Kevin Carter's famous photograph of a vulture stalking a starving Sudanese child See discussion in chapter 7.
17 Peter Hitchens (2011), 'Radio Silence', *Mail Online*, 11 August, http://hitchensblog.mailonsunday.co.uk/2011/08/radio-silence.html.
18 Barthes (1977), pp. 18–28.
19 David A. Bailey and Stuart Hall (2002), 'The Vertigo of Displacement', in *The Photography Reader*, edited by Liz Wells (London: Routledge), p. 381.

6 Ethics

1 Lars Boering, in Michael Zhang (2015), 'World Press Photo Strips Giovanni Troilo of His First Prize Win for Misrepresenting Photo', *PetaPixel.com*, 4 March, http://petapixel.com/2015/03/04/world-press-photo-strips-giovanni-troilo-of-his-first-prize-win-for-misrepresenting-photo/.

2 David Campbell (2014), 'The Integrity of the Image', *World Press Photo*, November, http://www.worldpressphoto.org/sites/default/files/docs/Integrity%20of%20the%20Image_2014%20Campbell%20report.pdf.

3 In 2010 a photostory by Stepan Rudik was disqualified from the World Press Photo competition for the removal of a barely visible foot. Michael Zhang (2010), 'World Press Photo Disqualifies Winner', *PetaPixel.com*, 3 March, http://petapixel.com/2010/03/03/world-press-photo-disqualifies-winner/.

4 Don McCullin, in Jessamy Calkin (n.d.), 'Bleak Beauty: The Photographer Don McCullin on His Life's Work', *The Telegraph*, http://s.telegraph.co.uk/graphics/projects/donmccullin/index.html.

5 Sarah Kember (2003), 'The Shadow of the Object: Photography and Realism', in *The Photography Reader*, edited by Liz Wells (London: Routledge), p. 215.

6 Donald R. Winslow (2009), 'Danish Photoshop Debate Leads to Disqualification', *National Press Photographers Association*. 13 April, https://nppa.org/news/811.

7 David Levi Strauss (2011), 'Doctored Photos: The Art of the Altered Image', *Time.com*, 13 June, http://time.com/3778075/doctored-photos-the-art-of-the-altered-image/#1.

8 Kember, p. 209.

9 John Taylor (1998), *Body Horror: Photojournalism, Catastrophe and War* (New York: New York University Press), p. 6.

10 Jim Rutenberg, and Felicity Barringer(2001), 'News Media Try to Sort Out Policy on Graphic Images,' *New York Times*, 13 September, p. A24.

11 Ibid. See Jennifer Good (2015), *Photography and September 11th: Spectacle, Memory, Trauma* (London: Bloomsbury).

12 Jean Baudrillard (2012), *The Gulf War Did Not Take Place*, trans. Paul Patton (Sydney: Power Publications).

13 Kenneth Jarecke, in John Pilger (2002), *The New Rulers of the World* (London: Verso), p. 125.

14 Elaine Scarry (1993), 'Watching and Authorising the Gulf War,' in Marjorie Garber, Jann Matlock and Rebecca L. Walkowitz (eds), *Media Spectacles* (New York: Routledge), pp. 57–64.

15 Baudrillard, p. 28.

16 Peter Howe (2002), *Shooting under Fire* (New York: Artisan Sales), p. 174.

17 See http://iraq.reuters.com/ .

18 Newton, p. 124.

19 Erroll Morris (2004), 'Not Every Picture Tells a Story', *New York Times Blog*, 4 November, http://www.nytimes.com/2004/11/20/opinion/not-every-picture-tells-a-story.html?_r=0.

20 Susan Meiselas, (2008), *In History: Susan Meiselas and Documentary Photography* (Göttingen: Steidl Verlag), p. 216.

21 Susan Meiselas, in Ken Light (ed.) (2000), *Witness in Our Time: Working Lives of Documentary Photographers* (Washington: Smithsonian Institute Press), p. 107.

22 Avishai Margalit (2002), *The Ethics of Memory* (Cambridge, MA: Harvard University Press), p. 181.

23 See, for example, the concept of 'weapon focus', whereby the presence of a gun at the scene of a crime adversely affects witnesses' ability to remember clearly the details of the event. The classic work on this is Elizabeth Loftus, Geoffrey Loftus Loftus and Jane Messos (1987), 'Some Facts about Weapon Focus', *Law and Human Behavior* 11(1), pp. 55–62.

24 Zelizer, p. 698.

25 Carrie Rentschler, (2004), 'Witnessing: US Citizenship and the Vicarious Experience of Suffering', *Media Culture Society* 26(2), p. 298.

26 Dori Laub (1992), 'Bearing Witness or the Vicissitudes of Listening', in *Testimony: Crises of Witnessing in Literature, Psychoanalysis and History* (New York: Routledge), p. 68.

27 Jeffery Blustein (2007), *The Moral Demands of Memory* (Cambridge: CUP), p. 323.

28 Ariella Azoulay (2012). *The Civil Contract of Photography*. (Cambridge, MA: MIT Press), p. 343.

29 Iwona Irwin-Zarecka (1994), *Frames of Remembrance: The Dynamics of Collective Memory* (New Brunswick, NJ: Transaction Publishers), pp. 163–4.

30 See Sobchack, Vivian. (2004). Inscribing Ethical Space: Ten Propositions on Death, Representation, and Documentary, in *Carnal Thoughts: Embodiment and Moving Image* Culture. Berkeley: University of California Press.
 Bill Nichols (1991), *Representing Reality: Issues and Concepts in Documentary*. (Bloomington: Indiana University Press); Taylor, *Body Horror*.

31 Sobchack, p. 298.

32 Nichols, p. 88.

33 Ibid., p. 84.

34 John Paul Caponigro (2000), 'James Nachtwey', http://www.johnpaulcaponigro.com/lib/artists/nachtwey.php.

35 Ibid.

36 Hale and Church (1996), 'Helping Hands', *News Photographer*, pp. 24–5.

37 The action can be seen in this ITN news report from the event: https://www.youtube.com/watch?v=Ev2dEqrN4i0.

38 For more on the story of Kim Phuc and Nick Ut, see, for example, Igor Solar (2012), 'Kim Phuc: "The Girl in the Picture" Forty Years Later', *Digital Journal*, 7 June, http://www.digitaljournal.com/article/326206#ixzz37jhttp7w, and http://www.digitaljournal.com/article/326206.

39 Hondros was later killed in Libya along with Tim Hetherington in April 2011. See http://www.chrishondros.com. See this multimedia piece by Hondros for more details of the incident: http://www.nbcnews.com/id/6871483/.

40 Sarah Terry (2005), *Aftermath* (New York: Channel Photographics).

41 Nichols, p. 80.

42 Ibid., p. 86.

43 Harriman and Lucaites, p. 36.

44 Taylor, p. 195.

45 Azoulay, p. 17.

46 Judith Butler (2009), *Frames of War: When Is Life Grievable?* (London: Verso).

47 Newton, p. 122.

48 Kozol, p. 19.

49 Barbie Zelizer (2010), *About to Die: How Images Move the Public* (Oxford: Oxford University Press), p. 315.

7 Aesthetics

1 Susan Sontag (2003), *Regarding the Pain of Others* (London: Penguin), pp. 26–7.

2 The question of this photograph's authenticity has been debated for decades and was first brought to public attention in Philip Knightley's 1975 book, *The First Casualty: The War Correspondent as Hero and Myth-Maker from the Crimea to Iraq* (Baltimore: John Hopkins University Press, 2004).

3 Sigmund Freud (1957), 'The Uncanny', in *The Standard Edition of the Complete Psychological Works of Sigmund Freud*, vol. 17, trans. J. Strachey (London: Hogarth Press), p. 219.

4 Jean-François Lyotard, *The Postmodern Condition* (Minnesota and Manchester: Manchester University Press).

5 Robert Adams (1981), *Beauty in Photography: Essays in Defense of Traditional Values* (New York: Aperture).

6 Weston Naef (ed.) (1995), *Alfred Stieglitz: Photographs from the J. Paul Getty Museum* (Los Angeles: J. Paul Getty Museum), p. 20.

7 Henri Cartier-Bresson (1952), *The Decisive Moment* (New York: Simon and Schuster), pp. 1–14.

8 John Szarkowski (2007), *The Photographer's Eye* (New York: MoMA), p. 10.

9 Cartier-Bresson, pp. 1–14.

10 David Levi Strauss (2014), *Words Not Spent Today Buy Smaller Images Tomorrow: Essays on the Present and Future of Photography* (New York: Aperture), p. 130.

11 Mieke Bal, in Strauss, p. 132.

12 Ingrid Sischy (1991), 'Good Intentions', *The New Yorker*, 9 September, pp. 89–95.

13 Martha Rosler, *Decoys and Disruptions: Selected Writings, 1975–2001* (Cambridge, MA, and London: MIT Press, 2004), pp. 151–206.

14 Ibid., p. 246.
15 Ibid., p. 238.
16 Andy Grundberg (1990), 'The New Photojournalism and the Old', in *Crisis of the Real: Writings on Photography* (New York: Aperture), pp. 185–6.
17 Ibid., p. 185.
18 Simon Baker, Boris Mikhailov and Mitch Epstein (2011), 'Documents for the World', Tate.org.uk, 1 May, http://www.tate.org.uk/context-comment/articles/documents-world.
19 Peter Lennon (2004), 'The Big Picture', *The Guardian*, 31 January, http://www.theguardian.com/artanddesign/2004/jan/31/photography.
20 Simon Morley (2010), *The Sublime* (London: Whitechapel, Documents of Contemporary Art), pp. 12–13.

8 A Network of Trusted Witnesses

1 Campbell, p. 89.
2 Sontag, *On Photography*. Sontag writes, 'Images are more real than anyone could have supposed. And just because they are an unlimited resource, one that cannot be exhausted by consumerist waste, there is all the more reason to apply the conservationist remedy. If there can be a better way for the real world to include the one of images, it will require an ecology not only of real things but of images as well' (p. 180).
3 Bleasdale to Lowe.
4 Erwin Staub, (2011), *Overcoming Evil* (Oxford: OUP), p. 327.
5 Ibid., p. 364.
6 Zeynep Devrim Gursel (2015), *Image Brokers Visualizing World News in the Age of Digital Circulation* (Berkeley: University of California Press).
7 Wim Wenders (2012), 'Eulogy for James Nachtwey at the Occasion of the Dresden Prize', *Burn* magazine, 11 February, http://www.burnmagazine.org/in-the-spotlight/2012/02/wim-wenders/.
8 Marianne Hirsch (2012), 'An Interview with Marianne Hirsch', Columbia University Press, http://cup.columbia.edu/author-interviews/hirsch-generation-postmemory.
9 Peress and Kismaric.
10 It should be noted that these earlier magic lantern displays, particularly those of Riis, were indeed conceived as spectacles and that entertainment was a large factor in their appeal and usefulness. But contrary to the phenomenon criticized by Rosler, this was spectacle that was designed to engage and prompt an active response, not to hypnotize or distance the viewer from the reality being presented.

11 Peress and Kismaric.
12 Zelizer, p. 325.
13 Peress to Mike Kamber, in Kamber (2013), *Photojournalists on War* (Austin: University of Texas Press), pp. 205–6.
14 Newton, p. 125.

Selected Bibliography

Adams, R. (1981). *Beauty in Photography: Essays in Defense of Traditional Values.* New York: Aperture.

Azoulay, A. (2012). *The Civil Contract of Photography.* Cambridge, MA: MIT Press.

Barthes, R. (1977). *Image, Music, Text.* Translated by S. Heath. London: Fontana Press.

Batchen, G., Mick Gidley, Nancy K. Miller and Jay Prosser (eds) (2011). *Picturing Atrocity: Reading Photographs in Crisis.* London: Reaktion Books.

Bate, D. (2009). *Photography: The Key Concepts.* London: Berg.

Baudrillard, J. (2012). *The Gulf War Did Not Take Place*, Translated by Paul Patton. Sydney: Power Publications.

Berger, J. (1972). *Ways of Seeing.* London: Penguin.

Blokland, S., and S. Pelupessy (eds) (2011). *Unfixed – Photography and Postcolonial Perspectives in Contemporary Art.* Heijningen: Jap Sam Books.

Burgin, V. (ed.) (1982). *Thinking Photography.* London: Macmillan.

Cadava, E. (1997). *Words of Light: Theses on the Photography of History.* Princeton: Princeton University Press.

Campbell, D. (2014). *The Integrity of the Image.* Amsterdam: World Press Photo, November http://www.worldpressphoto.org/sites/default/files/docs/Integrity%20of%20the%20Image_2014%20Campbell%20report.pdf.

Cartier-Bresson, H. (1952). *The Decisive Moment.* New York: Simon and Schuster.

Enloe, C. H. (2000). *Bananas, Beaches and Bases: Making Feminist Sense of International Politics.* Berkeley: University of California Press.

Foucault, M. (1980). *Power/Knowledge.* Edited by C. Gordon. London: Harvester Wheatsheaf.

Foucault, M. (2003). *The Birth of the Clinic: An Archaeology of Medical Perception.* Translated by A. M. Sheridan. Abingdon: Routledge.

Garber, M., J. Matlock and R. L. Walkowitz (eds) (1993). *Media Spectacles.* New York: Routledge.

Good, J. (2015a). 'An Action Research Intervention towards Overcoming "Theory Resistance" in Photojournalism Students'. In T. Lillis, K. Harrington, M. R. Lea and S. Mitchell (eds). *Working with Academic Literacies: Research, Theory Design*, Fort Collins, CO: WAC Clearinghouse and Parlor Press, 55–64.

Good, J. (2015b). *Photography and September 11th: Spectacle, Memory, Trauma.* London: Bloomsbury.

Grundberg, A. (1990). *Crisis of the Real: Writings on Photography.* New York: Aperture.

Gubrium, A., and K. Harper . (2013). *Participatory Visual and Digital Methods.* Walnut Creek, CA: Left Coast Press.

Hariman, R., and J. L. Lucaites . (2007). *No Caption Needed: Iconic Photographs, Public Culture, and Liberal Democracy.* Chicago: University of Chicago Press.

Hicks, W. (1973). *Words and Pictures (The Literature of Photography).* New York: Arno Press.

hooks, b. (1994). *Teaching to Transgress: Education as the Practice of Freedom.* London: Routledge.

Lee, A. (2014). 'Notes on the Exotic', *New Yorker*, 3 November, http://www.newyorker.com/books/page-turner/notes-exotic.

Linfield, S. (2010). *The Cruel Radiance: Photography and Political Violence.* London: University of Chicago Press.

Lyotard, J.-F. (1984). *The Postmodern Condition.* Minnesota and Manchester: Manchester University Press.

McCullin, D. (ed.) (2003). *Don McCullin.* London: Jonathan Cape.

Mirzoeff, N. (ed.) (2002). *The Visual Culture Reader*, 2nd edn. London: Routledge.

Mitchell, W. J. T. (1994). *Picture Theory: Essays on Verbal and Visual Representation.* Chicago: University of Chicago Press.

Morley, S. (2010). *The Sublime.* Whitechapel, Documents of Contemporary Art. Cambridge, MA: MIT Press.

Newton, J. (2000). *The Burden of Visual Truth: The Role of Photojournalism in Mediating Reality.* London: Routledge.

Pilger, J. (2002). *The New Rulers of the World.* London: Verso.

Rosler, M. (2004). *Decoys and Disruptions: Selected Writings, 1975–2001.* Cambridge, MA, and London: MIT Press.

Said, E. W. (1995). *Orientalism: Western Conceptions of the Orient.* London: Penguin.

Singh, R. (2006). *River of Colour: The India of Raghubir Singh.* New York: Phaidon.

Stallabrass, J. (ed.) (2013). *Memory of Fire: Images of War and the War of Images.* Brighton: Photoworks.

Strauss, D. L. (2014). *Words Not Spent Today Buy Smaller Images Tomorrow: Essays on the Present and Future of Photography.* New York: Aperture.

Susan, S. (2003). *Regarding the Pain of Others.* London: Penguin.

Szarkowski, J. (2007). *The Photographer's Eye.* New York: MoMA.

Taylor, J. (1998). *Body Horror: Photojournalism, Catastrophe and War.* New York: New York University Press.

Wells, L. (ed.) (2003). *The Photography Reader.* London: Routledge.

Index